The Graphic Art of Edvard Munch
by Werner Timm

P9-AFC-774

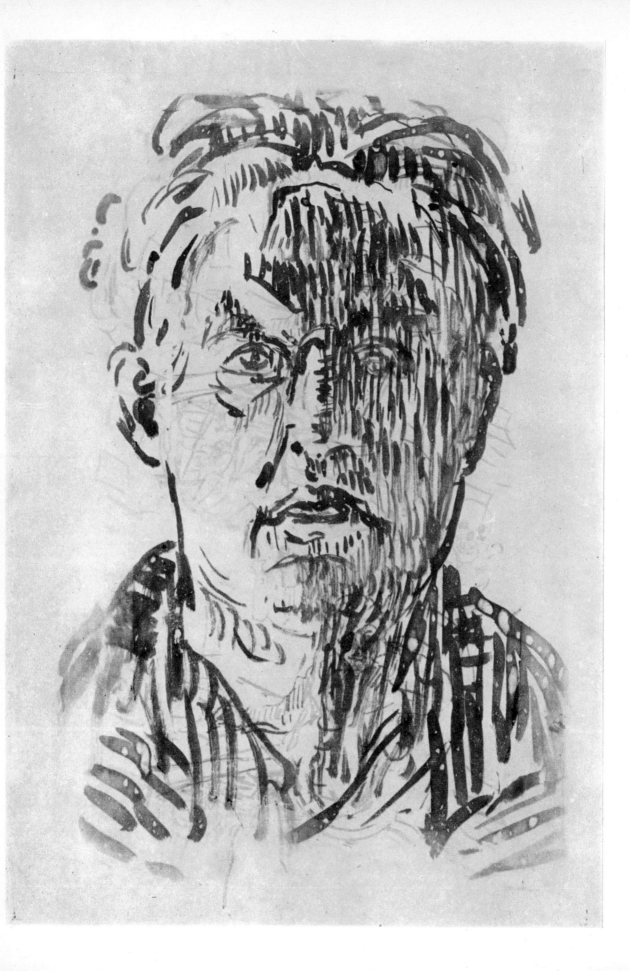

The Graphic Art of Edvard Munch

by Werner Timm

Translated from the German by: Ruth Michaelis–Jena
with the collaboration of Patrick Murray, F.S.A. (Scot)

New York Graphic Society Ltd.

Riverside Community College
Library
4800 Magnolia Avenue
Riverside, CA 92506

Second Printing, 1972

© English translation Studio Vista 1969
Published in the United States of America
by New York Graphic Society, Greenwich, Connecticut 06830
and in Great Britain by Studio Vista
Blue Star House, Highgate Hill, London N. 19
ISBN 8212–0333–9
Library of Congress catalog card number 78–81079
Made and printed in Germany (East)

Original edition: Edvard Munch Graphik Copyright 1969 by Henschelverlag Berlin
624 566 0

Table of Contents

Author's Note:

In the text and in the list of illustrations and plates graphics are numbered according to the *œuvre* catalogues of Gustav Schiefler (Sch). For etchings, additional numbers from the more recent catalogue by Sigurd Willoch (W) have been given in the full list of illustrations. Woodcuts and lithographs, made after 1926, and not listed by Schiefler, carry the numbers of the Munch-Museum at Oslo (MS). Etchings by Max Klinger, discussed in the third chapter, are numbered according to the *œuvre* catalogue by Hans Wolfgang Singer (S), the works by Rops according to Maurice Exsteens (see Appendix Notes 24) and the lithographs by Carrière according to Louis Delteil, *Le Peintre-Graveur Illustré*, Vol 8, Paris 1913. The titles of these publications are given in the bibliography along with titles of works frequently quoted in the notes. When several publications by the same author are quoted they are distinguished by Roman figures, for example: Langaard III. Sizes are given in centimetres, height preceding width.

'A work of art can arise only from man's inner self.
Art is man's longing for crystallization.'
Edvard Munch

Origins and Objects

At the end of the nineteenth century a fresh wind from the North was blowing across the Continent. People began to listen to the voices of Scandinavian writers who looked critically at the social situation of the time and the human problems it involved. Ibsen, Bjørnson, Hamsun and Strindberg brought Scandinavian literature to the attention of the world. Ibsen's plays caused a sensation in Berlin and in Paris.[1] In 1889 his *Ghosts* was chosen as the opening performance of the *Freie Bühne*. This production brought forth protests not unlike those accompanying Munch's first exhibition in Berlin three years later which ended in a scandal. Invited by the Berlin Artists' Union, he showed his work abroad for the first time in 1892. Shocked, however, at the unaccustomed boldness of the pictures the Artists' Union's conservative majority forced the closing of the exhibition despite the keen protest of an outvoted minority. 'The exhibition has caused a colossal offence, a lot of old painters here are infuriated by the new trends,' Munch wrote to Karen Bjølstad. But new tendencies cannot be checked. 'Intellectual and artistic trends are not forcibly suppressed,' the writer Theodor Wolff said in the *Berliner Tageblatt*. Munch stayed in Berlin, and soon had the opportunity of showing his pictures elsewhere. From then on Munch, a Scandinavian painter, achieved a stature equal to that of Cézanne, van Gogh, Gauguin, Toulouse-Lautrec and Hodler, and the world realised that painters as well as writers were in the new movement.

Edvard Munch was born on 12 December 1863 on the farm of Engelhaugen in Løten, in the province of Hedmark in Norway, the son of a doctor, Christian Munch. The following year the family moved to Christiania, the present-day Oslo. Munch's father was a serious, pious man of ascetic disposition. Fairly late in life he had married Laura Bjølstad by twenty years his junior. She died of tuberculosis barely thirty-three years old. A few years later Munch's eldest

1
Wood-block I for Sch 129

2
Wood-block II for Sch 129

sister, Sophie, died of the same disease and his highly gifted younger sister, Laura, became mentally ill; in 1895 his brother Andreas died. Of the four children only his sister Inger survived him. The death of mother and sister cast a shadow over his youth. He himself had a weak constitution and was often ill. This early acquaintance with death, with its brutal insistence on the uncertainty of life, significantly influenced his attitude and creative outlook. He himself said: 'Without illness and death my life would have been a ship without helm.'

In 1879 he began to study engineering at the Technical High School but left the following year to become a painter. He had shown a talent for drawing and painting previously, intelligently encouraged by Karen Bjølstad, his aunt who looked after the motherless children. His strong need for self-expression through drawing and painting was evident even then. After a difference of opinion with his father he attempted a reconciliation: 'I went home to reconcile myself with my father, but he had already gone to his bedroom. Quietly I opened the door and saw my father kneeling by his bedside praying. I had never seen that before. I closed the door and went to my room. I was restless, unable to go to sleep. At last I fetched my drawing board and began to draw. I drew my father, kneeling by the bed, the light on the table throwing a faint yellow glow over his nightshirt. I got out my paintbox and put in some colour. At last I succeeded and lay down, comforted, falling asleep quickly.'[2] Years later an impressive woodcut was made from this motif. (Sch 173).

Plate 144

Munch was self-taught. No academy can count him among its pupils, but from 1881 to 1890 he was very anxious to educate himself. He took drawing lessons from the sculptor Julius Middelthun. And when, in 1882, seven young artists—one of them Munch—formed a studio group, Christian Krohg offered to criticise their work. In the autumn of 1883 and in the following year he was at the open air academy in Modum, founded by Frits Thaulow. In Paris he painted for a while in Léon Bonnat's studio. Only in a very limited way

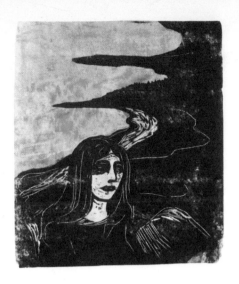

3
Girl's Head against
the Shore (Sch 129)
1899
Woodcut

can these artists be called Munch's teachers. He considered that among Norwegian painters Hans Olaf Heyerdahl had had the strongest effect on him. These artists gave him both his particular nationalistic awareness and introduced him to the mainstream of European art. An academic training in Copenhagen, Munich and Karlsruhe characterised this older generation, together with a leaning towards French art, at a time when Paris was becoming a centre attracting artists from all over the world. In the late seventies Thaulow, Krohg and Heyerdahl were in Paris, making their first contact with the new Naturalistic School. They saw the apex of all art in Impressionism. When Munch had reached this phase in 1889 Krohg wrote enthusiastically: 'He is an Impressionist, our only one meantime.'[3]

A characteristic of Norwegian art before Munch is its realistic content and its naturalistic form. Thaulow and Krohg were frequently in Skagen during the summer. Here Krohg found the models for his pictures in the life of the fishermen and sailors, and under the influence of socialistic ideas he painted the proletariat of the big cities. In 1880 he painted *The Sick Girl*. We find a related subject with Heyerdahl whose painting *The Dying Child* was shown in the Paris Salon of 1882. Another of Heyerdahl's paintings, *Death of a Workman*, received a medal in Paris in 1889. Like Munch, Heyerdahl enjoyed staying at Åsgårdstrand, where he was greatly attracted by the scenery.

In their subjects the pictures of these artists show similarities to Munch's, but on closer inspection it becomes clear that his interpretation took a different course. The apparent social overtones take second place to a deeper involvement of the inner self. Thus seen in a wider historical context Munch's vision of the Norwegian landscape, for example, has closer affinities with Romantic painting, such as that of Johan Christian Clausen Dahl and his countryman from Hedmark, Peder Balke, than with the down-to-earth contemporary Norwegian work.

Munch was befriended and encouraged by Christian Krohg who besides

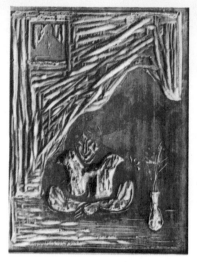

4
2 wood-blocks
for Sch 131
(The Fat Prostitute)

being a painter, was an art critic and writer, and Frits Thaulow. In 1885 Thaulow made possible Munch's first three weeks' stay in Paris, when he was particularly impressed by Manet. After his return he completed in 1885 and 1886 the first important works of his early period, *The Day After*, *The Sick Girl*, and *Puberty*. In 1889 he received a Norwegian State Grant, enabling him to stay for several months in Paris.

Between 1888 and 1890 a decided retreat from Naturalism and Impressionism manifested itself in European art. Gauguin opposed the analytical conception of the Impressionists with his own synthesis of simplification, concentration and submission to a unified idea. His disciples from Pont-Aven, and the *Nabis* form the avant-garde of this progressive movement which also determined Munch's development. Completely in tune with the contemporary idiom, and in reaction to a widely spread Naturalism, he evolved his fundamental works. His saying: 'I do not paint what I see but what I saw,'[4] corresponds largely with the principles of Gauguin and his circle.

In 1890 Ferdinand Hodler painted *The Night*, a picture in which he accomplished the transition from Naturalism to Symbolism. Symbolism in picture content and form gained in importance, though differently expressed by different individuals, so that one can hardly speak of a unified style. What the Symbolists have in common is imagery. Their statement does not end with what they see or saw, but seeks to convey a deeper meaning: the painting becomes a metaphor, a parable and a symbol. In this sense Munch's work is essentially symbolistic. For the pensive Norwegian who was turned introspectively to the deeper values of life, Symbolism was an adequate form of expression. He escaped the inherent danger of an abstract mysticism because his ties with the real world around him and its problems were deep and passionate. The symbolistic means became completely integrated with his own personal way of expression and were, in Gauguin's sense, submitted to a unified idea. It was his aim to present the essential, the true inner life. 'People

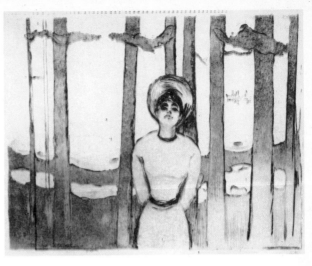

should understand the sacredness and greatness of it all,'[5] he wrote in 1889. To Munch the sacred is identical with the indestructible, and essential in the existence of man in a time of social crisis. Picasso is said to have held similar views. To Munch, the sacred meant all that is great and lasting in man's existance.

The Beginnings of Munch's Graphic Art, his Techniques

When early in 1894 Munch turned to graphic work he was no longer a beginner but already in possession of a mature and stable artistic conception. He had a good grasp of the special means of expression of this particular medium. How he came to devote himself to graphics seems to be a question of secondary importance. There was then a general interest in this medium, stimulated by, among others, Käthe Kollwitz, who turned to graphics in 1890, and Toulouse-Lautrec. Munch was certainly not experienced in graphic techniques but it appears that like Picasso, he could say: 'I do not seek, I find.' It is this very lack of concern with conventional methods and ideas which helped the independence of his graphic style and eventually proved an advantage. He did not have the beginner's difficulties common to most artists. This does not mean that this seemingly spontaneous sureness was gained without effort. He took the technique of graphics very seriously and was worried lest he spoilt an almost finished work by an extra stroke or cut. His corrections can be seen in different stages of the same work. Variations on a motif are found frequently. The woodcut *The Kiss* (Sch 102) was made between 1897 and 1902 in not less Plate 67 than four different variations, quite apart from the same theme being executed in other techniques. When one analyses the changes and variations of a motif one realises that they represent phases in clarification. Details are left out or are abbreviated. It must also not be overlooked that Munch's graphic work is closely related to his painting. Not only motifs but frequently even the composition itself is borrowed from paintings. This is still true at a later period when often painting and graphics, though existing separately, show much affinity. It is therefore possible to speak of a copy or a re-interpretation in the graphic medium of motifs previously expressed in paint. Such cases occur among other painters. Important in the process of transformation is how far the possibilities of the new medium have been considered, also how successfully a graphic work with its own laws and different values has been created from the original painting. Graphic variations of a painting depend on the original

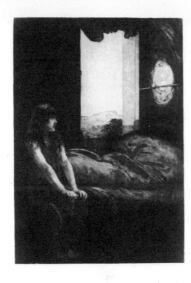
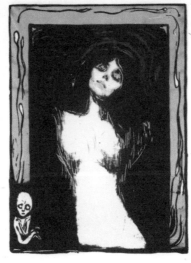

painting. There are examples of a whole composition being transferred unchanged to the new medium. In form and technique two different works of art are created in that way, each existing in its own right. They are the same in content but the priority of intellectual inspiration lies obviously with the painting. When Munch transferred one of his paintings to a graphic medium twenty years later, without changing the composition, this late copy owes its content essentially to the time of the first conception. The *Self-Portrait with Bottle* (MS 492) of 1925/26 does not represent a self-portrait of that time, rather does it show Munch as he saw and painted himself in Weimar in 1906. Such a going-back often has a deeper meaning. He seldom discarded a problem that had exercised him, but it occupied him for years, and the recurrence of a motif from the past was usually not mere chance. Often it was a visible sign of ideas which were once more in the artist's mind. In some other cases the connection is not so clear. It is mainly the theme as such which he re-created in a new medium, then again painted or drew. Glancing over these sequences of motifs, one soon recognises how deeply he was involved with the problem expressed in a work, especially with its psychological interpretation. Consciously he used all means at his disposal to realise his artistic conception. Each variation, whether painted, etched, lithographed or cut in wood, subtly changes and deepens the original theme. The graphic medium suited Munch's purpose. Textures of the material and the technique itself enforced discipline, while the simple nature of the means available called for both restraint and simplification.

More and more clearly, particularly in the woodcut, his concepts became transformed, and clarified to a greater maturity. It is very revealing to study in these sequences the stubborn, purposeful striving of the artist. For him, they were not just pictorial motifs repeated complacently but all too often were unsolved questions which deeply troubled him and with which we, too, feel deep concern, since they are vital problems that demand ever new solutions.

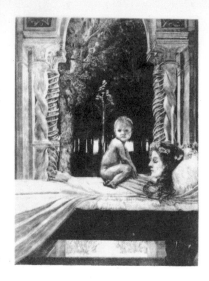

10
Max Klinger
The Dead Mother
1889
Etching

11
Dead Mother and Child
1899
Painting

Munch made his early experiments in graphic art in Berlin, at the beginning of 1894.[6] They were drypoint etchings, a technique in its simplicity fairly closely related to drawing. With the etcher's needle the drawing can be scratched immediately on to the copperplate. Munch liked this technique, and used it again later. 'He often carries a plate in his pocket, and scratches on it as the fancy takes him, a landscape, a waitress in a wine room, a few men playing cards, or a serious portrait of a gentleman.'[7]

Two portraits, comparatively small, drypoint etchings, are probably Munch's first graphic work. Together with the other etchings of 1894 they give an idea of his subject matter: *The Girl and Death, Vampire, The Sick Girl,* and *Girl at the Window.* These etchings show an astonishing sureness in the control of the drypoint. It is Sarvig's opinion that Karl Köpping, at that time one of the most prominent graphic artists in Berlin, possibly provided Munch with the stimulation. Perhaps he also learnt from Hermann Struck for whose well known *Handbuch des Radierens* he provided a drypoint later on.[8] The experienced printers who printed Munch's plates, may also have advised him on the more complicated techniques.

Plates 2, 3, 7, 8

The Berlin printing shops of Sabo and Angerer made the first pulls from his plates, which were black on white paper, while pulls from the same plates made by Felsing can easily be recognised by their blackish-brown print on yellowish paper.

In 1895 the techniques of aquatint and pure line etching were added to that of drypoint. *Bathing Girls* (Sch 14) and *The Day after* (Sch 15) are characteristic examples of this period. In Paris in 1896 Munch discovered a technique, almost extinct, mezzotint, which had reached its peak in the eighteenth century. He experimented in this medium of pure flats without any line which makes the subject stand out in soft and smooth transition from a dark background. Munch tried this out in several studies of nudes and in scenes with figures. The finest work of this group is perhaps the sensitively coloured

Plates 15, 16

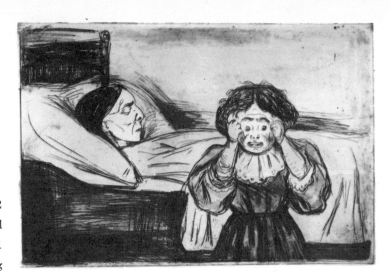

12
Dead Mother and Child
1901
Etching

Plate 21 mezzotint *The Lonely One* (Sch 42) with its tender colours drifting like a veil over the whole composition. Later, with other prints, Munch occasionally overprinted a separate plate to obtain this effect of elusiveness.

As early as 1894 lithography took its place alongside the techniques of Plate 10 intaglio. His first lithograph *The Young Model* (Sch 8) was made that year, and printed by Liebmann of Berlin.[9] The artist received important stimulation in this field in Paris, especially in the workshops of the master printers, Clot Plates 35, 55, 1, 49, 45, 43 and Lemercier. Such famous lithographs as *Vampire* (Sch 34), *Jealousy* (Sch 58), *Self-Portrait 1895* (Sch 31), *Portrait of August Strindberg* (Sch 77), *Separation* (Sch 68) and above all, the unique coloured lithograph, *The Sick Girl* (Sch 59), were printed at Clot's, who had printed for Toulouse-Lautrec, Cézanne and other important French artists. The French lithograph which reached its technical and formal perfection during the period of Impressionism, also influenced him.[10] When he prepared *The Sick Girl* for printing at Clot's, the German painter and graphic artist, Paul Herrmann, then living in Paris, came to the printing shop: 'I wanted to print at Clot's but was told: "Impossible, Mister Munch is booked already." The lithograph stones of the drawing were lying in order, ready for printing. Munch enters, places himself in front of the stones, closes his eyes, and directs, waving his hand in the air: "Print . . . grey, green blue, brown." Then he opens his eyes, and says to me: "Come and have a drink . . ." And the printer printed till Munch returned, and again closing his eyes, ordered: "yellow, pink, red . . ." '[11]

In 1902, a year very productive in graphic work, Munch recovered some older prints, originally in one colour, mostly black, and turned them into Plate 31 coloured lithographs by adding further stones. The lithograph *Madonna* (Sch 33) of 1895 was now printed from three stones, black, steel-blue and dark red, or even from four stones when a yellowish overtone was added.

Plate 35 Unique in printing technique is the lithograph *Vampire* (Sch 34), printed in 1895 by Clot of Paris, in greyish-green or black. In 1902 a second stone

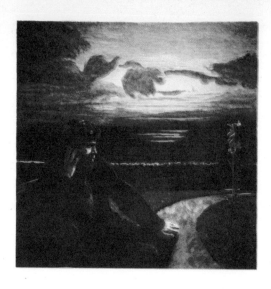

13
Max Klinger
Night
1888
Etching and aquatint

and a wood-block were added. The latter was sawn into three separate pieces, so that it could be used for printing in three different colours. In this way an interesting combination of print resulted, executed with great skill by Lassally of Berlin. Munch's rich invention again and again created new variations so that pulls of the same work may be quite different. It is difficult sometimes to know which single print to prefer, as each in its own way is unique and causes different reactions.

While the early lithographs were drawn directly with lithographic ink or chalk on the stone or a prepared zinc plate, he later on used transfer paper for greater ease of handling. At times, however, after this had been transferred to the stone he re-worked the whole thing.

There are a few woodcuts by Jean François Millet, from the sixties, which appear astonishingly modern. 'He foresaw new possibilities, and the few blocks he cut himself, showed a method which was only taken up generally much later on,' wrote Glaser.[12] These woodcuts remained unique since they had no imitators. Only Gauguin, at the beginning of the nineties, when seeking the simplification of a strong yet symbolistic style of woodcut, developed that of flat fields and bold generous contours.[13] These works might be called the incunablia of the modern woodcut. Gauguin's early work, of which only a few pulls were made, remained relatively unknown and unnoticed for some time. How conscious he was of the novelty of his technique is proved by his words of August 1901, to Daniel de Monfreid: 'This technique is so interesting because it goes back to the early days of the art of the woodcut, at a time when the woodcut as illustration has become more like an engraving. I am sure that my woodcuts, which are so different from all other examples of graphic work, will prove their value in time.'

The forceful language of this technique gained increasingly in importance. Félix Vallotton had interested himself since 1891 in the woodcut. In England Nicholson made known the new technique of broad flat fields. In this, too,

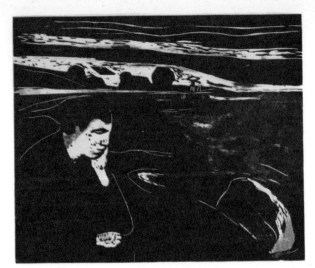

14
Evening
1896
Woodcut

Munch proved a master. The early woodcuts of 1896, printed by Clot or Lemercier, are characterised by a completely independent style of powerful expression. They are *Anxiety* (Sch 62), following in motif an earlier lithograph,

Plate 51 *Man's Head entangled in Woman's Hair* (Sch 80), *Evening* (Sch 82), and *Summer Night* (Sch 83). Munch was also influenced by the Japanese woodcut. As early as 1885 van Gogh had been strongly impressed by the Japanese master woodcuts in Antwerp. In Paris he copied Hiroshige's *Bridge in the Rain* as an oil painting. In 1893 Bing, with whom Munch was to exhibit three years later, showed woodcuts by Utamaro and Hiroshige which Pissaro called 'absolutely overwhelming'.[14] With Munch this influence is unmistakable in the woodcut,

Plate 67 *The Kiss* (Sch 102).

From the beginning Munch thought of including colour in his prints. The woodcut, *Anxiety* exists in an impressive blood-red version, while others were printed in several colours. With this technique one wood-block stresses the essentials of the drawing while the second adds two or three colours. This was possible only through a very individual, basically simple, preparation of the block which he had invented for himself. According to the number of colours required, he sawed the block into pieces which, after being coloured separately, were then put together again for printing. A witness, the Berlin painter and graphic artist Erich Büttner, has reported on this printing technique: 'I came to the master printer, Dannenberger, at Lassaly's, and saw how Munch's graphic work was being printed. I was amazed when I saw the blocks, which were pieces sawn apart, being inked, some red, some green, after which the block was built up again like a jig-saw puzzle. Then it went to the press, and the result was a multi-coloured print, with an even grain.'[15]

Two photographs of wood-blocks, preserved in the Munch-Museum at Oslo, illustrate this technique.[16] In the case of the coloured woodcut, *Head of*

Illus. 1–3 *a Girl against the Shore* (Sch 129), two blocks of even size, sawn into two pieces, were used, so that four colours could be employed: yellowish-brown

19

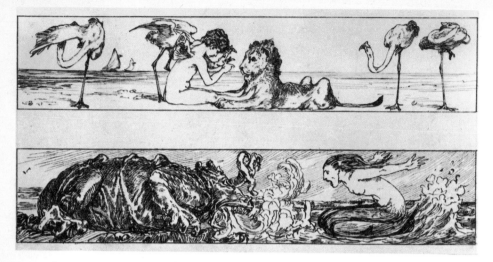

15
Max Klinger
Two designs for
illustrations
Before 1896
Pen drawings

and black for the figure in the foreground, blue-brown for ocean and sky, blackish-green or red for the countryside. It has to be remembered that through the super-imposition of the two blocks, the colour printed last dominates, though influenced by the ground colour. In-between tones are consciously created, and by the use of black, a greater unity of composition is achieved.

The second example, *The Fat Prostitute* (Sch 131) is less complicated: the block of the left part carries the whole composition, and was printed in black, the block of the right side was sawn into two parts, and printed in yellow and greyish-green. These two blocks convey a very clear idea of his technique of cutting; both with their energetic powerful strokes, and more finely scratched lines. Impressive also is the strong contrast of separate fields. In one block for *Head of a Girl against the Shore*, the grain of the simple pine wood Munch used frequently can be seen on the upper right. The fine graphic effect of this grain was deliberately emphasized in printing. Gauguin did the same when he used simple wooden packing cases, drift wood from the sea, for his woodcuts. Through Munch the deliberate stressing of the grain of the wood became generally accepted. With the coloured woodcut, *Women on the Shore* (Sch 117) he noted on a pull, next to the signature, 'One block, cut into three.' The sea, printed in a pale bluish-grey, the green countryside, and the black group of figures form the three parts of this woodcut. Later (before 1906) hair and contours of the standing girl were tinted a reddish-brown. In the sawing, the headland, jutting out into the sea, and connected with the remaining part only by a narrow strip, became endangered, and later on actually broke off. Prints from this block show the corrections which became necessary.

Illus. 4

Plate 73

The printing itself Munch usually left to expert printers after first trying out the effect with a few hand-pulls. There are also many experimental prints and pulls in separate colours. He carefully noted the changes, and made observations in his own hand about the particular state of a work. These notes

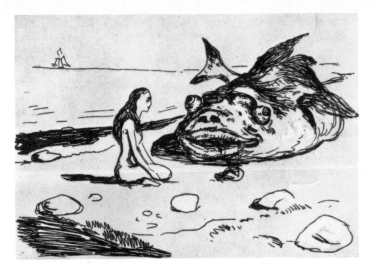

16
The Big Cod
1902
Etching

arose from his pleasure in the working process. It is not just the dry way of a scientist, observing different states. Munch once showed annoyance at such an idea, wearied by questions he was asked about the production of his prints, at a time when his graphic *œuvre* catalogue was being prepared. A visitor reported: 'We came to his small house. An etching stood on an easel, one half cut off. Munch pointed to it, saying: "This poor head has been standing there for long enough. But, you see, I have not been doing any etching." He stamped his foot slightly, and continued: "The art critics have taken away my pleasure in etching. When they write books about my graphic work, they do not leave me in peace. They want to know how I made every stroke, whether this one or that one came first, whether the acid was effective first here or there, etc. And now I am completely embarrassed the moment I take up a needle. I keep thinking of the people who look at my work so critically. I am no longer free, and until I regain my peace of mind I shall not do any etching."'[17] The spontaneity of his creation was impeded by both self-analysis and his growing knowledge of the intricacies of the design process.

According to Sigurd Willoch who, as director of the Oslo National Gallery, was entrusted with the examination of Munch's work left to the city of Oslo, the artist's graphics consist of 714 works: 378 lithographs, 188 etchings and 148 woodcuts.

Munch's productivity in this field rose steeply during the early years: there were 8 works in 1894, 29 in 1895, 45 in 1896, and 56 in 1897 when the first climax was reached. After that there are generally no more than twenty works in one single year.[18] The year 1902 formed an exception when he made 69 graphic works; also towards the end of 1908 and in 1909 he turned more and more to graphic art. No less than 75 works of this period are known, among them the cycle of *Alpha and Omega*, with 22 lithographs. In 1909, for the first time, lithography took a prominent place. His graphic work ended about 1930, apart from a few exceptions. Until his death in January 1944 he was

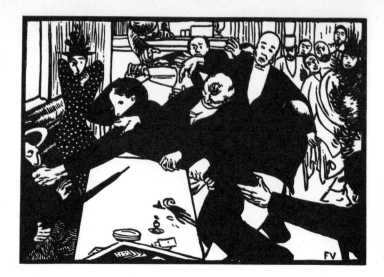

17
Félix Vallotton
Scene in a Cafe
1892
Woodcut

solely engaged in painting. This rejection of the graphic medium may be taken as a symptom of his increasing interest in a sphere of painting which had had its beginnings long ago, and his wish to finish some uncompleted work with which he was deeply concerned. However, he had by then created a sufficiently large body of work to ensure him fame in the field of graphics.

Influences of Contemporary Graphic Art, The Example of Max Klinger, Félix Vallotton and Félicien Rops

Max Klinger and Edvard Munch appear in their work as representatives of two epochs, and yet, according to their dates of birth, they belong to the same generation. Klinger, born in 1857, was only six years older than Munch. However, during the last decades of the nineteenth century a very small difference in age may have been of decisive importance for the adoption of new trends. Klinger's graphic work contains many ideas and progressive beginnings which point towards the future. Tendencies of social criticism, for example, found their continuation and completion in the work of Käthe Kollwitz. Klinger anticipated Munch in much of his imagery, but he could not overcome the naturalistic convention of the nineteenth century, and its outmoded romantic symbolism.[19] This very position and the strong literary content of his work secured him a remarkable success with the contemporary public. Over-appreciation has long since turned into unwarranted depreciation, and only slowly is a more balanced valuation of Klinger's work gaining ground. Without doubt, he made a very considerable contribution towards a new assessment of graphic work as an independent art form. Towards the end of the nineteenth century, especially in France, a keen new interest in this medium became apparent. In Germany Klinger stands at the beginning of this development. His graphic work started in 1878, and was largely completed when Munch made his first etchings in 1894. It may be assumed that Munch became acquainted early on with Klinger's popular cycles which were widely current in several editions. Also, close cultural relations between the Scandinavian countries and Germany at this particular time allowed for personal contacts. A connecting link may have been Klinger's friendship with Munch's teacher and supporter, the Norwegian painter, Christian Krohg, to whom Klinger dedicated his series *Eve and the Future*, 1880. Paul Kühn suggests that Krohg's sensational tale, *Albertine*, describing the life of a prostitute had in turn inspired Klinger.[20] Klinger's cycles *A Life* and *A Love* deal with a closely related subject. The problems posed, social and psychological, must have interested Munch very

much. All the same, works in which he uses motifs similar to Klinger's throw much light on the great difference between the two artists. Klinger's influence on Munch is not limited to his early graphic work but extends to about 1908, though by then Munch's own style had long since been formed. Sure of himself, he introduced Klinger's imagery into his own work, and made it completely his own. We can see the same process of creative adaptation at work in, for example, van Gogh's *Sower*, after Millet.

Regarding intellectual conception, not execution, there were hints in Klinger's work which were to find ultimate form only with Munch. What Munch had in mind always, the summing-up of life's experience in a cycle called *The Frieze of Life*, was achieved in subject in some of Klinger's series: *Eve and the Future*, 1880; *A Life*, 1884; *Death*, 1889; *Drama*, 1883; *A Love*, 1887, etc. In motifs, they are closely related to Munch's work. Klinger gave much thought to the subjects of Eros and Death, and restored importance to the graphic cycle devoted to a special theme. A confrontation of related motifs in both artists' work shows clearly the relationship in subjects, though at the same time demonstrating inherent contrasts.

By chance Klinger's *Spring* and Munch's *Summer Night* take almost the same place in the early graphic work of the two, carrying even the same number, 19, in their *œuvre* catalogues.[21] Contents and atmosphere are closely related. Both etchings represent a young girl in a group of trees; longing and expectation are expressed. Klinger relates this atmosphere to the awakening of nature in spring, while Munch represents it as the excitement of the northern midsummer night. Klinger's style is still influenced essentially by the naturalistic tradition of the nineteenth century, in detail as well as in the overall composition. Each tree, from its gnarled roots to the fine spread of its branches, is carefully drawn with great delicacy. Munch is more relaxed, largely foregoing detailed treatment, showing his trees only by outlining the middle part of the trunks. Compared to Klinger he gives a close view, not

18
Max Klinger
Design for illustration
Before 1895
Pen drawing

Plate 24
Illus. 5, 6

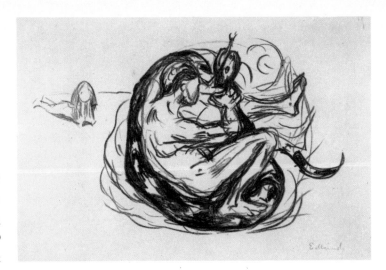

only limiting his picture but concentrating more on the psychological problems concerned. Even if Munch had drawn a reclining instead of a standing figure, he would have done so without treating it in Klinger's rather theatrical manner. The vertical shape of Klinger's etching stresses, in accordance with the content, the vertical line of the trees. Munch prefers the heavily flowing horizontal line which, emotionally too, emphasizes weight.

Plate 31 *Awakening* (S 164) by Klinger, and Munch's *Madonna* (Sch 33) represent the conception symbolically, as Munch's subtitle *Conception* states clearly. In both works an embryo has been included, subtly suggesting new life. Munch undertakes the difficult experiment of hinting at the moment of conception, reflected by the expression in the woman's face, while Klinger in his etching, from the cycle, *A Love*, represents the same situation in its more earthy implications.

Illus. 7, 8 A comparison of Klinger's etching, *The Dead Mother* (S 239), and the
Illus. 10–12 corresponding motif in Munch's work (Sch 140) is very revealing. Hans Wolfgang Singer to whom we owe the extensive *œuvre* catalogue of Klinger, considers this 'incomparable work, the most beautiful Klinger ever created'. Most likely Munch knew this etching from the cycle *Death*. Quite independent of this, the subject touched him deeply through the memory of his mother's early death and that of his sister. It demanded presentation. The over-elaboration of Klinger's etching makes it difficult for us today to do justice to its significance. In the rich detail the purely human seems neglected while Munch presents it clearly and to the exclusion of everything else. In contrast with the care-worn, sunken face of the dead woman of Munch, the figure in Klinger's picture appears to be as beautiful as Snow-White in her glass coffin. The child squats on the dead woman's chest, large eyes turned uncomprehendingly to the onlooker. Details are drawn with greatest care. For the elaborate columns Klinger used sketches made in S. Paolo Fuori le Mure in Rome. There are also allegorical allusions, as in the tender little tree, growing in front of the

20
Félix Vallotton
The Big Funeral
1892
Woodcut

Böcklin-like darkness of the wood. This is not just part of the background scene but represents a symbolic connection with the main theme, varying the motif of life and death: young growth against the darkness of dying. In Munch's work the child stands in front of the bed in panic fear. It appears to be about to break into a wild shriek of despair, of which the child itself is afraid, holding its hands over its ears in sheer dread. There is no detail, nothing unnecessary, only the naked event is presented with uttermost intensity: life and death packed into the vertical and horizontal.

Klinger's etching *Night* (S 171) from the cycle *Death*, is matched in motif Illus. 13, 14 by Munch's woodcut, *Evening* (Sch 82). The superficial similarity is striking: the gloomy sky over the sea with the line of light on the horizon and a male figure sitting near the edge of the picture, supporting his bowed head. Here, too, Munch's conception appears firmer, more taut, and above all, more true.

Similarly the etching *The Big Cod* (Sch 165) has such strong parallels to Illus. 15, 16 a related motif of Klinger's that a direct adaptation cannot be excluded, particularly as these examples are not isolated. As late as 1909, in the cycle *Alfa and Omega*, Klinger's influence can still be traced. As these influences originated from drawings, not as easy of access as Klinger's widely published graphics, Munch must have seen them either in exhibitions or become acquainted with them through reproductions. Munch most likely knew a Klinger volume, published in 1899 by Max Schmid, in the popular series of Velhagen and Klasing's *Künstlermonographien*. In it there is, for example, the reproduction of a sketch which anticipates Munch's *Omega and the Tiger* (Sch 316).[22] Munch is known, however, to have made studies for the animals of his cycle in the Copenhagen Zoo, proof again that we are not dealing with mere imitation.

The decorative and symbolic borders of much of Klinger's graphic work, (for example Singer 102, 174 and 178) might have inspired Munch to similar Illus. 9 border work, one might even say, seduced him, for it rather impairs the effect

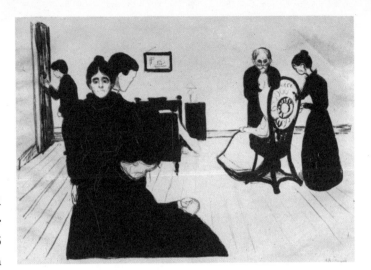

21
The Death Chamber
1896
Lithograph

Illus. 8
Plate 49

Illus. 20, 21

Illus. 22, 24

Illus. 17

of the main picture instead of supporting it. It seems logical therefore that in some later states of his work, for example *Madonna* (Sch 33), or with the Strindberg portrait, Munch discarded the symbolic surrounds.

Félix Vallotton (1865–1925) had, in the early nineties, developed a style of woodcut rich in contrasts by putting black fields, practically without any drawing, against the white of the paper. Vallotton influenced many artists, and most likely Munch owes him much inspiration. His subjects, too, were related to Munch's own: *The Big Funeral*, 1892; *Anxiety*, 1894; *Panic*, 1895; portraits of Verlaine, 1891; Ibsen, 1894; and Dostoevski 1895. It appears that any possible influence Vallotton had on Munch concerned not his woodcuts but his lithographs. Here we find dark figures, their softly rounded contours rhythmically arranged in the picture space. Vallotton's *Funeral* and Munch's *Death Chamber* 1896 (Sch 73) are related in motif and form. Vallotton's portrait of Dostoevski and Munch's self portrait (Sch 31) were done in the same year. They were a type of portrait Vallotton had affected years before: emphasising the light on the face by a dark background. Is it chance that Vallotton's lettered ribbon becomes a skeleton arm with Munch? But, as with *Death Chamber*, the comparison also reveals the fundamental differences of the two artists. How much more striking becomes the meeting with death in Munch's work! The portraits, too, are only superficially similar. Vallotton's portraits are more obvious, more poster-like. Munch's self-portrait appears less earthly, more pensive and searching. If one adds for comparison a portrait by Eugène Carrière, that of Verlaine, 1896, for example, Munch's interpretation is half-way between the magic of Carrière, whose faces seem to rise from a mist, and the more solid reality of Vallotton. With several other works of this artist, one is reminded of Munch, even if only in the secondary details, as in the woodcut *Scene in a Cafe*, 1892, with its simplified drawing of the faces in the background. The frightened figure on the far left corresponds to Munch's motifs of anxiety.

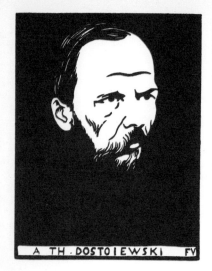 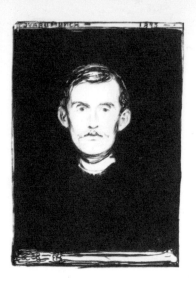

Munch's affinity with Félicien Rops (1833–1898) should also be considered. His work was at that time familiar to all artists, even if only for its eroticism. The Polish poet, Stanislaw Przybyszewski, with whom Munch became friendly in Berlin, mentions Rops in his writing on Munch, published in 1894. Whole nights were spent in the Berlin Bohemian circle, discussing Rops, as Julius Meier-Graefe recalls: 'The West, the Paris of Huysmans and Rops formed the background for talks on pathological eroticism.'[23] Similar to Klinger's, Rops *œuvre* contains numerous motifs on the general theme of *Eros and Death*. In the etching *Revenge of a Woman*, described by Przybyszewski, 'the terrible tragedy of man, destroyed by woman', is presented with cynical frankness and precision. *The Kiss* shows a naked couple, standing on a base, surrounded by snakes, and a third work of the same cycle, *Les Diaboliques*, has been compared to Munch's *Puberty* (Sch 164).[24] This etching *Le Plus Bel Amour de Don Juan* allows interesting comparisons. The posture of the sitting naked girl, her hands clasped on her lap, seems very similar at first sight; even the dark threatening shadow in the background in Rops's work, the fluttering coat of 'the fantastic figure of the poet Barbey d'Aurévilly', has its parallel in Munch. But the relationship is superficial, the two pictures have little in common. While Rops's motif is charged with lascivious decadence, Munch's presentation arrests through the purity of its conception, the strength of feeling and a sense of human dignity.

22
Félix Vallotton
Dostoevski
1895
Woodcut

23
Eugène Carrière
Paul Verlaine
1896
Lithograph

24
Self-Portrait
1895
Lithograph
Illus. 25, 26

The Sick Girl

The Invalid (Edvard Munch)

I feel no pain, still I am sick;

All strength has left me, I am empty.

I am running down, as does the wheel,

Separated from the spring that drove and held it.

Oh, they nurse me with affection.

And yet I know the end is near.

I am not sad. Rest will be my share,

And I will blossom calmly in a quiet breeze,

As do the flowers in my garden.

Otto Julius Bierbaum.

Plate 7　　　The drypoint *The Sick Girl* (Sch 7) of 1894 belongs to Munch's early graphic work. His previous rendering of the same motif is the first display of his own very personal imagery. About the painting's origin and significance he has this to say: 'When I saw the sick child for the first time–her pale head with the bright red hair against the white pillow–I gained an impression which evaporated during work. I painted a good but a different picture. I painted it repeatedly for a year, scraped it out, let the colours run, and tried again and again to recapture my first impression–the transparent pale skin, the quivering mouth, the trembling hands. I had over-emphasized the chair and the glass which distracted from the girl's head. When I looked at the picture, I only saw the glass and the surroundings. Should I take all that away? No, it would help to stress the head, and recover its value. I scraped half of the surroundings, and restored the proper balance. Now one could see both the head and the glass.

'Further I discovered that when inspecting the picture my eyebrows had contributed to the effect. I therefore hinted at them as a shadow above the picture. The head, so to speak, became the whole picture. I introduced wavy lines, leaving the head as the centre. I often used those wavy lines later on.

'At last I stopped, exhausted. I had to a large extent recaptured the first impression, the quivering mouth, the transparent skin, the tired eyes. But the picture was not finished as far as colour was concerned. The colour was too pale and too grey, giving the impression of weightiness.

'During 1895 and 1906 I took up work on the picture again. I now gave it more of that strong colour I wanted it to have. I painted three variations. They are all unlike one another, yet each in its own way is an approach to my first impression. With *Spring*–the sick girl and the mother by the open window, sunlight streaming into the room–I made my farewell to Impressionism and Realism. *The Sick Child* opened a new road in my art. Most of my later work owes its origin to this very picture, which created more offence in

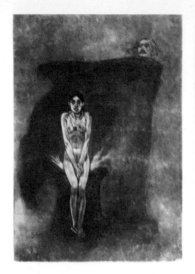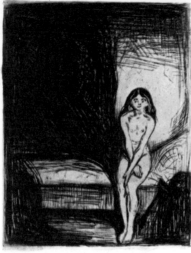

25
Félicien Rops
Le Plus Bel Amour
de Don Juan
1886
Heliogravure, retouched

26
Puberty
1902
Etching

Norway than any other of my works. When, on the opening day, I entered the hall where the picture was hung, I saw people crowding round it—there were shouts and laughter.'[25]

These words of Munch make it quite clear that as early as 1885/86 he worked on the first stage of his picture, eternally groping for a valid formulation. He painted five variations in the course of forty years, the last in 1927. So long as he owned his pictures, he kept working at them, a method typical of him. He did not like parting with a painting, and if he did so, he always made a replica for himself. Yet in such cases it was not merely that he felt the need to carry on working on his pictures, but rather that he was beset with the idea of giving away a piece of his own life and philosophy. He had to have his paintings with him as a prerequisite for creation. Letting a picture go was to Munch like losing a part of himself.[26]

His painting of *Spring*, 1889, is the most complete representation of the *Sick Girl* theme. Still influenced strongly by the Norwegian Naturalistic School, Munch's starting point, it nevertheless hints at his eventual goal. The presentation of atmosphere and detail increasingly took second place in favour of the essential, a general trend, not confined to Munch. Emphasis in presentation is laid on the essential elements. In the painting *The Sick Girl* the mother-daughter group took a prominent place; in the graphic work the emphasis on this particular part of the picture is even stronger, eventually concentrating attention on the head of the dying girl only.

Graphic and painted versions were increasingly found side by side as equally important solutions to one and the same problem; with unflinching tenacity he again and again tried to give pictorial expression to his inner experience. Graphic art with its technical versatility widely extended his creative potentialities, a factor which may have been a decisive reason for Munch's growing interest in this medium. The resulting expansion was increasingly found to entail a simplification in terms of formal image. While the

language of the woodcut is emphatic but restrained, and confined to a few wide areas and black and white contrasts, a painting appears to be a much more sophisticated organism. Munch felt it was necessary to take full advantage of either possibility. He in fact achieved his greatest heights in the medium of graphics and so was able to return to painting later on.

The confession that his whole work sprang from *The Sick Girl* is very revealing. It shows how soon he realised that the events of his life affected his art, and left him with no other course to follow.

A famous passage in his diary, written at St. Cloud, in 1889, concerning an impression he gained in a dance hall sounds like a programme: 'No longer shall I paint interiors, and people reading or women knitting; I shall paint living people who breathe and feel and suffer and love.'[27] Munch did not seek for picturesque motifs, he wanted to reflect the fundamental experience of human life.

The Sick Girl is a piece of experienced and endured reality, for this picture of a slowly dying child lays bare Munch's own realisation of illness and death. One might ask why this sad subject stands at the beginning. The answer becomes inevitable when one recalls his life. During his childhood and youth illness and death played a tragic part. 'Nothing but illness and death in our family. We were simply born to it.'[28] Munch's mother died from tuberculosis when he was a boy of five, and nine years later his beloved sister Sophie, who was only a few years older than himself, became a victim of the same disease. These two experiences affected him deeply and lastingly, and painting them seems, psychologically, to be an attempt to rid himself of the memory of those painful experiences.

The etching *The Sick Girl* shows the fine, pale face of the invalid who sits in any easy chair, looking out of the window into a distance beyond life and death. Beside her is the dejected mother. The picture is presented with such conviction that one is inclined to think of it as an actual impression of

his dying sister, even if one knows that the picture painted was not of his sick sister, but of a young model who outlived him by many years. The emotional reality has become reality itself.

A comparison of the painting and the etching reveals many differences despite the apparent sameness of the composition. Through the transfer to the greyish-black of print the effect changed considerably. The vertical parallels on the left of the etching, on the dress of the woman and elsewhere, give the impression of heavy, steadily falling rain. The sensitive hand of the artist is seen in every stroke, trying to express the inner meaning symbolically. The drypoint repeats the composition in reverse. This concentrates attention more strongly on the girl, staring into an imaginary distance, though this turn to the left slightly modifies the effect. Reversion has tightened the composition. Munch allowed for such alterations since his compositions were strong enough to stand the change of stress. Such changes may even have attracted him as new variants on his basic theme.

Two years later, in 1896, the same subject turned up again in his graphics. If the drypoint of 1894 conformed, by and large, to the painting, two new works, a drypoint (Sch 60) and a coloured lithograph (Sch 59), show an independent solution in their composition. The picture is now concentrated on the sick girl's head. Large and close-up, this is moved to the centre while everything else on the right, the contrasting white pillow behind the head and the dark shadow on the wall, is only hinted at. Compared to the painting the head is reversed while in the lithograph it remains the same.

Illus. 27
Plate 43

The soft stroke of the crayon in the lithograph suggests with delicate understanding the fine spiritual profile of the girl. Pulls of this famous lithograph are found in various colours, each in itself superbly executed; whether limited to blue and black, or in black, yellow, red and grey, the work in all its variations retains its very high quality. It was printed in the workshops of the master printer, Clot, in Paris, where Paul Herrmann found Munch selecting the

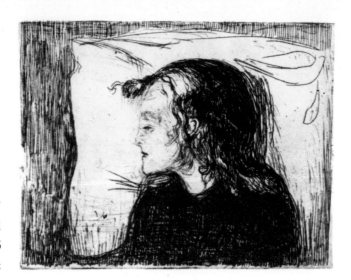

27
The Sick Girl
1896
Drypoint

colours and their sequence with an almost somnambulistic assurance. A surprising degree of knowledge is demonstrated by this example, showing that the technique of French lithography was fully mastered by Munch. Much as French art impressed him he carried his imagery within himself and while in Paris worked with perseverance almost exclusively on subjects he had brought with him.

Pictures of death occur again and again, and in varying form throughout his art, less in the medieval sense of the memento mori, not related to the life hereafter–but to life here and now. The experience of death, in the death of others, was forever with him, as a tragic but realistic part of his being and his art. The dread of death is an inescapable part of human life, alien but pertinent. He did not wish to be the painter of death but of life.

He experienced feelings of panic when confronted with the dead, and avoided taking part in funerals. Yet, the images planted deeply in his soul by the experiences of his youth could never be extinguished, and their translation into painting meant to him both liberation and a means of getting them under control. The scene of death, the chamber of death with all the relatives gathered, was repeatedly presented by Munch in painting, lithography, and

Plates 39, 40 woodcut. In 1896 he made the lithograph *Agony* (Sch 72) and *Death Chamber* (Sch 73), both printed in Paris. In *Agony* we look from the head on to a white death bed, while the afflicted relations crowd from the right in a dense dark group. Like phantoms, faces appear in the back of the room, in soft hazy lines. Overall there is a sense of oppression. The lithograph *Death Chamber* too is filled with this tormented atmosphere. The relations wait silently while a boy tries quietly to leave. Here, too, is the torture of being powerless before the inevitable, the horror of the unknown, the silent impatience wishing for it all to be over. The expressionist poet, Theodor Däubler, described this work in an essay: 'A death chamber. Everything simple, quiet, and even more matter-of-fact than in Maeterlinck's *Intruder*. Literature? No, tragic black, a terrible

diffusion of black. The dying in an armchair, on death's throne, turned away from us. The survivors are the real ghosts.'[29]

It is perhaps significant in a typical process of maturing that the death theme belongs mainly to Munch's early period. But as late as 1904 and 1920 the woodcuts *Visit of Condolence* (Sch 218 a), *Last Sacraments* (Sch 492 a), and *Sick Room* (Sch 492) were made, and also, as a very late work, there appeares in 1927 *Death of the Bohemian* (MS 538) which dealt with the death of Hans Jäger.

Plates 41, 145, 180

Munch and the Literature of his Time

During the decades before the turn of the century very close ties existed between the avant-garde of the fine arts and contemporary literature. It is significant in this context that artists and writers collected around journals, for example, 'Mercure de France' and 'Revue Blanche', in Paris, 'Jugend' in Munich, and 'World of Art', in Petersburg. Friendships between painters and poets were no rarity. It would be rash to conclude, however, that the fine arts were invaded by 'literary tendencies'. These personal contacts did not necessarily give the work of the period 'literary' contents, even if many parallels, relationships and contacts existed. 'It need not be "literary",' Munch defended himself in 1929, 'an insult many people use for paintings which do not represent apples on a tablecloth, or a broken violin.'[30] It is, however, striking that his circle of friends and acquaintances consisted to a large extent of writers, and less of his painter colleagues. This is confirmed by his many portraits of contemporary writers.

It may be assumed that he was familiar with the work of those he portrayed. There is no doubt that he knew Jäger's novels and Heiberg's plays, as well as the poems by Obstfelder, to name but a few. Little is known about his special leanings, though Schiefler wrote: 'Dostoevski became his favourite writer.' Zola impressed him deeply, as did Ibsen and Strindberg. Favourites were Jacobsen's *Niels Lyhne*, Hamsun's *Pan*, and Heinrich Heine's poems.[31] Hodin recalls that for some years Munch spent New Year's Eve with the Norwegian poet, Henrik Rytter, the two reading poetry to each other. Munch knew whole anthologies by heart. He also made some attempts at writing himself. Munch planned a cycle of graphics with poems in prose, and in his posthumous papers a dramatic work was found entitled *The City of Free Love*.

Among philosophers he was chiefly attracted by Nietzsche, Schopenhauer and Kierkegaard. Stenersen noted: 'In his later years Munch had a preference for Kierkegaard.' Ideas, feelings and human problems, expressed in the words of these writers and philosophers, turn up in a different way posing new

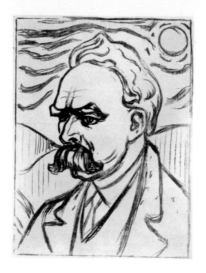

28
Portrait
Friedrich Nietzsche
1906
Lithograph

questions in his pictures. Their imagery is related in many ways. It is, however, difficult to point to influences in detail, as Munch was a master at absorbing sympathetic ideas, and impressing them with his own personality. The appropriation was spontaneous and unsystematic. Studies made on the influence of Nietzsche, for example, would seem to suggest that his effect on Munch was limited. In any case it is always difficult to isolate particular influences on such a complex character.

Illus. 28

A movement arose in Scandinavian literature in the late seventies which tried to represent, realistically and critically, life in a bourgeois society. The most urgent problems of a society in decline were dealt with in novels, plays and poems. 'What is actually behind that gold-plated and painted facade presented by the societies of big cities? Vanity and decay!'–a statement taken from Ibsen's play *A Pillar of Society*. The contradiction between a 'free' life on the one hand, and the restrictions imposed by a rigid regime on the other, has been fully expounded by the poets. The relationship between the sexes is often taken as a symbol of the failure of the bourgeois society, where the resultant frustrations often lead to tragedy. Such attitudes can be seen in the works of Bjørnstjerne Bjørnson, Jens Peter Jacobsen, Jonas Lie, Alexander Kielland, Henrik Ibsen, August Strindberg, Holger Drachmann, Arne Garborg, Hermann Bang, Gunnar Heiberg, and in the early works of Knut Hamsun. The young Munch made close contact with literary circles for the first time in 1884 when he came across the Bohemians of Christiania. He kept up a lifelong friendship with their spokesman, Hans Jäger, seaman, writer, philosopher and shorthand writer in the legislative assembly of Norway. 'Hans Jäger was one of the finest men I have known. He was honest,' said Munch.[33] In an essay about Munch, Sigbjørn Obstfelder stressed Jäger's importance to the artist: 'Hans Jäger greatly influenced Munch. Jäger gave to his time a strange and revolutionary urgency. At that period there must have been much for a painter's eye to absorb: meetings at night, dimly lit, in all sorts of cafes, many defiant

Plate 19

words expressed with neither hesitation nor fear, heady and often violent speeches, spoken with Norwegian brutality, vast shadows cast by misery, weakness and meanness. Spirits longing to be free and individual, but without the opportunity. And among all other faces there was a focus, this Jäger, whose logic, sharp as a needle, and cold as an icy blast, must, however, have been glowing at one time, so that all that was human in him could come forth and expand fully and richly.'[34] In 1889 Munch painted his portrait, and later the lithographs *Wedding of the Bohemian* (MS 537) and *Death of the Bohemian* (MS 538), 1927, are reminders of this friend who died in 1910. In the graphic work several lithographs, the earliest from 1896 (Sch 76), are portraits of Jäger. It was no accident that Munch's last and very isolated graphic work is a representation of him. 'Only a few days before his death, sick and weak, he made a portrait lithograph of this friend of his young days, long since dead,' wrote Johan H. Langaard.[35] Both lithographs are closely related to the painting of 1889, their emphasis, however, being on the head.

Plate 180

Illus. 60

In the passionate, critical discussions of the Christiania-Bohemians on topical problems, the social situation, the emancipation of women, free love, and the radically rejected bourgeois order, Munch recognised ever more clearly the crumbling society he lived in. The dissolute life, the scandals at any price, which were demanded in the nine set rules of the Bohemians, were conscious anti-bourgeois provocation, an expression of protest, getting lost in the end in all too personal and anarchistic extremes, remaining without any decisive influence on contemporary society. Jäger's banned novel *Christiania-Bohème*, 1885, gives a realistic impression of the prevailing ideas of the group. Two of Munch's etchings of 1895 (Sch 10 and 11) have the same title. One (Sch 11) represents Gunnar Heiberg and Christian Krohg. Krohg wrote *Albertine*, a tale, which on appearance in 1887, caused no less a scandal than Jäger's book. It describes the life, full of misery, hunger and illness, of a young girl, seduced by a police inspector of vice control, who ended as a prostitute herself. Gunnar

Plates 12, 13

Heiberg's play *Aunt Ulrike* treats social problems against the background of life in Christiania, in the seventies. It appeared in 1884. *The Balcony* followed in 1894, a play, dealing with a dramatic love story, written in the style of Symbolism, and much appreciated by Munch. In 1896 Munch lithographed Heiberg's portrait (Sch 75), but he later quarrelled with the successful writer whom he caricatured as *Writer Hyena* in several lithographs (Sch 224, MS 516).

Plate 50

Plates 100, 101

Sigbjørn Obstfelder (1866–1900), too, whom Dauthendey called the poet of sadness and misery, belonged to the Christiania-Bohemians. Twice Munch did his portrait (Sch 78 and 88), a sign that he felt particularly close to this quiet, melancholic man. According to Stenersen, again and again his poems stimulated Munch to pictorial interpretations. 'He is believed to have conceived *The Shriek* after reading Obstfelder's poem: "I must have come to the wrong world."'[36]

Plates 18, 6

The aquatint *The Day After* (Sch 15) could be taken as an illustration for Jäger's novel, and has obviously taken its inspiration from it. The bourgeois reaction to this motif was just what the Christiania-Bohemians were looking for. As late as 1908 when a painted variation was acquired by the Oslo National Gallery, a critic wrote disapprovingly: 'Now townsfolk can no longer take their daughters to the National Gallery. How long will Edvard Munch's prostitute be allowed to sleep off the effects of drink in the National Gallery?'[37]

Plate 16

Jäger's social criticism, strongly expressed in his play *Olga*, 1883/84, and later on in the three-volume novel *Sick Love* declined into the merely personal and decadent. Much of the tormenting psychological atmosphere "...I felt sick, as I looked up to her ..." appears to be reminiscent of similar pictures by Munch. On 16th August 1880 Jäger wrote in this strongly autobiographical novel that Munch visited him in prison. It may also be remembered here that the first rule of the Christiania-Bohemians was: 'Thou shalt write down thy own life.' A frank exposure of real experiences, above all, of personal impressions, and feelings, is what Jäger aimed at in his novel. He disregarded social

conventions which he believed gradually undermined all natural social impulses, and led to hypocrisy and insincerity. If one looks at Munch's work from this point of view, it seems obvious that he transferred his own experiences to the pictorial medium, passionately and frankly.

In Berlin, too, he kept in close contact with writers: the Scandinavian Gunnar Heiberg, Holger Drachmann, Gustav Vigeland, Christian Krohg, Ole Hansson, who met at their favourite haunt which Strindberg had called *The Black Pig*. German friends were added: Richard Dehmel, Otto Julius Bierbaum, Max Dauthendey, Adolf Paul, Julius Meier-Graefe, Arno Holz, Walter Leistikow, Hermann Schlittgen, and, above all, Stanislaw Przybyszewski. Munch's first appearance in this circle is described by Adolf Paul, the chronicler of *The Black Pig*: 'One day, *The Pig* had just been started, a young Norwegian turned up, in a light pelerine and top hat, with dreamy eyes in a tired and moody, but energetic face. It was Munch.'[38]

At this time Munch's work was already so forceful that it in turn influenced the writers around him. In 1893 Max Dauthendey wrote a poem on Munch's picture, *The Head of a Drowned Man*, for Stefan George's *Blätter für die Kunst*. In 1911 his play *Maja* appeared, a comedy dealing with the Scandinavian Bohemians. It treats quite openly Munch's relationship with Strindberg. Yenast, who is described as a Norwegian Symbolist painter, declares in the play: '. . . since I have met Tavelung, and in theory share his hatred of women, I like best to portray women who, vampirelike, attack man and suck him dry with their kisses.' In Otto Julius Bierbaum's collection of poems, *Irrgarten der Liebe*, there is one suggested by Munch's *Sick Girl*. The lithograph, *In the Land of Crystals* (Sch 93) 1897 inspired the writer Willy Pastor to a work of the same title. Munch and Strindberg were frequent guests at Stanislaw Przybyszewski's and his Norwegian wife, Dagny Juell. In Przybyszewski's work there are again and again allusions to Munch's motifs. Through many a night the friends discussed the problems which then engaged them so passionately. Przybyszewski,

the Polish poet, writing in German, had originally studied medicine, and enjoyed describing situations of perverse eroticism. At Christmas 1894 he gave Munch a copy of his *Vigilien*. There he writes: 'from all the frames of my pictures, woman appeared, the cosmic will, Eve, the ruler, for over every living thing woman rules supreme.' In *Androgyne* a frieze of women's heads in different moods is described. *Epipsychidion*, 1900, is a song of praise to the sea, the beach, the sun, the light Norwegian nights and love. The scene is set in Munch's homeland, 'written in Christiania Fjord and the Plaza del Mera 1889/99.' Other themes—love and jealousy—are contained in the play, *Totentanz der Liebe* 1902, and in the title even, *Der Schrei*, another tale of Przybyszewski's, the inspiration of one of Munch's best known woodcuts is obvious.

The first publication about Munch came from the Berlin circle: *Das Werk des Edvard Munch*, with four contributions, one by Stanislaw Przybyszewski, who was also the editor, one by Franz Servaes, one by Willy Pastor and one by Julius Meier-Graefe (1894). In turn, Munch made a portrait etching of Knut Hamsun, the writer, for the journal, *Pan*, founded by Meier-Graefe. Years later Theodor Däubler was to write about this in an essay on the artist.[39]

His contacts with Scandinavian writers continued during Munch's stay in Paris. In 1890 he lived temporarily with the Danish poet, Emanuel Goldstein, in St. Cloud. He drew a vignette for his collection of poems, *Alruner*, published in 1891. In Paris, he also met again Jonas Lie, Sigbjørn Obstfelder and Hans Jäger. In 1894 he made the acquaintance of an Ibsen translator, Graf Prozor, and Lugné Poë, friend of the *Nabis*, and director of the *Théâtre de l'Œuvre*. In 1896 Strindberg reviewed with enthusiasm, in the '*Revue Blanche*', Munch's successful exhibition at the Bing gallery: 'Edvard Munch, thirty-two years old, esoteric painter of love, jealousy, grief and death... He has come to Paris to find understanding with the connoisseurs, without fear of ridicule which kills cowards and weaklings, but makes the shield of the brave shine like a ray of sunshine.'[40]

Munch met Strindberg in Berlin, and had painted his portrait in 1892. In
1896 he drew him in Paris for a lithograph (Sch 77). How tense the relation-
ship was between them is revealed in an episode, told by Dauthendey. Munch
showed him the Strindberg portrait with its symbolic border meant to re-
present the extreme contrasts of male and female. This and the misspelling
of his name as 'Stindberg', had annoyed the writer. 'Strindberg lived next
door until yesterday,' said Munch. 'But now he has gone quite mad. Look what
he has written to me: "Everybody knows that it is physically possible to ex-
tinguish a light through a thick wall. I am sure that you want to kill me. But
I'll prevent it. You are not to become my murderer." '[41] Another event, years
later, shows that Munch, too, believed in occult forces. When painting in
Warnemünde, in 1908, the wind blew over his easel. 'That is Strindberg!' the
painter exclaimed angrily, as if only he could play him such a trick.[42]

Munch's contacts with the main representatives of literary Symbolism
seem natural, as in their circle he found confirmation of the ideas and con-
cepts which had engaged him for a long time. Outwardly his meeting with this
group is documented by the portrait of Stéphane Mallarmé (Sch 79), made in
1896. 'It is quite nice,' wrote Mallarmé's daughter, Geneviève, 'but it is similar
to those heads of Christ which were found on the Veronica cloth and under
which is written: "Look at it for a long time, and you will see the eyes
close." '[43] Naive as these words may sound, they convey, unknown to the writer,
the magic-symbolistic character Munch had given to the successful portrait of
the great poet.

At this time he was commissioned to illustrate Baudelaire's *Les Fleurs du
Mal*. The plan, however, came to nothing, and only a few drawings remain in
his posthumous papers.

The most important literary parallel to Munch's own work is to be found
in Ibsen; it is symptomatic of the relationship between the artist's work and
contemporary literature.[44] In spite of their individual differences both writer

Plate 49

Plate 48

and painter found their life's task in dealing critically with the deeper problems of a contradictory period. There appears to be no doubt that Munch's pictures, filled with dramatic tension, influenced Ibsen. Munch himself once defined his attitude, particularly with a view to Ibsen's dramatic epilogue *When We Dead Awaken*, 1898: 'It was in 1895 that I had an autumn exhibition at Blomquist's. The uproar over my pictures was enormous. People wanted to boycott the place and call for the police. I met Ibsen there. He came up to me: "I am very interested," he said, "believe me, you will fare just as I did—the more enemies, the more friends." I had to join him, and he wanted to see every picture. A large part of *The Frieze of Life* was shown. *The Melancholic Young Man by the Shore, Madonna, Shriek, Anxiety, Jealousy, Woman in Three Stages*. He was particularly interested in *Woman in Three Stages*. I had to explain the picture to him. Here is the dreaming woman, there the woman hungry for life and there woman as a nun, standing pale-faced behind the trees. He enjoyed seeing my portraits, specially those where I had stressed the character so strongly that they came close to caricatures. A few years later Ibsen wrote *When We Dead Awaken*. It dealt with the work of a sculptor, never finished, which disappears abroad. I came across many motifs, similar to my pictures in *The Frieze of Life*: the man bent in melancholy, sitting among the rocks. Jealousy—the Pole with a bullet in his head. The three women—Irene, clad in white, dreaming longingly about life, Maja, hungry for life, naked. The woman of grief with the stern pale face between the trees, Irene's fate, the nurse. The figures of these three women turn up in many of Ibsen's plays, just as in my pictures. On a light summer night we see the darkly-clad woman in the garden with Irene who is naked or clad in a very clinging garment. Her longing white body contrasting with the dark colour of grief in the mystic glow of the bright summer night, that summer night when life and death, day and night, go hand in hand. In Ibsen's play the portraits of the sculptor are mentioned, caricatures, heads of animals, which the sitters

received as gifts. In Ibsen's *When We Dead Awaken* the sculptor's work *Resurrection* remains unfinished. This also happened to my work.'[45]

Commissions Munch received also led to superficial points of contact.

Illus. 29 First, in Paris in 1896 he was asked to design a poster for *Peer Gynt*, printed in the journal, *La Critique*, but also published separately as a lithograph (Sch 74). It shows Mother Åse, sitting, and Solveig, looking up to the moun-

Illus. 30 tains. A second theatre advertisement is full of symbolism. Made for a performance of *John Gabriel Borkmann*, in the *Théâtre de l'Œuvre* in Paris (Sch 171 a) 1897/1902, it was to carry the names of the actors as customary in its right lower corner. In his design Munch did not deal with one single scene of the play but showed a close-up portrait of the author against the background of a Norwegian coastal landscape, and a tall lighthouse, its rays piercing the dark.

In 1891 Ibsen had finally returned to Christiania where he lived until his death in 1906. In 1902 Munch did both a painting and the impressive litho-

Plate 77 graph, *Ibsen in the Grand Hotel Café in Christiania* (Sch 171). The head of the writer with his thick hair, mighty and forceful in its dignity, is presented in front of a dark curtain. One forgets that Ibsen was small, perhaps Munch only represented his face for this very reason. It was Ibsen's spiritual stature he wanted to portray. The cafe was the meeting place of the Christiania-Bohemians, and through the window one can see the busy street traffic, which the artist significantly related to the writer.

In 1906 Max Reinhardt had succeeded in gaining Munch's collaboration for the scenic design of his famous production of *Ghosts*. Arthur Kahane, an eye witness, says: 'After careful consideration Ibsen's *Ghosts* was selected for the opening performance of the just completed *Kammerspiele*. With its concentration on the interplay of five characters, it offered the best opportunity for 'Chamber Music' on the stage, a quintet of five exquisite instruments. The cast had been chosen: Madame Sorma, Moissi, Madame Höflich, Reinhardt

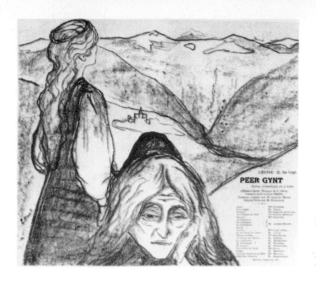

29
Solveig and Mother Åse
1896
Lithograph

and Kayssler. There was as yet no designer. According to Reinhardt's principle, finding for each play not only the best but the only possible designer, Munch was the obvious choice. It was difficult, however, to win over this obstinate man. In the end he agreed, tempted by the possibility no painter could resist, of letting him decorate entirely to his own design a room in the *Kammerspiele*, the festival hall. Thus, as a wonderful by-product of the *Ghosts* commission, there came into being a frieze, later to become known as *The Reinhardt Frieze*. For the play itself he did not, like other painters, make designs of decor and figurines, but painted two or three pictures representing the situations in the play. However, I have heard Reinhardt say a hundred times that from no other designer had he received such strong stimulation, as he did from Munch's paintings. And he succeeded completely in that memorable production in transferring to the stage the wonderfully impressive atmosphere of the painter's vision. Later on Munch once more designed the decor for an Ibsen production at the *Kammerspiele*. This time it was *Hedda Gabler*, with Hermann Bahr as producer.

'Every day Edvard Munch was at the theatre; he lived right amongst us, worked through the day, drank at night, and painted alternately his *Ghosts* pictures and the frieze. Sometimes he sat for quite a while in my office, completely still and without moving, very serious, scarcely saying a word to anybody. He seemed not to see or hear what went on around him, entirely taken up with himself, with not a muscle moving in his face! What went on behind this calm facade? What was working behind these strong features, this strange strong forehead? Then, some small thing was enough to startle him. He became bright and laughed: the simple merry laugh of a child. He was always equable and friendly, yet still somehow reserved, a stiff Northerner, difficult to penetrate. For us he remained a stranger, a puzzle. He had something of the child and the savage, an almost animal primitiveness, a Parsifal-like innocence. And again, he was immensely complicated, with his knowledge of deepest

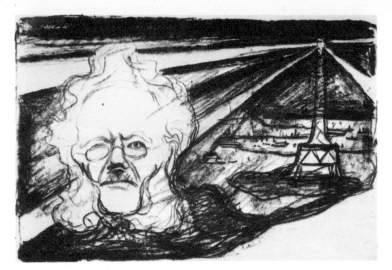

30
Ibsen with Lighthouse
1902
Lithograph

secrets. One only had to see his pictures: where was there another to be so completely man, to experience woman, and suffer through her? Sometimes he was ridiculously obstinate, did not look up or listen, neither to left or right, remained untouched, not deflected by praise or censure. But behind this obstinacy was a gigantic iron will, sure of itself in a somnolent kind of way. There was a will for freedom which appeared to burst all social conventions, and could arise and grow only in an essentially deep loneliness.'[46]

Illus. 31

Munch painted the scenic designs for *Ghosts* in oil on canvas, the largest painting measuring 62×102 cm. With the emphasis on the few figures, standing isolated in the room, he expressed the fate-laden dramatic atmosphere of the play. On these designs are based the lithographs, made in 1919/20, *Family Scene* (Sch 486), and *Oswald* (Sch 487). In the later interpretation of the mature artist they have again undergone a deepening. The figures with their threatening shadows once more hint at the human problems of the play. The final scene with the mother and her dying son looking towards the sunrise is most impressive. This motif is related to *The Sick Girl* but also to the conception showing the sun as a symbol of the future and of life. The tragic dualism of Death and the Hereafter is treated as a parable.

Plates 166, 167

After reading Ibsen's play *John Gabriel Borkman*, Munch declared it to be the finest presentation of a winter landscape in Norwegian art. The final scene of this play was the inspiration for a lithograph *Starry Night*, made according to Sarvig in 1920. Borkman has collapsed on a height overlooking a wintry fjord; a very Munch-like concept.[47]

In the nineteen-twenties Munch was asked to illustrate Snorris's *Heimskringla* sagas, but after making a few woodcuts he refused.[48] These woodcuts belong to the last period of his graphic work, between 1920 and 1931. In motif they are closely related to one of Ibsen's early historical plays *The Pretenders*, 1864, inspired by the Hakonsaga of Sturla Thordssohn. The woodcut *Ordeal* (Ms 657) is best known; it is a scene from the first act, when Inga

Plate 182

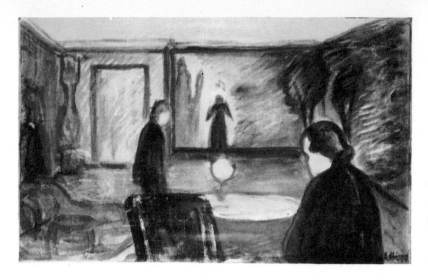

31
Setting for Ibsen's
Ghosts
1906
Painting

von Warteig has to undergo the ordeal by branding in the Christ Cemetery in Bergen, to ensure Hakon's right of succession. In the catalogue of an exhibition of Munch's woodcuts, held in the National Gallery at Oslo in 1946, showing for the first time an extensive selection of his late woodcuts, no less than fourteen relating to this historical subject are mentioned.[49] A cut, obviously made as early as 1917 or 1919, with the deeply wrinkled face of a man in the foreground, most likely represents the ancient King Skule (Ms 669). Plate 173 About 1919/20 another woodcut was made, a scene from the fifth act, known as *The Last Hour* (Sch 491). It shows King Skule, before leaving his refuge at Plate 172 the monastery at Elgesäter, being slain at the gate by the men of Trondhjem into whose hands he had delivered himself. In contents Munch's work follows closely Ibsen's description of the scene, seeing the old Norse legend through his eyes. 'The courtyard of the Elgesäter monastery; the chapel with the yard door on the left (sides reversed in Munch's painting); the monastery wall with a heavily locked gate in the background; a bright moonlit night; three Birkenheim chiefs on guard...' King Skule is seen standing on the right in front of the chapel, clasping the hands of his daughter Margarete, Hakon's wife, in farewell. While Munch keeps carefully to Ibsen's presentation, he is using the poet merely as a medium to expound an ancient Nordic event that has long since become a legend. Norway was not liberated from Danish rule until 1814 and separated from Sweden only in 1905; in her long struggle for independence a strong national attitude had grown which encouraged the development of a national literature.

A feeling for tradition had certainly made the young Ibsen choose his material. Munch took up the subject for similar reasons: as in his University Murals it was a chance to express the 'uniqueness of the Norwegian as well as the generally human'.

A knowledge of Scandinavian and contemporary literature is not of course the only key to the understanding of Munch's art which, in any case is of a

highly individual character. Yet the Scandinavian writers of the period, Strindberg, Ibsen, etc., do provide a degree of insight into contemporary society; an insight that can only lead to a fuller and deeper comprehension of all that Munch sought to express.

Eros and Death

Munch was twenty-five years old when the plan for *The Frieze of Life* matured. It was to be a monumental cycle about human life, primitive life in its elementary grandeur, and the hidden sides of man's relationship with his fellows. Through stressing certain states of life which he experienced deeply, Munch tried to present the spiritual situation of man in his time, and show up the indestructable inner wealth of existence. He was conscious that in doing so he was running contrary to the beliefs and opinions of contemporary society. He broke through the hypocritical taboo which forbade all dealing with erotic questions. To him these questions held an all important urgency. The idea of *The Frieze of Life* came to him first in that Paris dance hall, when the vision of the dancing couples in an atmosphere of music and smoke seemed to him an image of life itself.

As he recalled the occasion:

'Singers from Rumania appeared on the stage, interpreting the passions of love, hate, longing and reconciliation, and beautiful dreams, the soft music combining with the colours. And such colours—the sets with their green palms and the bluish-grey water, the strong colours in the Rumanians' costumes, all in the bluish-grey haze. The music and the colours caught my imagination, transporting me on the waves of the music into a world of bright and happy dreams.

'I felt the need to do something, I felt it would be easy, anything would shape under my hands as if by magic. This is what I would present: a strong naked arm, a strong brown neck, a young woman putting her head against a burly chest. I wanted to paint all this as I was seeing it just now, but in a blue haze. This couple at the moment when they were not just themselves but only a link in a chain of a thousand generations ... People will understand the sacredness and greatness of it all, and will take off their hats as though they were in church.' And he ended with his often quoted statement: 'I should like to make a number of such pictures. No longer shall I paint interiors, and

people reading or women knitting, I shall paint living people who breathe and feel and suffer and love.'[50]

The subject of *The Frieze of Life* engaged the artist for many years. In 1902 in an exhibition of the Berlin *Sezession* twenty-two paintings of this cycle were shown. Love and death were the subjects of the two main sequences. 'A turbulent inner life, given over without restraint to sorrow and joy, to despair and ecstasy, faith and doubt, had here found expression.' (Jens Thiis).[51] Smaller variants of the frieze came into being such as the one commissioned by Dr. Linde for his villa in Lübeck, and by Max Reinhardt for a room in the *Kammerspiele*. Dr. Linde did not like his pictures, perhaps because they were not the most suitable decoration for a nursery. He received others in exchange, and a fine folder of graphics *Aus dem Haus Max Linde* (Sch 176–191), 1902. *The Reinhardt Frieze*, also, was all too soon sold. Munch complained later that nobody wanted to have the cycle as a whole, and the pictures were therefore scattered. But what the artist did not achieve in painting, he sometimes managed to do in graphics; in many collections, works belonging together did stay together. It is perhaps to be regretted that he did not collect graphic works to form a composite cycle, or even conceive them as such, the way Klinger had done, and as he himself did only once in his *Alfa and Omega* which is like a paraphrase of *The Frieze of Life*.[52]

Munch's attempt to represent the basic emotional experiences of man, and his own groping with these subjects for years, enabled him to see sex as one of the most powerful driving forces. Even more did he find this true of a society that made the relationship of the sexes artificial and hence problematical.[53] It was not given to him to look at the erotic with the gay sensual mediterranean unconcernedness of Picasso whose work, like Munch's, is to a large extent indebted to the erotic. The lasciviousness of Félicien Rops' work was equally outside his interest. To him the erotic meant not only the sensual and the passionate but fate itself. 'Women give birth and die,' Munch's friend,

49

Sigbjørn Obstfelder, wrote, and his tender, sensitive lyrical poetry has many affinities with Munch's own concepts.[54]

The deep seriousness, even the tragic mood of a great many of his pictures about love never indicate a pessimistic acceptance of it as senseless. The loneliness, despair, and often sheer demonism of love are not ignored, but there always remains the promise of fulfilment, gaining in depth through grief and sorrow. He recognises no easy way, no taking and forgetting, only the fierce inner struggle that is demanded of man. Seen as an eternal seeking and finding and separation, the relationship of the sexes form the content of many of his pictures. The working of Eros has something fateful, since happiness in love is rare. The value of such strong and elementary, though often destructive, emotions by which the lovers Munch portrayed were ruled, may be realised clearly when measured against the patterns of the petty-bourgeois world in which he was forced to live.

'Munch . . . does not need to go to Tahiti to see and experience the primitive in human nature,' the critic, Franz Servaes wrote as early as 1894. 'He carries his own Tahiti within himself, with the sureness of a sleep-walker he travels through our confused civilization. We stand before his pictures as before a revelation from primeval days when there existed simple ties between man and man, and man himself was an unbroken being . . .'[55]

Gauguin and Munch were both oppressed by the bourgeois society around them. The anxious question, the title of one of Gauguin's pictures: 'Where do we come from—what are we—where are we going?' engaged both artists very deeply. Gauguin believed he had found his utopia in the South Sea Islands, or at least that he had found an approximation. Munch stayed in Europe, throwing himself into the turbulent bustle of big cities where much of his work came into being. It is strange that the subjects we come across here are set for the most part in Munch's Northern homeland, just as if he had never left Norway. It was, however, the experience of life in large cities

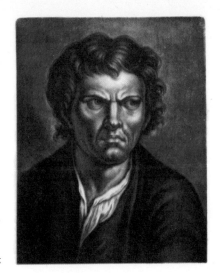

32
August Degmayr
Jealousy
1740–70
Mezzotint

which made him aware of human problems, and the artistic stimulation he received furthered the boldness of his expression. In the South Sea Gauguin found a microcosm of the good life. Munch never looked for a Tahiti on the Norwegian coast. He did not flee the world, he faced it. In the given circumstances he examined and laid bare the powers of Eros. For a Norwegian, so deeply attached to his country, it seemed natural to choose the coast of his homeland as a background. Through having its roots in Norway, Munch's art gained visibly in weight and depth. The influence of the stern grandeur of the fjord scene, the extreme climate, the sparsity of human habitation, all these circumstances favoured feelings of loneliness and melancholia and excited the passions. His countrymen, Knut Hamsun and Olav Duun, have described the same situation in their novels.

Munch's art has many roots, and its intellectual content is more complicated than his simple settings. They must be understood rather as symbols of a much more complex situation. What inner tension is expressed, for example, Plates 20, 79 in the work, *Two People by the Sea* (Sch 20 and 133)? A white-clad woman with long flowing hair stands by the shore, looking out to sea as a man approaches her. Both are still separated, full of longing, a step would be enough to bring them together. But the small gap between the couple has the effect of a deep chasm which cannot be bridged, and behind it all lies the anxious question: 'Will there ever be a way to each other?' The work is also called *The Lonely Ones*, and it almost appears that the deceptive closeness of Plate 44 another being makes loneliness more pungent.[56] The lithograph, *Attraction* (Sch 66) represents two lovers on a summer night, turning to each other. A tender delicate atmosphere pervades this composition. The woman's hair blows over to the man, symbolically showing the fragile ties which bind man and Plate 45 woman. A counterpart in subject to *Attraction* is *Separation* (Sch 68), a large lithograph steeped in melancholic blue. Again, there are two young people by the shore. The girl's hair, blowing down on the man's shoulders, is reminiscent

51

33
The Kiss
1892
Painting

of lost ties, the ties are loosening, and the man turns away, his face pained. As the line of the shore fades in a soft curve, love, too, is fading.

About Munch's presentation of *Jealousy* (Sch 58) Gustav Schiefler wrote: 'He represents jealousy in the agonised features of a man with keen blue eyes, and a pointed beard, in such a way that one believes one is experiencing the tormenting pricks of passion oneself. The scene the tortured man sees before his mental eye is expressed in soft flowing lines, as his beloved one stands naked before his rival.'[57] This work reflects the tense situation that arose between Strindberg, Przybyszewski, Munch and a young spirited Norwegian woman, married to the Polish poet, and maliciously called by Strindberg, 'Aspasia of us all'. Munch himself said about this: 'I do not understand how my nerves stood it. I sat at the table unable to speak, Strindberg talked, I thought the whole time: "Is it possible that her husband does not notice anything at all? Perhaps he will first turn green, and then furious." '[58] This state of affairs was confirmed in a letter Strindberg wrote on 2 January 1894: 'The Pole is unhappy for Aspasia now visits *The Black Pig* alone with Munch. This means that the end is like the beginning.'[59] Though Munch was personally concerned in the event, he represented jealousy as a general human experience.

The erotic motif *The Kiss* has many variations. A painting of 1892, still strongly influenced by French Impressionism, but executed in his own highly expressive manner, shows two lovers by the window. An etching (Sch 22) takes up this motif again three years later. From the edge of the picture, the couple has been moved to the centre, naked and passionately embracing. There is a powerful interaction between the light and darkness, indicating mental tension and giving the impression that a natural phenomenon of tremendous intensity is taking place. Years later Munch worked again on the same motif, this time in a woodcut (Sch 102). He suppressed the sensual part of the etching, and under the influence of the Japanese woodcut reduced it to a symbol. The work is also a representation of new techniques, supremely handled. Here for

Plate 55

Illus. 32
Illus. 33

Plate 25

Plate 67

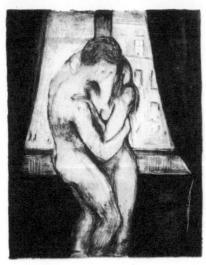
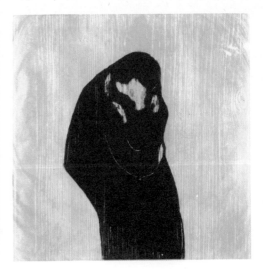

34
The Kiss
1895
Etching

35
The Kiss
1902
Woodcut

the first time, with the exception of Gauguin, an artist deliberately used the special effect of the grain of the wood.

Plates 58, 59
Illus. 44
Plate 184

The cycle of Eros culminates in the motif *To the Forest* which exists in several graphic and painted variations, as a coloured lithograph (Sch 100) of 1897, and (Sch 444) of 1915; and again as a lithograph in the cycle *Alfa and Omega* (Sch 312) 1909. The motif *Kiss in the Fields* (Sch 232 and Ms 707) is also related in content, and in its strange evening atmosphere is reminiscent of Millet.

In *The Frieze of Life* Munch gave a prominent place to *Man and Woman in the Forest.* 'It is somehow the picture that holds the whole cycle together. Two naked people with the city at a distance, it is a picture of life and death. The forest, taking its life from the dead, the town seen beyond the tree tops, all this is a representation of the strong and opposing forces of life.'[60] Even without the symbolic meaning pointed out by the artist, this motif in its woodcut variations in different colours is very impressive. Closely together a couple walk towards the forest which looms before them. Within its darkness love will find its fulfilment. The gesture of the linked arms seems ancient and natural, yet at the same time seen by Munch as always new.

Plate 31

In *Leda* Leonardo da Vinci presented the mystery of procreation in mythological disguise. Munch looks at the woman's face at the moment of conception. He tries to represent the inner reaction of the lovers as it shows in their faces. In 1894 he made a painting of the subject, in 1895 an etching and a coloured lithograph (Sch 16 and 33). This motif carries the title *Madonna* or more simply *Conception*. In 1894 Stanislaw Przybyszewski wrote about the painting: '...a robed madonna lies on a crumpled sheet, with the halo of the future martyrdom of birth, a madonna represented at the moment when the mystery of eternal procreation fills the woman's face with a radiant ecstasy.'[61] This work has more symbolic details than many others. A preliminary sketch to the painting shows the very contours of the halo which later, in the lithograph,

53

became less obtrusive as part of the lines surrounding the head. The decorative border renders explicitly the theme of the picture, with its design of much enlarged spermatozoa and an embryo.

The picture of the pregnant woman again reveals to Munch the tragic entanglement of life and death. A lithograph of 1898 (Sch 95) shows in its upper part a pregnant young woman in front of a tree looking out to sea, while the sun rises behind her. In the lower part, separated by a decorative band, lies a naked woman at the moment of childbirth. Growing plants with their buds shown as schematically rendered faces, appear to symbolise birth. Does this picture illustrate Obstfelder's line, mentioned before: 'Women give birth and die'? Once more the eternal cycle of life and death. The exhausted body of the woman, the expression of pain, the whole way of presentation, allows for such an interpretation.

Plate 148

Many years later, related to his conception of the frieze in the great hall of Oslo University, the artist returned to the motif in a lithograph (MS 476). The iconographic relationship is obvious, but the subject appears more mature and clarified in this new variation. Fatalism has disappeared and hope has gained ground. Munch had come to this understanding after long inner struggles. The symbol of the tree of life, which he liked so much, appears quite natural. The dead rest in the ground into which the tree's roots stretch. Full of confidence the pregnant woman leans against its trunk, arms resting on her gravid body, eyes turned towards the bright sun. Again life and death are shown in symbolic form. This is a picture full of promise, turned towards triumphant life.

Plate 149

In the motif *Ashes (After the Fall, Sch 120)* which exists in several variations, Munch presents his idea of Woman's victory over Man, as well as the desperate realisation that even the closest sexual relationship cannot overcome permanently the inner chasm between two people. It is not just the deep melancholy after fulfilment which is hinted at, but also the despair overwhelm-

Plate 76

ing the man while his partner, standing erect, triumphantly arranges her hair. Love and passion have turned to ashes.

Unflinchingly Munch strove after valid statements on the problem of sex with which he was so lastingly and often painfully involved. To him it was a struggle of uncertain outcome which through his own inner tension, never to be permanently relaxed, oscillated between happiness and sorrow, life and death. A magic, tender closeness is presented in the picture of the young couple sitting naked by the shore and looking out to sea, (Sch 311) in the *Alpha and Omega* cycle. "Alpha was in love with Omega. The evening saw them sitting side by side, looking at the golden column of the moon as it was reflected in the gently moving sea."

Illus. 43

But again and again moments of harmony and ecstasy are confronted with death, human catastrophies presented realistically, document-like, as in the etching, *Dead Lovers* (Sch 139). Time and again Munch sees Eros and Death as the two dominant forces, not necessarily opposed but interwoven and in their synthesis making up the human condition.

Plate 83

Erotic fulfilment means being close to death. 'The waves of life rock them in their embrace, and the woman's smile is like the smile of death,' Munch wrote under a love scene.[62] The linking of Eros and Death, implying polarity and unity at the same time, is an ancient motif. He gave it contemporary form and interpretation. The Middle Ages had expressed the subject pictorially in the motif of *The Girl and Death*. The Renaissance tried to represent Life and Death mainly in the confrontation of the youthful naked body of a woman and a gruesome skeleton. A macabre note enters when Death is shown as the lover who tries to embrace his struggling victim. Munch carries this motif further when he makes the girl not resist death's embrace, but give herself passionately to it. 'Death kissing an ardent woman is a striking symbolisation of those ecstasies which death, love and the approach of birth bring about,' Franz Servaes wrote in 1894, about Munch's etching *The Girl and Death* (Sch 3).[63]

Plate 2

36
Hans Baldung Grien
Death and the Woman
C. 1517
Painting

Munch's ideas on this subject have perhaps found their most vital form in this work. Eros and Death in mutual relationship are an expression of an equally conflicting and complex human existence. Apart from this deeper meaning the drypoint which takes up the motif from a previous painting, is of astonishing vitality and freshness. Even lesser details, such as the standing on tip-toe of the girl, testify to the artist's keen observation. The body, outlined in a few strokes only, is of plastic strength, and the stipple-effect of the drypoint is skilfully used for the girl's hair and the skeleton. The sure concept, details and technical perfection, all show the hand of a master.

Two years later Munch playfully varied the subject, in the drypoint *Two Girls and the Skeleton* (Sch 44). There are now two models flirting with the skeleton between them. More seriously the theme is taken up again in the lithograph *The Kiss of Death* of 1899 (Sch 119). This work shows only the heads, close together, of Death and the Girl, her long dark hair falling on his shoulder. Illus. 37

Plate 74

Munch called his *Frieze of Life* a poem of love and death, a term which might well be applied to much of his graphic work.

Woman's Inner Life

'Oh, this sensuality, this absorbing sensuality! When he took up a book, and began to read, he could not think of what he was reading because of the figures of naked women, capering between the lines, till he forgot the book and the lines, seeing nothing but women.' This physical and psychological state that Hans Jäger has described in his novel *Christiania-Bohème* has its pictorial

Plate 54 equivalent in Munch's woodcut *In the Brain of Man*, 1897 (Sch 98). It shows a man's head with the vision of a naked woman poised above it. In this motif, too, several levels of consciousness mingle: the intellectual argument about woman's place in society, which was topical and exciting as never before, and every man's awareness, of her sensual attraction. Munch was directly involved in these problems and tried desperately to avoid them. He spoke later on about 'those damned affairs with women'. But without this personal involvement he could not have dealt with the subject so intensely. Pictorial and written documents point to the fact that a deep love which alone could have solved his problems and relaxed his tensions, was denied him, at least for any length of time. Woman to him remained a strange being, good or wicked, but always a puzzle. Here, too, his personal experience is typical of the times he lived in:

Plate 81 Woman as the dangerous principle, temptation, *Sin* (Sch 142) with her incalculable, primitive desires was on the public mind. But it was also the time of woman's emancipation, her liberation from centuries-old degradation. The question of free love entered into the struggle for equality and the right to free expression of herself. But a clarification of feminine issues could in the end come about only in the framework of a general new order of society. This was stressed over and over again. In 1879, the year Ibsen's *Nora* appeared. August Bebel expressed it most clearly: 'The question concerns the position woman will occupy in our social organism, so that she can become a fully effective member of society, with equal rights, able to develop all her potentialities. From our point of view this question is closely linked with another, namely, which form and organisation society will adopt in order to replace

37
The two Girls and
the Skeleton
1896
Drypoint

suppression, exploitation, misery and want in a hundred shapes, by human freedom, physical and social soundness. The so-called woman's question for us is therefore only one aspect of a general social question which at present occupies all thinking people, and only as a whole can these questions be solved.'[64]

How deeply Munch recognised the political implications of this background is uncertain. His interest was focussed on man, and how he stood up to the strains and stresses of social conditions. These social conditions are only rarely hinted at, to Munch their impact on man's soul was all important. The relationship of the sexes and the life of woman became the main themes of his work. All too often they turned inwards to pictures of loneliness, hopelessness, despair and anxiety. Contemporary literature contrasted this very anxiety with the pleasures of life. But it is typical that these pleasures mostly belong to a utopia and not to reality. Munch's work is somewhat different. The positive values are not found in pictures of light-hearted joy, but in a deeper layer of experience altogether. Käthe Kollwitz, once speaking about the essence of her art, said: 'Without the basic feelings of a full life, there is no life at all.'[65] Munch's ideas are closely related to this, and in presenting the indestructable values, he shows clearly, that however tragic or gloomy life may appear, it will in the end emerge triumphant.

Munch's relation to woman is marked by a deep dualism of longing and fear. In Przybyszewski's *Androgyne* there is a sentence describing this state of mind: 'He longed for her, and was filled with senseless fear of seeing her again.' Munch made portraits of women which are hymns of love. But he also did others in which she is a blood-sucking vampire, as with his Salome motifs; or even a man-destroying demon, as in the several variations of the Marat theme. These concepts seem to spring from the idea that woman's emancipation was turning her social inferiority into a sinister suppression of man. Munch's relationship with women was obviously of a quite sophisticated nature,

wavering between desire and despair, and deeply moved by each new experience. He succeeded, in an unprecedented way, in revealing the most delicate movements of the soul, and in portraying psychic states. His contemporaries were aware of this. In 1894 Przybyszewski wrote: 'Edvard Munch was the first to represent the finest and most subtle inner processes.'[66] His work was a thrust into the realms of psychoanalysis when its founder, Sigmund Freud, was developing his revolutionary theories. At various times Munch called his pictures "Cycles from Modern Soul Life", confirming once again that his interest was predominantly in matters that lay behind the obvious and visible. One might easily assemble a larger group of these pictures under the title, "Of the Modern Woman's Inner Life".

Plate 8 *The Girl by the Window* (Sch 5) is still completely a child, still completely lost in looking at the outside world. Light is streaming into the room. Everything is open, and life is in the future. The chiaroscuro resembles that of Rembrandt's etchings, particularly in the way the magic contrast of light and dark expresses spiritual content.

Plate 24 In another etching *The Voice* (Sch 19), also called *Summer Night*, the girl has wakened to maturity. She stands under pine trees by the shore, while a boat glides on a calm sea. Listening apparently to some half-caught sound, she tilts her head back a little. The feeling of loneliness and the still uncertain longing of a very young woman is expressed in the tender figure and the illusive atmosphere of the work. Munch is concerned with the transition from childhood to
Plate 89 adolescence in the different variations of *Puberty* (Sch 164). The girl looks at us with the eyes of a frightened child, and the big shadows in the background suggest her inner anxiety and unrest. Her arms lie crossed bashfully on her lap. About the picture Adolf Paul said: 'One day I came to visit him. He lived in rooms at the corner of Friedrichstrasse and Mittelstrasse, two flights up. He was painting. On the edge of the bed sat a girl in the nude, a model. She had not the looks of a saint, yet seemed innocent, chaste and shy, and that in spite

of all humiliation. It was this that had tempted Munch to paint her. And as she sat there in the radiant spring sun, steeped in bright light, the shadows of her body behind and above, threatening like fate, he painted her with all the absorption he was capable of, and thus created in the picture which he called *Puberty*, something lasting, universal, deep and true to life.'[67]

This glance of a friend at the painter and his model is a testimony to Munch's way of work. He had been engaged with the motif since 1885, long before he came to Berlin. But again und again it fascinated him like something entirely new, and after painted variations he re-worked it in the graphic medium. In 1894 he made a lithograph (Sch 8), his first ever, and an impressive drypoint (Sch 164) in 1902. It may be true that Munch borrowed the motif from Félicien Rops, yet the conveyance is only superficial, and we are left in the end with two works which differ in their essential statements. As ever, longing and loneliness remain the basic themes of much of Munch's work.

Plate 10
Plate 89
Illus. 25

A rare coloured mezzotint of 1896 (Sch 42), worked in delicate faded pastel-like tints, shows a young girl seen from the back, on the shore, looking out to sea. During the same year that *The Lonely One* was made, reviving romantic concepts in a modern style, he did the coloured woodcut *Moonlight* (Sch 81). Here, too, the motif is very simple. The figure of a woman in the foreground, cut off by the picture's edge at the level of her shoulders, has her face turned to the onlooker. Behind her are the outlines of a small wooden house with one window. All is magically lit by the cool light of the moon. The vital point of the picture is its atmosphere in which he expresses hope and resignation, unsatisfied longing and loneliness.

Plate 21
Plate 53

Visits to hospitals had provided Munch with the opportunity of studying the traces of ageing and illness on the body of woman (Sch 154). He also drew a tired old woman, fallen asleep on a bench (Sch 152), a motif which might have attracted Käthe Kollwitz or Barlach equally. A deep concern with human destiny is behind all these pictures.

Plate 86
Plate 87

While, on the one hand, a number of important pictures represent woman as a vampire, threatening and killing man, Munch also realised that woman can be threatened herself, can be lonely and at man's mercy. In the lithograph Plate 33 *Lust* (Sch 35), 1895, the lecherous hands of men stretch from all sides towards the body of a half-naked woman, and in another lithograph of the same year, Plate 32 *The Alley* (Sch 36), a young naked girl walks down a long alley, lined by men wearing evening dress and opera hats. A lithograph (Sch 108) of 1898 repeats the motif of demoniac and distorted faces leering at nakedness. Unsolved social problems concerning the position of woman, and also the question of prostitution, are at the root of this work.[68]

The jealousy motif too has its feminine counterpart. The coloured wood- Plate 66 cut *Rouge et Noir* (Sch 115), shows in the foreground the face of a woman, and like a vision behind it two lovers in close embrace. The colours, black for the woman's head, and a reddish tinge for the couple, underline the symbolic meaning of the picture.

In the story *Androgyne* Przybyszewski described how in a work of art a woman's face can express her innermost feelings and sensations, and one may well assume that the poet had Munch's work in mind when he wrote this particular tale: '... and along the wall, a strange ornament was repeated to form a kind of freize, showing the same female face with ever-changing expressions, ever new grief, despair, passion, desire... An endless row of heads, their expressions constantly changing; an endless range of emotions, from the first longings, to the deep whirlpool of frantic despair—the endless song of love.'

Plates 22, 23 Munch's motif *Woman* (Sch 21 and 122) is a typical example of the way he reduced complicated phenomena to symbolic yet simple statements of fact. When considered from the angle of iconography, it is the centuries-old subject of the 'ages of life' which was by no means rare in the 19th century, if one takes, for example, the well-known work of Böcklin. But the genesis of the

38
Three Heads
1909
Lithograph from
Alpha and Omega

motif dates back much further. It was presented, for example, by Hans Baldung Grien (1484/85–1545) as showing the Ages of Woman, in a group of ten studies of nudes, and Tobias Stimmer (1539–1584) made a cycle of five woodcuts on the same subject. Generally, painters influenced by these medieval concepts deal allegorically with the impermanence and frailty of human life. Thus in another painting by Hans Baldung Grien we see death lifting his hour-glass next to the three stages of life: childhood, maturity and age. The motif was frequently taken up again in the nineteenth century by many artists. Superficially Munch, too, presents the three stages of life, not, however, as an allegory of physical life, but as stages in the psychological development of the three women. Gustav Schiefler described *The Three Stages of Woman:* 'In the centre, seen from the front, stands a naked woman with a lovely body, smiling proudly, legs apart, her raised hands folded behind her head. (Woman governed by desire). On the left, also seen from the front, is a spectral-looking woman, with dark eyes, deeply set, and a pale drooping mouth. She wears a simple black dress. (Woman in a mystical, dark mood). The last of them seen in right profile, turned away from the others, in a light dress, is a girl looking longingly across the sea. (The child-like, flower nature of Woman).'[69]

Strindberg gives his own individual interpretations to the motif: 'Sweetheart, virago, sinner, or, the girl portrayed, the pregnant woman, the saint.'[70] Paul Gauguin defined the types more accurately as virgin, courtesan and nun. It has also been pointed out that Munch may have been influenced by a painting of Jan Toorops' of 1893, which presents this trinity as marital love, spiritual love and courtesan. In a painted variation a man is seen, on the right, turning away from the women, and leaning his head against a tree: a melancholic Paris who has given up the choice.

These widely differing interpretations show that the actual ages only play a secondary part. Youth and age are not to be contrasted, but the symbolic figures are there, first and foremost, to present the manifold and unfathomable

essence of woman, as the subtitle *Sphinx* suggests. This interpretation does not exclude the artist thinking also of different moods of the same woman, three typical stages of her existence.

More closely related to the actual stages of life is Munch's coloured woodcut *Women on the Shore* (Sch 117). Here there are only two women, a young one, standing in a light dress, looking out to sea; next to her, sitting huddled, an aged woman. These are contrasts of the greatest simplicity: the sea and the countryside, the young woman and the old one, black and white, hope and resignation. Munch repeatedly uses this motif. To begin with we find the group of women on the Paris theatre poster for *Peer Gynt* (Sch 74), and it is Solveig who, standing erect, looks into the distance with Mother Åse sitting next to her. Then, in 1897 in Paris, Munch made a painting called *Mother and Daughter*. The year after he made the coloured woodcut *Women on the Shore* and about ten years after this, a drawing again testifies to the artist's interest in this motif. The differences in age are now more strongly stressed. The old woman looks wasted, her face fallen in, her body is covered by a loose garment–an impressive figure. The young woman beside her is naked. The woodcut *Old Men and Boys* (Sch 235) is similar in its allegorical presentation of two generations.

Plate 73

Illus. 29

Plate 72

Plate 108

Salome

The story of Herodias' beautiful daughter who demanded the head of John the Baptist is a Biblical theme which has fascinated artists through the centuries. Munch was attracted by it because it revealed the dual nature of woman, lover and vampire. His interest was centred less on the Biblical personality of Salome than on the reasons behind her action. This theme of woman killing man was to haunt his art for much of his life, as it did many other artists of that period. Among them was Wilde, whom Munch met in Paris. He knew the writer's tragedy *Salome*, written in 1893, on which Richard Strauss based his opera. Aubrey Beardsley also drew inspiration from Wilde's work for his famous illustrations published in 1894. Further, in 1903 there appeared at the Insel Verlag, in Leipzig, a bibliophile edition of the tragedy illustrated by Marcus Behmer. Wilde's presentation was important to Munch, in so far as it went beyond the facts of the Bible. Salome inflamed by love for John the Baptist, is rejected. She can only kiss the lips of the dead man. 'How beautiful is the Princess Salome tonight,' begins Wilde's tragedy, and it ends with Herod's judgment: 'She is monstrous, thy daughter, she is altogether monstrous.' Did not Munch love women, and was he not at the same time afraid of them? The parable of Salome perfectly expressed his own ambiguous feelings. Considered generally as woman threatening man, this again allows for almost eternal variations.

As early as 1894, the first year of Munch's graphic work, we find this motif as *Vampire* (Sch 4). In this drypoint a blood-sucking hybrid appears, true to Greek iconographical tradition, with large dark wings, in effective contrast to its seductive white woman's body. She has the strong claws of a bird of prey, ready to grip her victim. Munch himself appears to be the victim as the presentation suggests a self-portrait. In a lithograph of 1900 *Harpy* (Sch 137), he repeated the motif. Here, winged destruction descends on the reclining skeleton-like body of the man in the foreground. In the lithograph *Vampire* (Sch 34) following on an early painting, Munch abandoned the myth-

Plate 3

Plate 80

Plate 35

ological approach. He simply represented a woman bending in passionate ecstasy over a man's neck, while her loosened hair imprisons him like the tentacles of an octopus. Life, naked and passionate, has taken the place of the mythological metaphor.

There are many examples in literature describing woman as a vampire. We may remember Baudelaire's work, and also a late poem by Heinrich Heine which is a brilliant literary parallel to Munch's picture. In fact, this might be an illustration to Heine's poem.

'Her kisses lamed me, they made me limp,
She blinded my eyes with her kisses,
My spine's very marrow she drew,
With her mouth's wild sucking.'[71]

In the first state of the etching *Woman* (Sch 21 A), the dark figure of a woman on the right, holding a head–a detail Munch omitted in the second state–again allows for associations with the demoniac Salome-like nature of Woman. In 1896 the etching *Girl with Heart* (Sch 48) was made, 'a naked girl holding a heart in her hands, squeezing it so that the blood runs over her feet on to the ground.'[72] It appears that this symbolic motif has a significance similar to that of an etching made the following year, *The Cat* (Sch 89), showing a reclining woman with a man's head in her outstretched hands. Another etching of 1913 (Sch 397) has the same title. It represents a love scene, the reclining woman drawing down the head of a man. Taken by itself this work hardly shows a connection with the vampire theme, but the reluctant bearing of the man indicates the link.

The *Salome Paraphrase* of 1898 (Sch 109) shows the relation to the theme more clearly. This very stylised presentation has obviously a dual meaning. On the right and on the left are female hands and arms holding the head of a bearded man. With Munch, the motif of the loose hair is a frequent symbol

Plate 37

Plate 138

Plate 62

65

for both affectionate ties and utter slavery. The face of the woman remains shadowy. Schematically the picture suggests the female genital organs. Munch's friendship with the student of medicine, Przybyszewski, may be the explanation for this particular treatment.[73] In form as in content a second woodcut *Head of a Man below a Woman's Breast* (Sch 338) appears a companion and an analogy of this strange motif.[74]

Plate 63

A lithograph of 1903 (Sch 213) shows the heads of a couple, closely and tenderly together, with nothing unusual at first sight. But it is significant that the woman's head towers above the man's, her neck seeming unusually long. Once again her hair falls on the man's head, enveloping him. At once a strong impression of attachment becomes obvious. The man's head is now seen to be a self-portrait, and the title *Salome*, with its implication of the severed head of St. John reflects a personal experience.

Plate 103

The underlying pictorial metaphor is probably linked with an experience that made a lasting impression on Munch in 1902. This was the time of his friendship with Tulla Larsen, but he had withdrawn from it in order to dedicate himself completely to his work. Friends thought out an insensitive trick to bring the two people together again. They let Munch know that his beloved was dying. He rushed to the scene only to see the supposed invalid rising jauntily from her death-bed. When he turned away, deeply hurt, she pulled out a revolver to shoot herself. Munch wrested the weapon from her, but it exploded, injuring one finger of his left hand. The incident fortified his secret fear of Woman. The *Salome* lithograph was made the following year in 1903.[75]

In the satirical cycle *Alpha and Omega*, 1908/09, the artist's greater detachment appears as liberation, even as conquest. A few caricatures of 1904 and 1905 give a similar impression. Three drypoints of 1905, closely related to one another, take up the *Salome* motif. Schiefler described *Salome* (Sch 223): 'A woman, standing ... wearing a large hat with feathers, and a low-cut loose

Illus. 39

39
Salome
1905
Drypoint

dress, holds a man's head in her elegant hands, her face smiling.'[76] The decisive strokes emphasize the caricature. The head in Salome's hands is unmistakably Munch's. Similarly, another etching, *Cruelty* (Sch 225), shows a woman with a man's head in her lap, about to scratch out one of his eyes. There are more

Plate 100 figures in the third etching, *Phantoms* (Sch 224). Here the *Salome* motif is seen as a parody. Salome, wearing a sumptuous plumed hat, sits idly, having a head presented to her on a plate, together with a bottle of wine. In the background, on a throne, are Herod and Herodias. This motif allows for dual interpretation. It is striking that Herod is represented as the writer Gunnar Heiberg, caricatured by Munch previously in the same way, namely as 'Buddha-Pagode', and usually together with the critic Bødtker. The *Salome* parody, *Phantoms*, has close affinities with these caricatures. The people on the throne look on, guiltily, as the head is presented to that fashionable fair lady. With this the personal content of the *Salome* motif takes on a new meaning. Munch once more is the beaten one, the one who has been killed. It is not Woman who is the enemy, but his intellectual rivals, the successful friends of the old days. These now people his caricatures, themselves not devoid of self-irony.

Plates 76, 139 Another motif, appearing for the first time in graphics in 1896 (Sch 69), with a variant in 1899 (Sch 120 and 132), and 1913 (Sch 400), covers the same ground. An impressive lithograph of 1899 (Sch 120) shows two lovers in front of a dark forest, the tree trunks looming ghost-like in the moon light. He called this work *Ashes* with the subtitle, *After the Fall*. The man is shown as dejected, his face buried in his arms. The woman stands erect arranging her hair, proud and sure of herself, her bodice open. Woman has risen as Venus triumphant above the dismal man, like Salome above the dead John.

Plate 117 *The Death of Marat*, a coloured lithograph of 1906/07 (Sch 258), takes up the theme again through a historical event of the then not so distant past, with Charlotte Corday replacing the harpy and Salome. But just as the bodies are shown naked so the actual event is stripped of its historical significance. Trium-

phantly the woman stands next to the dead body. In the coloured lithograph the woman's body is all red, the colour of blood, of sensuality and rebellion, that of the man greenish with the green of decay. It is significant that this whole cycle of themes is temporarily abandoned about 1907, the time of the crisis in the artist's life which, among other things, brought about a change in his attitude to women.

Surprisingly at first sight, there appeared in 1930 yet another Marat-like composition *Professor Schreiner before Munch's Body* (MS 551). A scientist, anatomist, and friend of the artist, takes the place of the killer-woman. Munch does not represent him as a murderer, but as a man approaching the body —Munch himself—in the way of his profession. The ageing artist, now almost seventy years old, represents himself as dead, his physical death being confirmed by the doctor. The artist's approach to death has become matter-of-fact and objective.[77]

Plate 179

Pictures of Dread

'This artist has felt deeply the
sufferings of the world,
And has represented these anxieties in
his work.'

Karl Scheffler

'My dread increases all the time. There is no communication. Nobody exchanges smiles. Each rushes along as if he were being whipped, and from the little houses I hear crying and sobbing, they are crying behind me, crying, crying . . .' Despair, loneliness and dread speak from these lines of the quiet lyric poet, Sigbjørn Obstfelder, Munch's friend, who died when only thirty-four years old.[78] Munch was moved by similar feelings, and in his pictures of dread, they deepened to an existentialist position. Through anxiety which spontaneously attacks man, he becomes aware of his isolation. With Munch anxiety arose from the tensions of contemporary life. The voices of many artists joined him in accusation. Georges Rouault wrote that to him painting was 'a cry in the night, a suppressed sobbing, a choked smile'. Munch's receptive, sensitive nature was given to anxiety. He suffered from an unreasoning fear of open spaces and his growing awareness of these anxieties is subtly expressed in a variety of ways. Dramatic tides of desire and fear had already determined his approach to women. He sometimes felt a strange dread when he had to cross an open square or a wide road and shared with both van Gogh and Gauguin the illogical conviction that he was persecuted and threatened by others. Karl Friedrich Suter, who travelled with him, told how the artist suddenly disappeared in a station. He had changed to a train coming from the opposite direction to escape from an imagined persecutor. In this respect, apart from temperament, his Norwegian origin played an important part. The grandeur of his homeland, and the dramatic contrast between the long dark winter, and the exciting midsummer nights cannot but condition sensitive men. The Norwegian's close ties with the formidable powers of nature probably prompted his exaggerated belief in the supernatural. A final cause of neurotic disturbance was, of course, the crumbling order of society around him. 'It was given to Edvard Munch's deeply probing mind to diagnose panic dread in what was apparently social progress,' wrote Oskar Kokoschka.[79]

Plate 29 One of Munch's lithographs, *Anxiety* (Sch 61), shows a group of people

against the background of a Norwegian fjord. The apparent situation does not mean much, but on closer examination the strangely winding lines of shore and mountain, the discord of the stormy cloudscape, imply tortured restlessness. The group in the foreground is—as a motif—related to the artist's picture of the Karl-Johansgate, Oslo's promenade. They are round-faced girls and gentlemen in dark suits, wearing the fashionable top hat, as Munch himself used to. But the faces have changed, becoming mask-like, and the dark dress suits all too clearly suggest mourning. The sky above it is as red as blood.[80] In a woodcut of the same motif (Sch 62), the scenic background is is darkened, and only the faces stand out, pale as ghosts. This picture reveals an existential experience on the same lines as those described by the French writer, Albert Camus. Suddenly, and without apparent cause, familiar surroundings seem to alter, everything loses its familiarity or friendliness and becomes alien and hostile. A growing implication of enmity makes man aware of his terrible and unconquerable loneliness. He faces threat instead of security, a threat he cannot brave. Munch's lithograph represents this moment of realisation. We do not see the actual person but his outward world in its changed and sinister form. The lithograph, *Anxiety*, refers to an older, famous work by the artist, *The Shriek* (Sch 32). Plate 28 An identical scene is reversed, and the tension, latent in *Anxiety* here becomes vocal in an outcry of horror. Seized by terrible fear, the figure in the foreground changes into the very symbol of fear and outcry. An earlier study of 1891/92 shows a man in the right-hand corner, leaning against the railings of a bridge, with a blood-red sky above. This man is Munch himself, and he wrote a text for the drawing,[81] which reveals the depth of experience behind the work: 'I walked with two friends. Then the sun sank. Suddenly the sky turned as red as blood, and I felt a touch of sadness. I stood still, and leant against the railings. Above the bluish-black fjord and above the city the sky was like blood and flames. My friends walked on, and I was left alone, trembling with fear. I felt as if all nature were filled with one mighty unending shriek.'

Experiences like this came to Munch as a natural catastrophe against which he was able to make no defence. This was somewhat similar to van Gogh's emotional state when in passionate absorption he painted his exciting blazing landscapes.

Karl Hofer's memoirs show clearly what a strong impression the natural phenomena of the far North can leave on a painter: 'The atmosphere of the Lofoten region is at times very interesting and impressive. The rusty-reds and sulphur-yellows in the air recall the twilight of the gods, and then again there is leaden fog, when the islands loom like phantoms, only to dissolve; everything seems to be unreal, it is the magic of the North.'[82]

With Munch these stirring natural experiences opened up deeper layers of consciousness, and in themselves became a parable for the fear of life itself.

Illus. 57 In his fable of Alpha and Omega there is a passage reminiscent in feeling of *Anxiety* and *The Shriek*: "He ran along the beach. Sky and sea were as red as blood. He heard shrieks in the air and pressed his hands to his ears. Earth, heaven, and sea seemed to vibrate, and he was filled with horror."

About 1915/16 and 1920/21, during and after the First World War, we again find presentations of dread in Munch's graphics. It is remarkable that he always shows groups of people exposed to fear, the individual experience becoming a collective one. They are people who, under the impact of approaching terror, cling together. Some lithographs (Sch 437 and MS 559) represent groups of people, transfixed by terror, on a narrow mountain path, overhanging rocks to one side, and a sheer precipice on the other; a nightmare of fear and despair.

Plates 156, 157

When Munch was again able to travel to Germany after the First World War, he witnessed the revolutionary events of those years in Berlin and other cities. He saw how the awakened proletariat demanded its rights. And the louder it raised its voice, the more violent and brutal became the reactionary forces. Massacres, charges on demonstrators, murderous attacks, the murder

of progressive politicians, became daily events. A great unrest had taken hold of the people which found reflection in his work. There is, for example, the lithograph, *Grenadierstrasse Berlin* (Sch 496) of 1920, with the passers-by crowding to the front of the picture, and great numbers of people gathered before the tall houses in the back. The title for a woodcut of the same period, *Panic* (Sch 489), seems not quite adequate, for the movement of the dense anonymous crowd, flooding out of the picture towards the imaginary spectator, has something irresistible, a strength that can face terror. The woodcut *People in a Square* (Sch 490),[83] shows groups of people talking, and demonstrating that solidarity which unites men during extraordinary events. Related in content to this woodcut is a lithograph of 1922 (Sch 510), which clearly represents a particular demonstration, that at Frankfurt station, at the time of Rathenau's funeral in Berlin. The treacherous murder of this distinguished politician was the cause of strong protests in nearly all the larger German cities. Munch happened to be passing through Frankfurt when he witnessed the demonstration, and sketched it. He must have been touched by it very personally as Rathenau had been one of his first patrons, and had remained his friend.

Plate 159

Plate 171

Plate 170

Plate 158

In connection with Munch's pictures of dread, the name of the Danish philosopher, Sören Kierkegaard, is often mentioned. His work *The Concept of Dread* published in 1844, was to become a strong influence on the Existentialists. Like Kierkegaard Munch experienced anxiety as a phenomenon of existence, the realisation of projection (Heidegger). Times of crisis when an apparently dependable order is being questioned, demand a new clarification of the basic questions of human existence. It is significant in this respect that Existentialism began in Germany after the social convulsions of the First World War. It does not appear that the writings of Kierkegaard had any direct influence on Munch's pictures; they were completed before the artist came across the writings of the great Danish philosopher. 'Only in later years did I

come across Kierkegaard's work and I find strange parallels with him. I now understand why my work has so often been compared with his. Earlier I could not understand it.'[84] As in the case of Kierkegaard, Munch's private experience of dread was deep and original, only eventually finding artistic expression because of the strength of his inner compulsions.

The Cycle Alpha and Omega
Satire and Caricature

In the autumn of 1908 Munch suffered a nervous breakdown which forced him to spend some time in a Copenhagen clinic. This crisis was a turning point in his life. The restless years of wandering which for two decades had taken him roving from place to place, ended. His passionate involvement with the innermost realities of life in difficult times had deeply engaged him in actual life itself. In the long run his nature could not stand the stress. Also, he had reached a stage where the question of the fundamental meaning of existence, this final question behind all human conflicts, becomes more urgent. Apparently, all he needed was something concrete to enable him to become aware of this situation and arrange his life accordingly. For the change was not initiated by the shock of this crisis: it was in fact the ultimate catalyst in a slow development. Munch's work, done in Warnemünde in 1907 and 1908, shows that he was getting away from introspective soul dissection and gaining a changed and more mature insight into life's contingencies.

His stay in the clinic of Dr. Daniel Jacobson, whose portrait Munch painted and lithographed (Sch 273), gave him the leisure needed to clarify his thoughts and feelings, and allowed him to overcome the enervating tension which so far had marked his relations to life. Some great change had taken place inside him which enabled him to face the world.

Plate 124

During his eight months of convalescence he never laid down his brush or crayons, on the contrary his graphic productivity increased. Dr. Jacobson did not hinder the artist's eagerness to work in any way, as he knew very well that painting and drawing were a liberation for Munch from threatening visions, an absolute need. A drypoint of this period, which represents the open, clear face of a nurse (Sch 269) is often taken as evidence of his changed attitude to Woman. Though up till now he had laid the emphasis on her lustful and vampire-like nature, he now came to see her softer side. The tender portrait of the nurse underlines the artist's newly acquired maturity. It seems as though the idea of a harmonious partnership of the sexes was gaining ground.

Plate 121

In the Copenhagen zoo Munch drew animals: flamingoes, monkeys, tigers and bears. From these sketches he made lithographs which drew attention to his studies. In a terse, masterly way he isolated the very essence of the animals. With a few strokes he succeeded in capturing the elegance of the flamingo, the shaggy coat of a bear, or the mask of a tiger. The artist was genuinely attracted to the animal world.

Closely connected with these animal studies is his graphic cycle of twenty-two lithographs *Alpha and Omega* (Sch 117–138). Previously he had made a few satirical studies of this kind. In Warnemünde in 1908, according to Gustav Schiefler, the artist showed him some pencil drawings which he called *The First Men*. Schiefler advised him to publish them in a series. That was shortly before Munch's stay at the clinic, and most likely Dr. Jacobson encouraged the plan. The writing of the text, too, must have been revealing evidence to the doctor of his patient's state of mind. In this manner text and pictures of *Alpha and Omega* were made. It has been called one of the most pessimistic works of the artist,[86] and certainly it is extremely bitter, its roots being buried in his early experiences of life. It must, however, not be overlooked that the actual events are treated here in the manner of a parable, showing his greater detachment. Behind the satirical allusion to the first human couple lies the suggestion of a summation of basic experiences. To a large extent these very experiences had previously been important motifs of his pictures: love and jealousy, the faithlessness of Woman, melancholia, anxiety and death. The subjects of this series are linked with the rest of his creation through close iconographic relationship and, even more, through an inner continuity.

Illus. 40, 41

Illus. 42–59

40
Three Flamingoes
1909
Lithograph

Edvard Munch: Alpha and Omega

'Alpha and Omega were the first beings. Alpha lay in the grass, dreaming. Omega approached him full of curiosity. She broke a frond off a fern and touched him, so that he awoke. Alpha loved Omega. In the evening they sat huddled closely, watching the path of the moon on a placid sea. They walked in a deep forest full of strange animals and plants, around them a mysterious darkness. The ground was covered with many wonderful flowers. Suddenly Omega was seized by fear, and she fled to Alpha's arms. For many days the island was bathed in radiant sunshine.

'Once Omega lay in the sunshine on the edge of the forest while Alpha rested in the shade. Suddenly a huge cloud rose from the sea, spreading over the sky, and plunging the island into gloom. Alpha called Omega, but Omega did not hear. Then Alpha saw Omega, holding the head of a snake in her hands, and staring into its glittering eyes, a huge snake which had climbed up her body from among the ferns. Suddenly rain came pouring down, and Alpha and Omega were seized with fright.

'One day Alpha met the snake in the fields, he struggled with it and killed it. Omega watched from a distance. Then Omega met the bear. She shuddered when its soft coat touched her body. She put her arm round the bear's neck, and the arm disappeared in the thick fur. Omega met the poet-hyena. Its coat was dishevelled. Its trite words of love did not touch her, but she made a wreath of laurel with her small soft hands, and crowned the hyena, her sweet face tenderly close to its wicked head.

'The tiger put its cruel wild head near to Omega's lovely little face. Omega did not tremble. She put her hand into the tiger's mouth, and stroked its teeth. When the tiger met the bear, it smelt Omega's scent, the scent of the pale apple blossom which Omega kissed every morning at sunrise. They leaped at each other, and tore each other to pieces. Suddenly, as if on a chessboard, the

41
Two Lion Marmosets
1915
Lithograph

figures changed place. Omega leant against Alpha. Curious, and without under-
standing, the animals stretched their necks, and looked on.

'Omega's eyes used to change colour. On ordinary days they were pale
blue, but when she looked on her beloved one, they became black, with crimson
spots in the black, and it then happened that she hid her mouth in a
flower. Omega's heart was fickle. One day Alpha saw her sitting by the
brook, kissing a donkey, whose head lay in her lap. Then Alpha fetched
the ostrich, and leant against its neck. But Omega did not lift her eyes
from her pleasant task of kissing. Omega was tired and tortured with a
desire to possess all the animals on the island. She crouched in the grass and
cried violently. Then she rose and roamed about the island. She met the pig.
She knelt down, hiding her body in her long black hair. And Omega and the
pig possessed each other. But Omega was bored one night, and when a golden
moon lay cradled on the waters, she fled on the back of a hart across the sea
to the pale-green shores below the moon. Alpha stayed behind on the island.

'One day Omega's children came to him, a new generation, grown up on
the island. They gathered round Alpha calling him father. There were small
pigs, snakes, monkeys, beasts of prey and other monstrous offspring of the
woman. He was in despair. He ran along the shore. Sky and sea were as red
as blood. He heard shrieks in the air, and held his hands to his ears. Sky and
sea swayed, and he was full of dread. One day the hart brought Omega back.
Alpha sat on the shore. She came up to him. Alpha heard the blood sing in
his ears, the muscles of his body tensed, and he beat Omega to death. Then,
when he bent down and saw her face, he was filled with fear. She looked at him
as she had done once, in the forest, at that time when he had loved her most.
He was still lost in looking at her, when the monsters and beasts of the island
fell on him, and tore him to pieces. The new generation filled the island.'

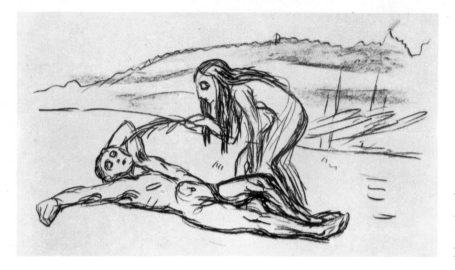

42
Alpha and Omega
1909
Lithograph

43
The Rising Moon
1909
Lithograph

44
The Forest
1909
Lithograph

45
Shadows
1909
Lithograph

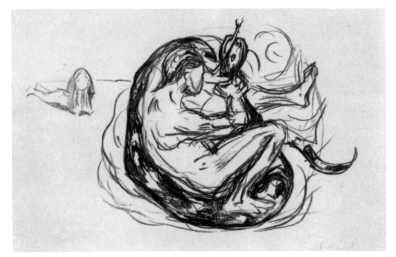

46
The Snake is strangled
1909
Lithograph

47
The Bear
1909
Lithograph

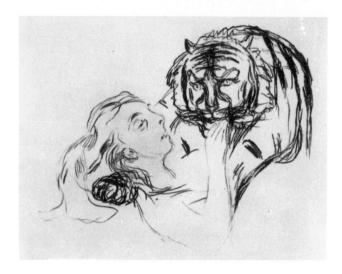

48
The Tiger
1909
Lithograph

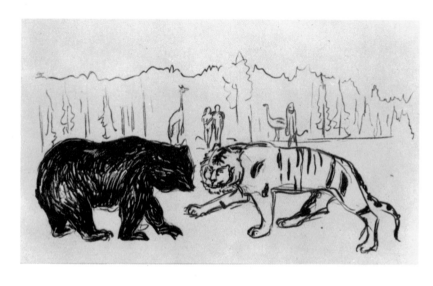

49
Tiger and Bear
1909
Lithograph

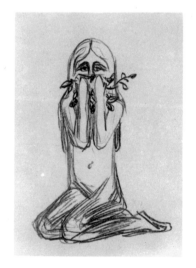
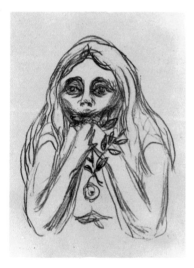

50
Omega and the Flowers
1909
Lithograph

51
Omega's Eyes
1909
Lithograph

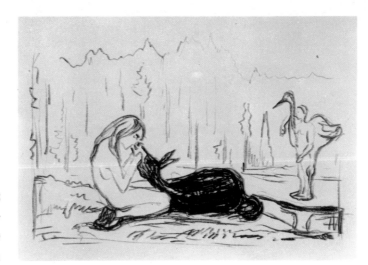

52
Omega and the Donkey
1909
Lithograph

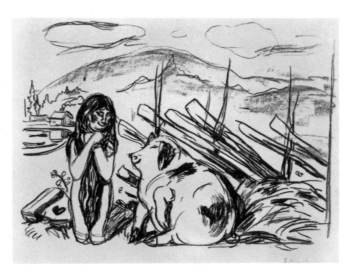

53
Omega and the Pig
1909
Lithograph

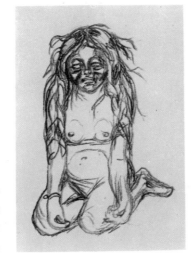

54
Omega weeps
1909
Lithograph

55
Omega's Flight
1909
Lithograph

56
Alpha's Progeny
1909
Lithograph

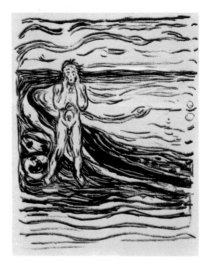

57
Despair
1909
Lithograph

58
Omega's Death
1909
Lithograph

59
Alpha's Death
1909
Lithograph

The hidden meanings in this fable compare in many ways with the caustic humour in his caricatures. He had a genuine sense of the comic, particularly when it verged on the tragic, while his humour, often mordant, was mixed with self-irony.

In this context Ole Sarvig mentions his early erotic caricatures, for example *The Girl with Heart* (Sch 48), or *The Alley* (Sch 36), though these works can hardly be taken as caricatures, they are too serious and lack the liberating exaggeration. Other works show a clear tendency towards the grotesque, as *Lust* (Sch 108), 1898, with its weird distorted faces bending over the naked body of a woman. Or again, the strange confrontation of the young girl and the cod which, dragon-like, opens its enormous mouth (Sch 165). *Burlesque Lovers* (Sch 106) and that lithograph, unique of its kind, *Homage to Society* (Sch 121), reminiscent of Daumier, and exposing bourgeois tittle-tattle, also belong to the small group of caricatures dating from the late nineties.

Plates 37, 32

Illus. 60
Plate 98

About 1902/03 Munch was busy on a satirical cycle, *Beasts and Men*, the motifs of which can be followed up to 1911, when he had a few caricatures printed, actually conceived some ten years earlier. The cycle, however, was not finished. Behind this type of work lies the fact that Munch, who had been gaining a reputation abroad, particularly in Germany and France, was still fighting for recognition in his own country. It is true he had friends and was acquainted with influential people who acted as his patrons, but public recognition, above all by the very conservative press, was slow in coming. He was also embittered by the fact that some friends of his young days, who had stayed at home, had, to him undeservedly, gained wealth and fame. He resented their complacent superiority, while he had to keep on struggling. From this point of view one can understand the grim irony of his caricatures. One of the lithographs, printed as late as 1911, but carrying on the stone the date of 1902, *The Rich Man* (Sch 344), shows a well-dressed, portly gentleman, distributing money to a group of beggars, surrounded by dogs gnawing bones. Under it Munch wrote:

'The rich steal from society. When the rich give alms, they steal twice; they steal hearts as well.' This caricature is a strange mixture of social criticism and personal matters, because behind the rich man stands a big dog begging. The dog has a moustache and a human face; and with this Munch hits at the critic Sigurd Bødtker, four lithographs of 1903 showing the same intention even more clearly. They have been drawn together on the same stone (Sch 206 to 209), and represent a smug mandarin-like animal figure sitting, and a poodle opposite, begging and cringing to it. Munch expressed in this work his contempt for the critic Bødtker, while the offensive mandarin figure or 'Poet Hyena', is Gunnar Heiberg. The last of the four lithographs shows a painter, the artist himself, at the easel, while a prancing poodle attacks him furiously. Munch never tired of repeating these Heiberg–Bødtker caricatures in ever new variations. Connected with the Salome theme, the motif underwent a strange Plate 100 metamorphosis in 1905, in a drypoint (Sch 224) and a lithograph (Sch 229). Herod–Heiberg has the severed head of St. John–Munch presented to him with a bottle of wine. How deep was the masochistic urge behind the attacks, is Plate 101 shown in a further lithograph from a series *Cause and Effect* (MS 516). The artist himself lies in the foreground of the picture, a wasted corpse, surrounded by a group of inquisitive people, among them Gunnar Heiberg, Sigurd Bødtker, Christian Krohg clearly recognisable, and a pastor, bending over Munch's body, with the pathetic words: 'He has suffered much, he has also accomplished much.'

Occasional notes reveal the biting irony with which he could revenge himself. Under a lithograph (Sch 346) he wrote, for example: 'As nothing had come of his poetic art, he adopted blue spectacles, and turned art critic.'[87] And another (Sch 337): 'After a morning drink and two pages from the Bible, I begin my essay on perverse art.' He also did some very rude caricatures on the subject of the press (Sch 218), for example. Of much higher artistic value, Plate 99 and one of his strongest and most convincing caricatures, is *The Swamp*

(Sch 205), from the projected series *Men and Beasts*. On a more general but equally poignant note, he managed in this grotesque presentation to sketch a striking allegory of smug bourgeois self-sufficiency. The creatures wallow swinishly in the swamp, having sunk from human to animal.

Sometimes the caricature invades more serious presentations. *Metabolism* (Sch 334) is a typical example. The title alone is ironic and the subtitle of the lithograph, drawn on the same stone as a presentation from *Alpha and Omega*, is symbolic–*The Tree of Art*. On the ground under a fruit tree are large beetles, rats, hamsters, pigs and other beasts, eating the ripe fruit which has fallen to the ground, while at the same time they are burrowing at the tree's roots. Considering this motif in connection with the story of *Alpha and Omega*, the beasts might be Omega's monsters. A deeper meaning is revealed, however, by a note from the artist's hand, on a copy of the work in possession of the Berlin *Kupferstichkabinett*: 'While I slept a beast came and ate my laurels.'

It would be wrong to draw a sharp dividing line between the caricatures and Munch's other work. The one affects the other, and the same pictorial metaphors are used. The tree, for example, is a motif Munch uses again and again.

The poster of a Norwegian exhibition shows the head of the artist among the roots of a tall fruit-bearing tree, representing his life's work.[88] This symbolism is again related to a woodcut of 1898 (Sch 114), showing a man, half rooted in the ground, feeding the growth of art with his heart's blood which is streaming from a chest wound.

Plate 65

In 1915, under the influence of the First World War, the allegorical work, *The Tree* (Sch 433) came into being. From a hill of dead bodies rises a mighty tree, the sun breaking through its branches. Is there behind all the tragic, and all the senseless murder of war, hope for a better future, symbolised in the rays of the sun? Is it the ever recurring antithesis of life and death, hope and despair, which the artist wants to express? In the large painting for the

Plate 150

assembly hall at Oslo University, made at that time, he answers this question positively: life!

The symbol of the fruit tree appears again in 1915 in a coloured litho-graph (Sch 459). The satirical character of this presentation is expressed in the subtitle, *The Neutrals*, pointing to the profit the neutral countries made during the war.[89] The significance is only hinted at, because the work does not appear to accuse or be critical. It was the reality, not the symbol, which seems to have fascinated the artist: two young people gathering apples.

Plate 155

Back to Nature
Return to Norway
New Motifs

The crisis of 1908 was a dramatic break but it did not necessarily put an end to everything that had gone before. More than many other artists Munch often returned to motifs he had used years before, thus uniting the various phases of his creativity, building bridges between early and late methods of approach, and so giving them an inherent continuity. Certain subjects, which had impressed the artist long ago because of their psychological overtones, were recast repeatedly in new moulds, as though they were demanding a constant re-acknowledgement. To Munch such action was necessary, almost compulsive, and he dealt with these problems as if he had to fight a Lernaean hydra whose cut-off heads are growing again too rapidly.

From about 1900 there began a steady change in his attitude to the world around him, reaching its culmination about 1907. His imagery remained, but his adoption of new motifs showed that when he went to Oslofjord, taking with him his experiences and achievements, this was certainly not in the nature of a final retreat. He rented or bought houses at Kragerø, Hvitsten, on Jeløya and in Skøyen. The property acquired in 1916 at Ekely in Skøyen, became his permanent home. The wish for quietness and concentration obviously played an important part in his choice, and is easily understood when one remembers how many restless years the artist had spent in cheap hotels. He also recognised instinctively that like Antaeos he needed to keep in touch with the soil, and this soil for the Norwegian could only be Norway. His chosen solitude did not lead to loss of contact with the outside world; it took on a different form. As early as in 1909 he travelled again to Germany, and visited Paris and London in the following years. But then, and after the war, he only made short journeys, usually for the opening of an exhibition. The larger part of the year he spent quietly in his home, his wants were few, and he was constantly at work though sometimes he was seized by restlessness, and moved from one house to another. People and scenes of his immediate surroundings entered into his imagery as important new components, not as symbols of psychological processes but rather

for their natural and normal impact on him. A further symptom of his changed point of view is that the conception of his pictures now often considered the deliberately picturesque; and, above all, required a richer, more brilliant palette. These more positive pictures are proof of his conquest of anxiety.[90] At this time he repeatedly painted women in the nude, in gleaming warm colours, finding sensual delight in the beauty of their bodies.

From 1909 he was busy with his sketches for the decoration of Oslo University's Assembly Hall, for which a competition had been declared, and which was won by him after overcoming many obstacles. In the first version *The Mountain of Men* was the centre of three large pictures, forming a triptych. It was a gloomy vision of the life of men who painfully struggle, with many sacrifices, to climb a steep mountain. Only a few reach the summit to see from there the light of a happier future. But in the final painting this theme is abandoned, the rising sun has taken the place of the mountain sending its powerful rays in all directions, over land and sea. To understand the deep symbolic meaning of this painting, one has to imagine what the return of sun means to the Northerner after he has lived through the long dark months of winter. Thus the picture's symbolism becomes explicit as an affirmation of life itself.

The vision of *The Mountain of Men*, inspired by Nietzsche, was by no means finished for Munch. He still worked at it in 1928: 'You see,' he explained to a visitor, 'this picture should be finished soon. I work at it a little every day. Can you recognise the people, climbing wearily over those rocks and crevices and through the brushwood? Can cou see those people? They are poor devils. Not one will reach the summit. But I have a variation called *The Mountain of Life*. Here they are better off. They are stronger, and for this reason they reach their destination. I am not yet sure which of the two I will finish.'[91]

Plate 57 Two lithographs of 1897 show similar concepts. In *Funeral March* (Sch 94) a

pyramid of men rises on a foundation of dead bodies, the apex of the pyramid being a coffin, carried on hands. The same idea is represented in the lithograph *In the Country of Crystals* (Sch 93). As in *Funeral March* a figure rests in the coffin, head raised: 'With rigid astonishment the figure recognises a scene beyond a lake in the foreground, all crystalline shapes, with the sun rising above.'[92] All this seems to suggest man's life, his desperate struggle allowing him to see the promised land only at the moment of death.

Looking back on those two lithographs of 1897, it becomes clear that he now had a more positive outlook. Detaching himself from personal involvement, he gained a deeper insight into life itself: '*The Frieze of Life* represents the joys and sorrows of every man and woman, while the University decorations show the great eternal forces.'[93] The psychological aspect, always tinged with the subjective and personal, has receded. Mankind's destiny takes its place within its historical, social, intellectual and natural limitations. 'It is my will that the decorations should represent a complete self-contained world of ideas, and that the pictorial expression should concern itself with the particularly Norwegian as well as the generally human,' he explained in connection with the Assembly Hall murals.[94]

Two of the main compositions were repeated in lithographs in 1914: *The* Plates 146, 147
Story (Sch 426) and *Alma Mater* (Sch 427). 'In *The Story* historical science has been traced to its origin in oral tradition. In it is shown an old man, like blind Homer, in tattered clothes, under a hundred-year-old oak, telling stories. Lost in his vision, he accompanies his tales with gestures. The two figures are surrounded by the beautiful landscape of the Schären islands, simplified in an almost Homeric style, yet completely Norwegian, with the sea and the bare rocks in the fading light of the evening.'[95]

The scene of the second lithograph is more pleasing: green pastures, slender birches, mountains in the blue distance above the shimmering waters of a fjord. But instead of the ancient oak of *The Story* there is a tall young tree.

In an early version entitled *The Scholars* several groups of children were added to represent allegorically the study of natural science. The final version corresponds in its simplicity to *The Story*: in the centre is the figure of a mother suckling her child, and three children at play. This peaceful scene is immediate and real, and only secondarily, by implication is it a symbol of the university.

Among his new motifs were representations of workmen. They should be considered as deliberately chosen and relevant to the statement of the painting rather than as accidental elements in a changing environment. They became a deliberate new concept in his pictures. Workmen had been represented occasionally in previous years, for instance one stands in an etching of 1902 (Sch 146), and there is the impressive woodcut, *The Old Fisherman* (Sch 124), of 1899. But with the painting of 1908, *Brick-layer and Mechanic*, a series of monumental representations of workmen began, similar to the work of Ferdinand Hodler who painted a reaper in 1909, and *The Wood-Cutter*, in 1910. For Munch the picture of a workman became the picture of working man as such, in whose natural and skilled activity he saw the basis of human society. Casual remarks confirm his sympathy for the working class: 'The workers, this grey exploited mass, who supply us with all we need, and who will soon enough snatch power from the middle-classes.'[96] In 1911 we come across the motif in graphics for the first time, *Workmen in the Snow* (Sch 350), a woodcut variation of a painting of the same year. In 1912 there followed a lithographed variation (Sch 385), and finally in 1920 a bronze group. The artist considered another painting of workmen clearing snow from a slope important enough to present to the National Gallery in Berlin, after a big exhibition in 1927. He painted and lithographed a third group of workmen with three cement mixers in 1920 (Sch 484). Years later he combined the three into a design for a tympanum for the proposed decorations at Oslo Town Hall, on the theme, 'Workmen build the Town Hall'. This realistic choice of

Plates 84, 70

Plate 133

Plate 132

motif is revealing. Munch even planned a companion to his *Frieze of Life*, with pictures from the life of workmen. Stenersen wrote of this project: 'The new frieze did not get very far. Munch completed half a dozen pictures of digging and building workmen. The most impressive is a large one: *Workmen going Home*. They come streaming down a street, close to each other, towards the onlooker. This wave of people sweeps away everybody who tries to stem it. Nobody can stop the workers' onward march. 'Do you know who is coming there? It is I. The bourgeois rabble has tried to enslave me, too. But that is impossible now.'[97]

The thoughts Munch had about the place of art in the future, 'the time of the workers', is shown in a letter to Dr. Ragnar Hoppe, of February 1929: 'I am aware that many people in the Northern countries were very much against my way of painting during the last years, against painting on a large scale and against the laying bare of psychological phenomena. Explicit art, with its treatment of details. its sleek execution, and its small scale, is accepted everywhere. But I believe that this art will have to give way soon to a new spirit. The small picture with its broad frame belongs to the living room, it is bourgeois art. It really is an art for art dealers which gained recognition after the bourgeois victory of the French Revolution. Now the time of the workers has arrived. Soon art will belong to everybody, and will have its place on the large walls of public buildings.'[98]

In a series of lithographs Munch represented people from his daily surroundings: *Girl and Youth in Poultry Yard* (Sch 372) 1912, *Young Farm Servant* (Sch 373), 1912, *Jensen with Duck* (Sch 378) 1912, *Girl from Skagen* (Sch 475) 1919/20, a young woman seated, washing her feet after working in the fields (Sch 482) 1920, and finally a laughing, strapping peasant girl (Sch 508) 1920. With swift easy strokes the artist presents simple country life, unconstrained, without pathos, in its natural dignity. These pictures hide no 'second reality', they do not peddle an abyss of mental torture. His changed

Plates 130, 131, 162, 165. 164

surroundings strongly impressed and deepened his imagery. He did not see a northern Tahiti in his rural environment, but the realisation of a harmonious and dignified existence for man in society.[99]

Side by side with the new themes which so clearly show the change in his outlook, old motifs remained important, and he dealt with them time and again, with the gnawing persistence that was so characteristic.

Groups of subjects whose inherent problems would appear to have already been solved reveal yet again the endless variety of Munch's imagery. Again

Plate 151 he painted pictures of anxiety and death. In *Dance of Death* (Sch 432) 1915, a skeleton stands next to the artist, a warning double of himself. The struggle with the demoniac powers of life continued. An inner conflict persisted between feelings of unity with nature on the one hand and a dread of life on the other, which is perhaps the reason why, next to pictures of anxiety. There are vistas full of inner harmony, quietness and grandeur.

In his paintings, landscapes, which had engaged him as a motif in their own right from the nineties onwards, gained significance. Early examples in

Plates 68, 69 graphics are *Large Snowscape* (Sch 118) 1898, and *Seascape* (Sch 125), of the following year. In *Snowscape*, a strong woodcut, he succeeded to perfection in reproducing the sad melancholy of the long Nordic winter night. The seascape seems like a counterpart, with the shimmering light of the moon on the water. These landscapes are full of stern grandeur and the suggestion of loneliness. He knew how to give an architectural effect even to the small area of a well tended garden surrounding an elegant villa, as in the etchings, *From the House*

Plates 94, 95 *of Max Linde*, made in 1902.

That he was able to convey this quality even to work on a small scale, is clearly shown by the enchanting little landscape, included in 1907 in the first

Plate 118 volume of Gustav Schiefler's *œuvre* catalogue (Sch 260). Its value lies equally in the sensitive and delicate handling of the drypoint technique and the depth of feeling expressed, making this miniature and unsigned work a graphic gem.

Woodcut landscapes are characteristic of the artist's later period, for example *Cliffs by the Sea* (Sch 389) 1912, and *The House on the Coast* (Sch 441) of 1915. Comparing these two works with those of 1898/99 the inner change becomes obvious once again. If the earlier woodcuts represent nature mainly as a means of reflecting emotions, these later ones show it for its own sake. The impressiveness of the Norwegian scene's geological formations is treated in the grand manner without over-emphasis on detail.

Plates 140, 141

Erotic motifs, too, are quite common. In 1913 the artist made a series of drypoints representing love scenes which form a complete group, and could have easily been joined in a cycle. To these belong *Two People* (Sch 398), *The Cat* (Sch 397), *The Bite* (Sch 396), *The Secret* (Sch 403), and *Ashes* (Sch 400). These etchings are related to earlier motifs, particularly so *Ashes*, others are entirely new, and this mood displays again the power of Eros, the passion of love. His new approach is contemplative and more relaxed, the tormenting images of Eros being replaced by calmness and submission. While these images do not conceal the problems involved in his sexual relationships, they are evidence of a more positive attitude towards them.

Plates 135, 138, 137, 136, 139

After the etchings he returned to the woodcut two years later, and worked a few erotic motifs in this technique. One of them is *Lovers in a Pine Wood* (Sch 442). The black of the untouched wood-block areas reproduces the dark of night, while in contrast there are the deftly cut faces of the couple, the woman's body, and the background. For the rest there are outlines only. The almost enforced simplicity of the technique is in strange contrast to the delicacy with which the scene has been contrived. Still more impressive is *Kiss on the Hair* (Sch 443). This woodcut has the magical effect of an icon. It is concise, stern in composition, with the girl's face seen from the front and her hair falling down on her shoulders. The man's head is shown in profile. The figures appear as dark silhouettes, covered by a transparent, abstract pattern of white lines. The erotic has become spiritual in this deepened concept which

Plate 142

Plate 143

he seemed to have brought to perfection originally in 1897 in the woodcut,

Plate 67 *The Kiss.*

Plate 183 A woman's portrait made in 1931 is among the last woodcuts. This picture of Birgitte Prestö (MS 703), is of proud grace and natural distinction, confirming once more the artist's changed attitude to women. The age of the vampires is gone. The picture has portrait-like features, and the model is known to us from other works of the period. It appears, however, that he wanted to give more than an individual portrait. Rather had he a general impression of Woman in mind, and that is why he called the woodcut *The Gothic Girl.* This portrait of a woman, almost half length, appears tall and monumental. The contours are tersely drawn, the eyes clear and poignant, the brows, nose and mouth carefully shaped. An almost unreal web of white lines in which the vertical dominates, covers face, neck and the low-cut dress. This is the portrait of a woman who has gone through life, knowing its joys and sorrows. Upright she faces the future. Wasn't this the very situation in which the artist now found himself?

Posthumous examination of his work shows that Munch's graphics to all intents and purposes ended in the early thirties. Yet, after an interval of ten years spent in painting, he made a few more graphic works. They were concepts of long ago, begun early, and pressing for completion. In content two pictures seem to have risen from the well of memory, visions and faces from

Plate 185 the past. A woodcut, dated 1943, *Spider's Web* (MS 706) shows a plump repugnant woman–the spider–crouching, while in the fine meshes of the web several male figures have been caught, desperately struggling to escape. Others dangle, drained to skeletons. Once again, in a ghostly light, the vision of Woman as a vampire, as Salome, reappears.

Illus. 60 His last graphic work, a lithograph, is a haunting portrait of his friend from younger days, Hans Jäger. This writer had greatly influenced Munch some thirty years before. Memories of the stirring days of the Christiania-Bohemian

95

60
Portrait Hans Jäger III
1943
Lithograph

circle, where so many of his friends were to be found, nearly sixty years earlier, and particulary of this friend, must have induced him to make this portrait.

Portraits and Self-Portraits

His extraordinary perception of the psychological made Munch an excellent painter of portraits. His overwhelming desire to see the essence of a person drove him to this particular art form. 'When I meet a new face, I constantly ask myself: what sort of a person is this? I have no peace until I have painted him.'[100] This remark is characteristic not only of him as a portrait painter, but of his conviction that unless he painted people and things, they had no real existence. He nearly always portrayed people who fascinated him or to whom he felt personally close. He seldom accepted portrait commissions. There were times when he felt the spontaneous need to draw or paint the person opposite him.'When we rose from the table,' wrote Hermann Schlittgen, 'Munch said suddenly: "This is how I have to paint you, life-size, as gay as you are now." '[101] Alternatively he could produce a copperplate and hurriedly scratch a portrait with a firm hand. The sitter did not always find himself portrayed as he saw himself.Munch saw more than the external features, and groping more deeply he tried to establish his sitter's character in all its individuality.[102]

Seen purely from a biographical point of view, his portraits mark the steady extension of his relationships with the world around him. He found his first models in his own family: his father, his young aunt, Karen Bjølstad, and his sisters, Inger and Laura. He painted good friends, his fellows from the Christiania-Bohemians, Hans Jäger, Sigbjørn Obstfelder. In the roving years that followed, in Berlin and Paris, this circle became bigger. Portraits were made of Knut Hamsun, Graf Kessler, Gunnar Heiberg, August Strindberg, Stéphane Mallarmé, Helge Rode, Stanislaw Przybyszewski, Holger Drachmann, Henrik Ibsen, Walter Leistikow, Henry van de Velde, Friedrich Nietzsche, Emanuel Goldstein, Tor Hedberg, and others. Numerous portraits of poets and writers indicate his close ties with literary circles. Another group consists of portraits of his patrons: Dr. Max Asch, Dr. Max Linde, Walter Rathenau, and Gustav Schiefler, of Hamburg, who published the *œuvre* catalogue and possessed the most important private collection of Munch's graphics. There are,

Plate 181

Plates 6, 18, 19

Plates 26, 50, 49, 48, 61, 91, 77, 90, 113

Illus. 28

Plate 122

Plates 27, 92

too, people from museums, Jens Thiis and Ludwig Justi, for example,[103] who through acquisitions, publications and exhibitions, furthered his work. The mysterious figure of Albert Kollmann must not be forgotten. He had early appreciated Munch's art and somehow knew when to turn up with a hundred marks to save the down-and-out artist. He made contacts for him with important patrons.[104]

Plate 177

Plate 112

Portraits of women, particularly in his graphic work, are more numerous than those of men. We frequently find models, for example, *Berlin Girl* (Sch 253), whom he also used for a nude study, which may be seen in a preparatory sketch for a larger portrait. Repeatedly he painted or drew the wives of men he met or became friendly with. There are the portraits of Mrs. Linde, Mrs. Schiefler, and Mrs. Gierløff. The respect and esteem expressed in Mrs. Linde's portraits show that even at a time when he seemed to be hag-ridden by the demoniac character of women, he was able to paint these uncomplicated pictures. Some of this work again marks special and personal ties. The admiration he had for the spirited Dagny Juell has already been mentioned. Apart from direct portraits, he also represented her in pictures on a general subject, as in the lithograph *Conception* (Sch 33). There was, however, a personal note in this. It carries a hidden declaration of love, as does the later portrait of Eva Mudocci, with the subtitle *Madonna* (Sch 212). In the late twenties the portrait of Birgitte Prestö (MS 703) became a sort of *leit-motiv* of his changed and detached attitude. The personal likeness has certainly taken second place to the overall restrained beauty of the picture. This is not an individual portrait but rather the mature artist's homage to a certain type of woman.

Plate 116

Plate 93

Plate 31

Plate 102

Plate 183

Munch's portraits demonstrate his rich and varied means of expression. The bold draughtsmanship alone is often surprising. In contrast to the big group of painted full figure portraits, there are very few in the more intimate medium of graphics. One example is the lithograph, *Frau Marie Linde*

(Sch 192) of 1902. Even half figures are comparatively rare, often just part of the shoulder has been sketched in, or all attention is concentrated on the head, either from the front or in profile. He seized on the essential features, ignoring all secondary details. He considered the eyes very important. We remember him describing how Omega's eyes altered colour with changing moods. The curve of the brows, the nose, the lines of the mouth, the outline of the head in general, all received careful treatment. He believed that in a portrait it was necessary to go to the frontiers of caricature. It is interesting from this point of view to compare the portrait of the writer Emanuel Goldstein (Sch 276) with the *Head of a Tiger* (Sch 288). When in drypoint, his work is remarkable for its delicate strokes and astonishing sensitivity. It is obvious that he did not aim at cool representation but at the truth, the fascinating human encounter.

Plate 122 and Plate 127 appear in the left margin beside the paragraph above.

His portraiture developed over the years to an ever increasing mastery. Looking at the later lithographed work one is struck by the casual, yet sure, way in which he handles his crayons. Several examples show how a head was first sketched in by its characteristic outlines, to be elaborated later. At times the artist used the full crayon rather than the point, to draw generous wide areas. But never is there technique for technique's sake. He is interested in it only as a means of artistic expression.

His work is to a large extent self-portrayal, not in the sense of an egocentric monologue, but rather as a way of trying to find the general through the personal, so that no self portrait is exactly like another. We see him young, self-assured and proud, meditative, worried, searching, full of self-contempt, grim, unstable, sick, convalescent and defiant. We get a clear picture of him as an actor in the incomprehensible puzzle of existence, commenting on himself at every stage of his life.[105] It is a strange phenomenon that many self-portraits are frequently found among artists whose work was so deeply involved in the problems of their day that the personal had to take second place. Dürer, Rembrandt and in modern art Gauguin, van Gogh, Beckmann and Käthe Koll-

witz are examples. Hence, the self-portraits, while representing phases of the artist's life, have also become documents of their period; they represent part of the artists' individual approach to the contemporary problems of their own society. Placed side by side for comparison they reflect the changing tides of life, a growing understanding, together with alternating moods of rebellion and surrender, of despair and self-conquest.

Taken alone, Munch's graphic self-portraits convey only an incomplete impression. It is necessary to consider the painted ones as well. It has been suggested but not proved that portraits in the graphic medium, produced in many copies, and therefore meant for public circulation, were, so to speak, 'licensed' by the artist, while the painted ones which he kept and only occasionally showed to visitors, were truer pictures of himself. In both these categories we come across idealised, or at least stylised, portraits as well as more stringent and less restrained ones, some being documents of bitterness and self-contempt. A number of painted self-portraits, revealing certain psychological states, have no counterparts in the artist's graphic work. Before 1895 and after 1934 there are no graphic self-portraits at all.

Looking at all the self-portraits, we must distinguish between the ones made deliberately as such and the 'latent' ones, as Gotthard Jedlicka has called them. A fairly large number of these is hidden in his graphics, sometimes obvious, sometimes only hinting at his own features. 'We might suspect in every couple, in every man who embraces or is embraced, a self-portrait of Munch; more than any other artist has he created works expressing this very experience with great psychological frankness, showing the impact of the experience in his own features,' wrote Jedlicka.[106] This can be demonstrated in many cases. The phenomenon of self-identification has a certain naivety, and is yet deeply moving. It shows the demoniac hold of Eros, whilst revealing the artist as a doctor watching his own psychical and physical response to a self-imposed trial, the consequences of which are as yet unknown. The self-portraits

61
Self-Caricature
C. 1927
Line block
from a drawing

Plate 1

reveal clearly his relation to death. The first self-portrait in graphics, a litho-
graph of 1895 (Sch 31) shows him at the age of thirty-two. In front of a velvety
dark background, is his head and at the lower edge of the picture, an ominous
skeleton-like forearm. At the period of this picture–it was made in Paris–he
encountered Symbolism in literature. But he did not see death as a literary
concept, rather was it a real threat and an incomprehensible power. The

Plate 103

double-portrait with Eva Mudocci (*Salome* Sch 213) has been mentioned already
for its deeper meaning. In two vignettes which he drew for the first volume of

Illus. 62

his *œuvre* catalogue, published in 1907, his portrait appears again, together
with the head of a woman. In the large vignette on the title page this motif is
surrounded by a strange hybrid creature, half fish, half snake, without doubt
an erotic symbol. In 1906 he was in Weimar and through Graf Harry Kessler
he became drawn into a circle of distinguished intellectuals. He painted himself
however, sitting solitarily in a restaurant. The room, in violent foreshortening,
stretches into depth, with a peculiar sense of threat. In the background are two
black-clad figures. The composition is similar to *The Shriek* and there are
parallels in the psychological situation. These are the years before the crisis,
and the self-portrait tells much of his disturbed state. An adaptation, a litho-

Plate 174

graph of 1925/26 (MS 492), some twenty years later, confirms that this self-
portrait was very important to him.

Plate 52
Plate 53

About 1906/08 he made a woodcut self-portrait (MS 697) which in motif
might be compared to the coloured woodcut *Moonlight* (Sch 81). Both works
represent a figure at the edge of the picture, looming phantom-like against the
moon-lit scene. The lightest parts, face, shoulders, the upper part of the arm
and the coat lapels, have been energetically cut. In contrast to this are the
fine sensitive scratched-out white lines on the right and left. A mysterious
atmosphere is given to the picture by a tall threatening shadow.

Plate 123

The *Self-portrait with Cigarette* (Sch 282), of 1908/09 shows the artist
relaxed, leaning back, surrounded by the harmonious lines of cigarette smoke.

62
Seventeen Vignettes for
G. Schiefler,
Edvard Munch.
Das graphische Werk.
C. 1927

All this has been sketched with fresh, lively strokes, and the face treated more carefully. This portrait belongs to the pictures of 'healing' which he often made in the years following when convalescing. From 1911 to 1915 he made four self-portraits in woodcut and lithography, his head clear, distinct and

Plate 134 close-up in the composition. The woodcut of 1911 (Sch 352) is the best known. The self-portrait in *Evening Conversation in Hvitsten* (Sch 353), a woodcut of 1911, also shows his newly gained stability and calmness. It was made at Ramme in Hvitsten on the Oslo Fjord, a property he had bought in 1910. He is seen, in the picture, talking to a friend, 'When we sat at night, the lamp lit, Munch got out a wood block, and cut a mirror image of our little group.'[107] The grouping was conveyed by the artist with only a few cuts carved in the wood, the outlines of which appeared white when printed. In 1915, during the

Plate 151 First World War, in the lithograph, *Dance of Death* (Sch 432), conversation with the friend is changed to conversation with death. The figures are close as if about to embrace.

In 1919 the Spanish influenza swept Europe, claiming many victims, particularly in the countries weakened by the war. Munch, too, was attacked by the illness. We only learn about it in his work when he had thrown off the disease. *After the Spanish Influenza*, is a well known painted self-portrait which shows the artist in an easy chair, wasted and feeble, barely having

Plate 175 escaped death. Possibly a lithograph (Sch 503), of 1920, is also related to this period of convalescence. Serious, marked by illness and age, the artist looks out from the picture.

Some of his pen sketches appear to be gay intermezzos. They turn up at the end of a letter to a friend, or are used as line blocks for the second volume of Schiefler's *œuvre* catalogue, published in 1927. These self-caricatures are most touching in their humanity. They show the artist spending Christmas alone,

Illus. 64, 63, 61 with the dogs, Truls and Tips,[108] or as he struggles with a mountain of papers.[109] Are they drawings or pulls which lie there in their thousands, or are

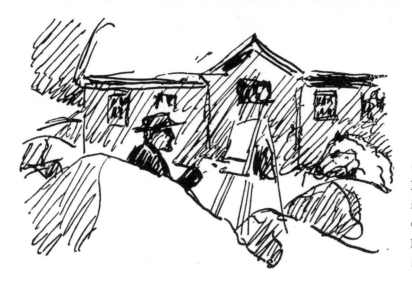

63
Munch at the Easel
in the Snow
C. 1927
Line block
from a drawing

they the many letters he does not read and never answers, and which yet disturb his peace of mind? Then there is the picture of the artist,[110] stamping through thick snow in his open air studio, working unflaggingly and at all seasons at the pictures which have gradually taken possession of his whole life.

And the shadows remain. In 1930 he drew himself in a lithograph (MS 551), lying dead before the anatomist, Professor Schreiner, a grotesque metamorphosis of the Salome–Marat motif. Another lithograph, *Professor Schreiner as Hamlet* (MS 549) is closely related, even if the dead body shows Munch's features less clearly. Professor Schreiner holds a skull in his hand, something quite natural to an anatomist, so that it remains questionable whether the literary title of 'as Hamlet' was really given to the picture by Munch. All the same, it does contain the question of 'to be or not to be', if on quite a different level.[111]

Plate 179

An old photograph shows Munch standing in front of his picture, *The Mountain of Men*, which he had fixed in parts on large wooden boards. He put himself before this monumental painting in a symbolic self-portrait, as a sphinx with a woman's breasts, a picture full of hidden meaning, suggesting the secret and puzzle of life itself.[112]

In the illustrations, made after about 1920, to Ibsen's *The Pretenders*, which occupied Munch for a long time, the figure of *King Skule* (MS 669), who tragically loses his life, is most likely to be a cryptic self-portrait and again a symbolic identification. More relaxed, freer, even if sceptical, he appears in a lithograph of 1932. In its easy drawing technique this *Self-portrait with Hat* (MS 456), is reminiscent of Max Liebermann's self-portraits.

Plate 173

Plate 176

The last self-portrait in graphics is obviously a hectograph (MS 732). It represents, full face, the man of seventy, loosely drawn, as he saw himself in the mirror, through his oval spectacles. It is a very plain, intimate portrait of the old artist which, at times, he gave to his friends with a dedication.

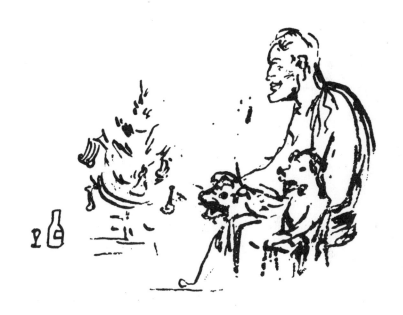

[Handwritten letter in German, largely illegible]

Lieber Herr Professor

— Vielen Danke für Glückwünsche
zu meinem 61 Geburtstag
— Wünsche Ihnen verlangt
durch die Karte Ihnen und
Frau Gemahlin unglücksel Neujahrswünsche
— Ein Brief schicke ich Ihnen
beifolgd —
Ihr Edvard Munch

64
Letter to
Julius Meier-Graefe,
with drawing
(Self-Portrait,
Christmas 1924)

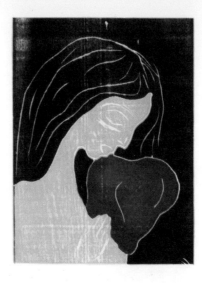

65
The Heart
1899
Coloured Woodcut

In his later years Munch devoted himself solely to painting. One of these later works, *Between Clock and Bed*, of 1940, again shows him after an illness, debilitated and weak, but resolved not to give up, to his last breath pledged to life.

Work and Impact

Only after Munch's death in 1944, when his work was examined and put into order in the deserted house at Ekely, was the full range of his artistic legacy discovered. Devoted solely to his work the artist had lived frugally in this house. 'The inside had a strange appearance and did not seem like any other ordinary mortal's house. Munch had lived in a few sparsely furnished rooms, looking as if he had never got properly settled, and was a temporary visitor only–a roving artist, always on the move . . . In the upper storey of the main building, in rooms which had obviously not been lived in for many years, masses of graphic pulls lay in piles, thousands upon thousands of his etchings, lithographs and woodcuts. Earlier on an attempt had been made to put them into some sort of order, but this was given up long ago. Large piles of print lay covered in dust and neglected, many others were strewn on the ground. Much precious work was ruined by dust, dampness and sunlight. In one of these rooms he had set up his hand press. This had originally been an old fashioned kitchen, a cheerless place which had served the artist as workshop. Everything pointed to the fact that Munch thought comfort at his work quite unimportant, and that it did not further his creativeness.'[113]

Now the graphic work could be surveyed. There were more than seven hundred single works. But the volume of all this, impressive as it may be, does not indicate its significance. This lies in its actual content. 'His graphic art is like a range of sheets from a diary, depicting not so much the outward events of his life as the inner ones.'[114] Many of the prints are of an intimate nature, very personal statements. Yet the personal also becomes general because of Munch's intensity and concentration of form. His own emotions and experiences only exist for him in the far wider context of society itself.

He revolutionised technique and forms of graphics, less in the sense of a further development or refinement than in his efforts at regenerating the technique, simplifying it, and giving it back its original elements: line, field and structure. His woodcut technique is reminiscent of the primitive forceful

ways of the woodcut's beginnings—'*retour à la bonne xylographie allemande*', as L. A. Lepère wrote, when in 1893/94 he left the scauper for the old fashioned knife.[115] Munch mastered to perfection the techniques of etching and lithography, and handled the drypoint with a sensitivity which can hardly be surpassed. His work pioneered a new expressive style which was developed further in the graphics of Expressionism.

In his art varied and diverse experiences find most powerful expression. In analysing his work, going back, for example, to the source of a particular inspiration, we may uncover the psychological and social background. For the understanding of his art there then emerge these important points: he tried to convey a picture of life as he saw it, and as he felt about it, sincere, true and independent from the taboos of the hypocritical morals of his time. Our historic distance enables us to define the merely topical and to see that the restless nineties of the last century, when Munch's creative activity was at its height, doubtlessly influenced his dualistic attitude. This was a period that had become uncertain of its values, and its disturbing alternation between hope and despair, commitment and negation, tormented him. *The Mountain of Life* is a symbol of this position. Will men fight their way to the light, or will they falter?

In the fifth decade of his life when he returned to Norway, his work shows an increasingly positive attitude. He begins to see life with greater detachment, culminating in the pictures for the Oslo University Assembly Hall. In this inner change, indicating a personal victory over anxiety, the artist's human stature is most clearly shown.

All the phases of his long life are essentially filled with the question of sense and values in human existence, even if the answer looked different at different stages. This question alone, put seriously and without reserve, prove the deep human concern of the artist.

His work has had a lasting effect on his contemporaries and on posterity.

It played an essential part in the development of modern art in general, and graphics in particular; a medium in which he was a pioneer. It was, however, not the perfection of form after which he strove constantly, but the rediscovery of man's soul. His passionate turning towards human destiny is the final criterion of his work.

Text Notes

1 'During the last twenty years Norway has seen a literary upsurge, an evolution, equalled only in Russia at that time,' Friedrich Engels wrote to Paul Ernst in 1890, when discussing the general social developments in Norway. '... the Norwegian peasant was never in bondage ... The Norwegian small citizen is the son of a free peasant, and due to this he is an upright man compared to the degenerate German philistine. And whatever may be the faults of Ibsen's plays, for example, they do reflect a narrow middle-class world, yet a world miles removed from the German one, because the people have character and initiative, and act independently, even if strangely, judged by outside standards.'
Berliner Volksblatt 5. 10. 1890
Compare: Marx–Engels, *Werke*. Berlin 1963. Vol 22 pp 81–82

2 Stenersen, R. Edvard Munch. Stockholm. Frankfurt a.M. Zürich 1950 p 12

3 Hodin, J. P. Edvard Munch. Stockholm 1948 p 34

4 Langaard, J. H. and Revold, R. Edvard Munch. *Meisterwerke aus der Sammlung des Künstlers im Munch-Museum in Oslo*. Stuttgart 1963 (Langaard V) p 6

5 Langaard op cit p 50

6 Ingrid Langaard, Edvard Munch. Modningsår. Oslo 1960. pp 275–76 suggests that Munch may have experimented with graphics before 1894.

7 Schiefler, G. *Verzeichnis des graphischen Werks Edvard Munchs bis 1906*. Berlin 1907. (Schiefler I) pp 20–21
Compare also: Hodin op cit p 93

8 Sarvig, O. Edvard Munch. *Graphik*. Zürich/Stuttgart 1965 p 22; Hermann Struck, *Die Kunst des Radierens*. Berlin 1908

9 Probably the lithographs *Madonna* (Sch 33) and *The Shriek* (Sch 32) which are dated as 1895 by Schiefler, were made in 1894. Ingrid Langaard op cit p 276, quotes a letter from Dagny Przybyszewska of 1894, mentioning these two works as lithographs.

10 Toulouse-Lautrec made his first coloured lithograph in 1892. Munch owned the cycle *Elles*, published in 1896.

11 Quoted: E. Büttner: in Thiis, J., Edvard Munch. Berlin 1934 (Thiis II) p 92

12 Glaser, G. *Die Graphik der Neuzeit*. Berlin 1922. p 292

13 Compare: Winkler, F., *Die graphischen Künste*, in: *Das Atlantisbuch der Kunst*. Zürich 1953. p 170: 'Paul Gauguin ... seems to have become in the eighties the originator of a broad treatment in the graphic arts.' Compare also: Sýkorová, L. Paul Gauguin, *Unbekannte Holzschnitte*. Prague 1963
Buchheim, L. G. (*Die Künstlergemeinschaft Brücke*. Feldafing 1956 p 76) writes: 'The originator of the broad treatment in the woodcut is Gauguin, who brought back from his first journey to Tahiti (1893) his highly individual woodcuts, pasted into his travel diary *Noa-Noa*.' Munch saw these in Paris in 1895.

14 Compare: Pissarro, C. *Briefe an seinen Sohn Lucien*, ed. J. Revald. Erlenbach–Zürich 1953. p 248. In Berlin Emil Orlik experimented with woodcuts in 1897, obviously stimulated by Nicholson. In 1900 Orlik went to Japan to study there in detail the technique of the Japanese woodcut.

15 Thiis op cit p 100

16 Compare: Exhibition catalogue: Edvard Munch, *Zeichnungen und Graphik aus dem Munch-Museum in Olso*. Albertina, Vienna. Nov–Dec 1966. Nos 155/56. The original plates, stones and wood-blocks of sixteen graphic works were shown in this exhibition for the first time.

17 H. Fehr about a visit in 1928, in: *Neue Zürcher Zeitung*, 8. 2. 1944. The second volume of the *œuvre* catalogue was published in 1927.

18 These statements are based on Schiefler's *œuvre* catalogue which lists Munch's graphics up to 1926. The comparatively small number of prints of this period, not

included in this catalogue, has not been taken into account. According to I. Langaard op cit (compare notes: 6) ten works were made in 1894, and twenty-seven in the following year.

19 Compare: Hamann, R. *Geschichte der Kunst.* Berlin 1933 pp 860–61: 'Max Klinger's art, important at the time, is now completely passé, not only alien to us, but completely out of date . . . He remains rooted in the Naturalism of the nineteenth century . . . He does not make the trivial mysterious, but the mystical trivial. With Munch, expression and mystique become more subjective and constructive, appearing mystical and stylised through simplification, and a terse confrontation of life and death, illness and compassion, mother and child.'

20 Kühn, P. Max Klinger. Leipzig 1907. p 128

21 Compare: Singer, H. W. *Max Klingers Radierungen, Stiche und Steindrucke.* Berlin 1909

22 Compare: Svenaeus, G. *Idé och innehåll i Edvard Munchs konst.* Olso 1953. pp 24–25

23 Hodin op cit p 52

24 Compare: Exsteens, M. *L'Œuvre gravé et lithographié de Félicien Rops.* Paris 1928. Nos 432, 429, 428. Munch's first painted version of *Puberty* was made as early as 1885.

25 Langaard op cit pp 51–52

26 Stenersen op cit p 85: 'I have no other children than my pictures. To be able to paint I must keep them near me. Only when I see them, can I create something new.'

27 Langaard op cit p 50

28 Stenersen op cit p 59
Darwin's theory of which this is reminiscent, was much discussed in the eighties and nineties of the last century, above all the problem of inheritance and degeneration. This was reflected in the literature of the period, for example: Hermann Bang's *Hoffnungslose Geschlechter* (1893), and Alexander Kielland's *Gift* (1882).
In Ibsen's '*Ghosts*' (1881) the painter Oswald fails, 'damaged from birth'. With Munch the lithograph–from a painting of 1897–99–*The Inheritance*, is proof how much this problem exercised him.

29 *Der neue Standpunkt* (1916). Dresden 1957 p 78. Przybyszewski (1894) and Edouard Gérard, the critic (1897) compared Munch with Maeterlinck.

30 Langaard V op cit p 62

31 Schiefler I op cit p 12; Benesch, O. Edvard Munch. Cologne 1960 p 16; Moen, A, Edvard Munch. *Seine Zeit und sein Milieu.* Munich 1957 (Moen I) p 24; Stenersen op cit p 109; Hodin op cit p 97

32 Svenaeus op cit

33 Stenersen op cit p 97

34 Obstfelder, S. *Pilgerfahrten* Stuttgart 1905 p 122

35 Langaard V op cit p 39 Munch fell ill on 19 December 1943, and died on 23 January 1944. According to Langaard's statement this lithograph is supposed to have been made in 1944, though generally–also by Langaard in another statement (Langaard IV p 62)–it is dated 1943.

36 Stenersen op cit p 109. Sigbjørn Obstfelder's *Digte* appeared in 1893. The poem mentioned is the following:
'I stare at the white sky
I stare at the grey-blue clouds
And the blood-red sun
This then is the world
This the clouds' home

A raindrop!
I stare at the high houses
I stare at the thousand windows
And the distant spire
This then is the earth
This man's home
The grey-blue clouds are gathering. The sun has vanished.
I stare at the well-dressed gentlemen
I stare at the smiling ladies
And the nodding horses
How heavy the grey-blue clouds have become.
I stare and stare . . .
Surely I have come to the wrong world
It is so strange here . . .

37 Stenersen op cit p 20
38 Compare: *Berliner Tageblatt* 15. 4. 1927
39 Däubler, T. *Der neue Standpunkt* op cit pp 71/86. References to Munch's work are met with in quite unexpected places. In Hans Henny Jahnn's novel *Perrudja* (1929) there is a passage: 'There was an engraving by the same master, with spermatozoa surrounding the picture the subject of which was love. They ended in a skeleton leg.'
40 *Revue Blanche* 1. 6. 1896
41 Dauthendey, M. *Gedankengut aus meinen Wanderjahren* Munich 1913 p 250
42 Quoted: E. Büttner; in Thiis II op cit p 94
43 Göpel, E. Edvard Munch. *Selbstbildnisse und Dokumente*. Munich 1955 p 29
44 Ibsen's work met with a strong response in Berlin, described by Stephan Grossmann in: *Gurlitt-Almanach auf das Jahr 1919*, Berlin 1918. p 99: 'Berlin was Ibsen's capital. From here he conquered the world. . . . at the turn of the century he was the most read author in Berlin, and also the one people modelled their lives on. Those who were unable to develop their own personality, copied characters from Ibsen's plays.'
45 Langaard V op cit pp 54–55
46 *Berliner Tageblatt* 28. 10. 1926
47 Stenersen op cit p 109, quotes Munch's statement differently: '*Rosmersholm* is the greatest winter landscape . . .', and Sarvig, too, p 265 and illustration on p 279, calls the lithograph *Starry Night* an illustration for *Rosmersholm*. This, however, seems to be a mistake, as the action of *Rosmersholm* takes place in summer. Also other details point to the lithograph depicting the final scene of *John Gabriel Borkman*. The work has been correctly described in the auction catalogue of Gutekunst und Klipstein, *Auktion* 82, 1956. No. 280. Schiefler (Sch 266), Sarvig (p 306), Langaard II (p 72) name further illustrations to *Ghosts*. Finally there are several designs for Ibsen's play '*Hedda Gabler*' and twelve illustrations for '*Peer Gynt*' (ca. 1920) in the Munch-Museum in Oslo. Compare: exhibition catalogue Edvard Munch. Stavanger Kunstforening 1967, Nos 135, 148–150, 162–173.
48 Stenersen op cit p 142
49 *Edvard Munchs Tresnitt, Utstilling 1946 Nasjonalgalleriet Oslo* Nos 81, 89–97, 101, 139.
50 Langaard V op cit pp 49–50
51 Thiis II op cit p 49
52 Munch repeatedly planned a comprehensive edition. G. Schiefler, who visited Munch in 1908 in Warnemünde, has this to say (Sch IV): 'We made plans for the publication of his works: the large lithographs and woodcuts were to be printed on

precious paper, and collected in a folder, issued as a kind of graphic frieze of life.'

53 In this respect Munch's work is of great significance, a parallel to that of Sigmund Freud, the founder of psychoanalysis, whose basic work was done in the nineties of the last century. M. S. Glasscheib, in his book *Das Labyrinth der Medizin*, Reinbeck near Hamburg 1961 pp 335–36, writes about Freud–and up to a point this also applies to Munch: 'Hardly anyone during the last centuries has brought about such fundamental changes in the soul of man merely by the power of his intellect, than this brave explorer. Alone, one against all, he forced man to take a closer look at himself. He taught him to recognise those powerful drives of sex which keep the world going. With unrelenting determination he examined the different levels of personality, and laid bare the ugly sides of human nature, revealing weakness and mendacity, and throwing light into the abyss of sex, which frightened him as much as he frightened the world with his discoveries.'

54 from the poem: 'Es seufzen alle Geschöpfe'.

55 *Das Werk des Edvard Munch*. Berlin 1894 pp 37 and 39

56 '. . . isolated in silent loneliness man and woman stand next to each other,' Max Huggler wrote in the exhibition catalogue Edvard Munch. *Kunstmuseum*, Berne 1958 p 10

57 Schiefler I op cit p 17

58 Stenersen op cit p 67

59 Paul, A. *Strindberg-Erinnerungen und -Briefe*. Munich 1924 p 185

60 Stenersen op cit p 28

61 *Das Werk des Edvard Munch* op cit p 19

62 Stenersen op cit p 77 The etching mentioned earlier, *Dead Lovers*, 'may be seen as Munch's reaction to the news of the death of Dagny Juell Przybyszewska in Odessa. She had been murdered by her lover, Wladyslaw Emeryk who, not long after, on 23. 5. 1901, committed suicide.' Paul Hougen in the Edvard Munch *Catalogue of Drawings*, Kunsthalle Bremen 1970, Cat. No. 96.

63 *Das Werk des Edvard Munch* op cit p 40

64 Bebel, A. *Die Frau in der Vergangenheit, Gegenwart und Zukunft*. Zürich 1883 Introduction p 1 (First edition 1879)

65 Compare: Bonus-Jeep, B. *Sechzig Jahre Freundschaft mit Käthe Kollwitz*. Berlin 1967 p 253. In 1893, under the influence of the first performance of Max Halbe's play *Jugend*, Käthe Kollwitz made the etching *Junges Paar*, in concept very close to Munch's work.

66 *Das Werk des Edvard Munch* op cit p 16

67 *Edvard Munch in Berlin* in: *Berliner Tageblatt* 15. 4. 1927. J. Meier-Graefe interpreted this motif in a brilliant essay in 1894: *Das Werk des Edvard Munch* op cit pp 77–87

68 This motif, too, is earlier found with Klinger, in the etching *Gefesselt* (S. 137) of 1884. It represents men in evening dress and opera hats, standing round a naked woman.

69 Schiefler I op cit No 122

70 *Revue Blanche* 1. 6. 1896
Gauguin, P. Edvard Munch. Oslo 1933 p 155. Benesch op cit p 28 characterises the *Three Stages of Woman*, as virgin, courtesan and mother, the longing, the proud in season, the burnt out. According to Benesch, Munch's representation inspired Egon Schiele's picture *The three Mothers*

71 Heine, H. *Gesammelte Werke*. Berlin 1951 Vol 2 p 356 'Zum Lazarus'

72 Schiefler I op cit p 48

73 *Das Werk des Edvard Munch* op cit p 22 Przybyszewski describes a picture by Delville; similar to Munch's: 'By the hips he is embraced by a she-devil whose body is an enormous phallic symbol.' With the self-portrait (MS 697) Ole Sarvig op cit

(p 289) interprets the shadow behind Munch as 'the shadow of an enormous vagina'. It is doubtful whether this is a true interpretation, more likely Munch wished to hint symbolically–as he had done before–at man's inescapable fate.

74 Listed by Schiefler as 1909, but with the remark: 'The woodblock seems to have been made earlier, but printed later.' Most likely the block is closely related to one made in 1898 (Sch 109).

75 Hodin op cit p 105. Munch said to Schiefler (Schiefler, G. *Meine Graphik Sammlung* Hamburg 1927. Schiefler IV p 32) that he had wanted to draw a portrait of the violinist, Eva Mudocci, ... the first time the woman appeared as an angel (Sch 212), the second time as a demon (Sch 213), and only in the third attempt had he managed to do the portrait (Sch 211).

76 Schiefler I op cit No 223

77 We come across related imagery with James Ensor. In 1888 Ensor portrayed himself in his *Self-Portrait 1960*, as a skeleton, and in 1889 another self-portrait shows his head as a skull. Compare: Croquez, A. *L'œuvre gravé de James Ensor.* Geneva/Brussels 1947 Nos 13 and 67

78 Obstfelder, S. *Novellen und Skizzen* Berlin 1915

79 Kokoschka, O. *Der Expressionismus Edvard Munchs.* Vienna 1953 p 14

80 A pull of this work carries a note–in French–in Munch's own hand: 'Nature was as if coloured by blood, and men appeared like priests.' Compare: Schiefler I op cit No 62

81 Langaard, J. H. and Revold, *Edvard Munch som tegner.* Oslo 1958. Illustration No 27 (Langaard II)

82 Hofer, K. *Erinnerungen eines Malers.* Munich 1963 p 78

83 According to P. Hougen the woodcut represents groups of people in a street in Trondhjem. It was possibly meant as an illustration for Ibsen's *The Pretenders* (Act 5). Compare: *Exhibition catalogue, Edvard Munch.* Albertina, Vienna. op cit No 159

84 Hodin op cit p 102

85 Schiefler, G. Das graphische Werk 1906–1926. Berlin 1928 (Schiefler III) p 18

86 Hoffmann, E. Edvard Munch, in: *Neue Zürcher Zeitung* 14. 12. 1963

87 Hodin op cit p 51, under the title *Der Kritiker* (Rosencrantz Johnson, Morgenposten) 1911

88 Stenersen op cit p 16

89 Schiefler III op cit No 459

90 Compare: Huggler, M. *Die Überwindung der Lebensangst im Werk von Edvard Munch,* in: *Confinia Psychiatrica* I, 1958, No 1, also in: Exhibition catalogue Edvard Munch. *Kunstmuseum* Berne, 1958 pp 6–15

91 H. Fehr in: *Neue Zürcher Zeitung* 8. 2. 1944 (Description of a visit to Munch's in 1928) Munch even tried to make a sculpture of *The Mountain of Men* (compare: *Billedhugeren Edvard Munch*, in: Aftenposten, Oslo, 4. 3. 1944). The lithograph, made between 1916–1920, called *Towards the Light* (Sarvig op cit p 168), with a group of climbing people, also continues the motif. In the first state there towered an enormous mountain of men, similar to the one from which Zarathustra saw the light. The mountain was to be built up of the struggling, the beaten, the fallen, the decayed, and the ones who had made their way triumphantly towards the light. Compare: Benesch, O. *Hodler, Klimt und Munch als Monumentalmaler,* in: *Wallraf-Richartz Jahrbuch.* Vol. XXIV, Cologne 1962 pp 333–358.

92 Schiefler I op cit No 93

93 Langaard V op cit p 57

94 Langaard, J. H. and Revold, R. Edvard Munch. The University Murals, Graphic Art and Paintings. Oslo 1960 (Langaard III) p 32

95 Thiis II op cit p 71

96–98 Stenersen op cit p 141

99 Years before, Gauguin, too, had spoken about his intention to settle on the Norwegian coast. In a letter to his wife he says: 'Should it not be possible to rent a fisherman's house on the Norwegian coast where I could work, and where you could come with the children during all holidays?': Gauguin, P. *Mein Vater Paul Gauguin*, Munich 1960 p 133

100 Stenersen op cit p 119

101 Göpel op cit p 41

102 It is revealing for Munch's method of work to consider how Gustav Schiefler's portrait (Sch 238) was made. Schiefler, G. *Meine Graphik Sammlung* Hamburg 1927 p 32 (Schiefler IV) has this to say: 'Munch had several times expressed his intention of making a portrait etching of myself ... At Christmas 1905 he wrote to me, asking me to come, as he had now decided on the concept of his picture ... on 31 December, at noon, from twelve to one o'clock he scratched my portrait straight on to the copper, from nature.'

103 Munch made a drawing of Justi in Berlin in 1927. A photo, made during the sitting, is reproduced in the exhibition catalogue *Edvard Munch, Bezirksamt Tiergarten, Berlin, September/October 1959*

104 Ernst Barlach, equally helped by Kollmann, gives a brilliant account of this extraordinary man, in his *Konto Kollmann.*

105 Munch's self-portraits were first assembled in: *J. H. Langaard and R. Vaering, Edvard Munchs selvportretter.* Oslo 1947.

106 *Jedlicka, G. Über einige Selbstbildnisse von Edvard Munch,* in: *Wallraf-Richartz Jahrbuch.* Vol XX, Cologne 1958 pp 225–260.

107 The friend is Gustav Schiefler. Compare: Schiefler IV op cit p 36

108 Schiefler III op cit p 122. There is an only slightly different variation of this drawing on a letter to Julius Meier-Graefe 1924. Compare: *Klipstein und Kornfeld, Berne, Auktion 89, 1958. No 85.*

109 Schiefler III op cit p 29

110 Schiefler III op cit p 10

111 'To do a good portrait, it goes without saying, one must be able to see into the soul of the sitter. To do a good self-portrait, one must look into the ashes. Man builds on the ruins of his former selves. When we are reduced to nothingness, we come alive again. To season one's destiny with the dust of one's folly, that is the trick. In the ashes lie the ingredients for portrayal of self.' Miller, H. *Big Sur and the Oranges of Hieronymus Bosch.* London 1958

112 Langaard III op cit illustrations p 61 and 63

113 Willoch, S. *Edvard Munchs raderinger.* Oslo 1950, Introduction

114 Stenersen op cit p 148

115 Compare: Schiefler IV op cit p 5

Bibliography

Muller, H. B. *Edvard Munch. A Bibliography*. Oslo Kommunes Kunstsamlinger. Årbok 1946–1951 (covers 59 years of contributions, up to 1950) and supplements Årbok 1952–1959. Oslo 1960

Das Werk des Edvard Munch. *Four Contributions by S. Przybyszewski, F. Servaes, W. Pastor and J. Meier-Graefe. Edited by Przybyszewski*. Berlin 1894

Linde, M. *Edvard Munch und die Kunst der Zukunft*. Berlin 1902

Schiefler, G. *Verzeichnis des graphischen Werks Edvard Munchs bis 1906*. (Schiefler I) Berlin 1907

Glaser, C. *Edvard Munch*. Berlin 1917

Schiefler, G. *Edvard Munchs graphische Kunst*. (Schiefler II) Dresden 1923

Schiefler, G. *Edvard Munch. Das graphische Werk 1906–1926*. (Schiefler III) Berlin 1928

Schiefler, G. *Meine Graphik-Sammlung*. (Schiefler IV) Hamburg 1927

Gauguin, P. *Edvard Munch*. Oslo 1933

Thiis, J. *Edvard Munch og hans samtid*. (Thiis I) Oslo 1933

Thiis, J. *Edvard Munch*. (Thiis II) Berlin 1934

Langaard, J. H. and Vaering, R. *Edvard Munchs selvportretter*. (Langaard I) Oslo 1947

Hodin, J. P. *Edvard Munch*. Stockholm 1948

Edvard Munchs Brev. Familien. *Et utvalg ved Inger Munch*. (Oslo Kommunes Kunstsamlinger; Munch-Museet skrifter 1) Oslo 1949

Stenersen, R. *Edvard Munch*. Stockholm/Frankfurt a. M./Zürich 1950

Willoch, S. *Edvard Munchs raderinger*. Oslo 1950

Kokoschka, O. *Der Expressionismus Edvard Munchs*. Vienna 1953

Svenaeus, G. *Idé och innehåll i Edvard Munchs konst*. Oslo 1953

Urbanek, W. *Lebensfries. 46 Graphiken*. Munich 1954

Göpel, E. *Edvard Munch. Selbstbildnisse und Dokumente*. Munich 1955

Moen, A. *Edvard Munch. Seine Zeit und sein Milieu*. (Moen I) Munich 1957

Deknatel, F. B. *Edvard Munch*. Max Parrish, 1950

Digby, G. W. *Meaning & Symbol in three Modern Artists*. Faber & Faber *Artists: Edvard Munch, Henry Moore and Paul Nash*. 1955

Moen, A. *Edvard Munch, Woman and Eros*. (Moen II) Allen & Unwin, 1957

Moen, A. *Edvard Munch. Tier und Landschaft*. (Moen III) Munich 1959

Langaard, J. H. and Revold, R. *Edvard Munch som tegner*. (Langaard II) Oslo 1958

Langaard, J. H. and Revold, R. *Edvard Munch. The University Murals, Graphic Art and Paintings*. (Langaard III) Oslo 1960

Benesch, O. *Edvard Munch*. Phaidon Press, 1960

Langaard, I. *Edvard Munch. Modningsår*. Oslo 1960

Langaard, J. H. and Revold, R. *Fra år til år*. A year by year record of Edvard Munch's life. (Langaard IV) Oslo 1961

Langaard, J. H. and Revold, R. *Edvard Munch. Meisterwerke aus der Sammlung des Künstlers im Munch-Museum in Oslo*. (Langaard V) Stuttgart 1963

Greve, E. *Edvard Munch. Liv og verk i lys av tresnittene*. Oslo 1963

Sarvig, O. *Edvard Munch. Graphik*. Zürich/Stuttgart 1965

Timm, W. *Edvard Munch*. Graphik. Inselbücherei No 535 Leipzig 1966

1863 born on 12 December at Engelhaugen in Løten, Hedmark, Norway, son of Dr. Christian Munch.

1864 Move to Christiania (Oslo).

1868 Mother dies at the age of thirty-three. The mother's sister, Karen Bjølstad, takes care of the family.

1877 His sister, Sophie, aged fifteen, dies—like the mother—of tuberculosis.

1879 He takes up the study of engineering at the Technical High School but leaves in 1880, to become a painter.

1881–1884 He studies with Julius Middelthun, Christian Krohg and in Frits Thaulow's open air-academy in Modum.

1884 He joins the Christiania-Bohemians.

1885 Three weeks' stay in Paris. He starts work on *The Sick Girl, The Day after,* and *Puberty.*

1888 First stay at Åsgårdstrand, where he rents a house in 1889, thereafter to spend the summer there regularly. Scenes from Åsgårdstrand appear in many pictures.

1889 First exhibition in Christiania. Stay in Paris from October 1889 to May 1890. Attends Léon Bonnat's studio for four months.

1891–1892 Journeys to Paris and Nice.

1892 An exhibition in Berlin causes a scandal at the Berlin Artists' Union, and is closed after a week. After December of this year he was to spend much of his time in Berlin.

1894 First etchings and lithographs. Stanislaw Przybyszewski publishes the first work on the artist.

1895–1897 Stay in Paris. Julius Meier-Graefe publishes a folder of eight of his etchings in 1895.

1896 First woodcuts.

1899 Journey to Italy in the spring of that year.

1902 First stay with Dr. Linde in Lübeck. The contact was made by Albert Kollmann.

1900–1907 Lives mainly in Germany, but during the summer in Åsgårdstrand.

1908 After a nervous breakdown, in a Copenhagen clinic till May 1909.

1909 Return to Norway. He rents *Skrubben* in Kragerø. He begins working at the designs for the murals at Oslo University, and makes the cycle *Alpha and Omega.*

1910 He buys the property of *Ramme* in Hvitsten on the Oslo Fjord.

1913 He rents Grimsrød on the island of Jeløya.

1916 He buys *Ekely* in Skøyen which becomes his permanent residence until his death.

1922 Murals for the workers' canteen in the *Freia* chocolate factory in Oslo.

1930 Plans for the decoration of Oslo Town Hall. About 1930 end of his graphic work, with only a few late examples.

1937 Confiscation of eighty-two of his works in Germany which are branded 'degenerate' by the Nazis.

1944 He dies on 23 January at *Ekely.* In his will he leaves 1008 paintings, 15391 prints and 4443 drawings to the city of Oslo.

Plates

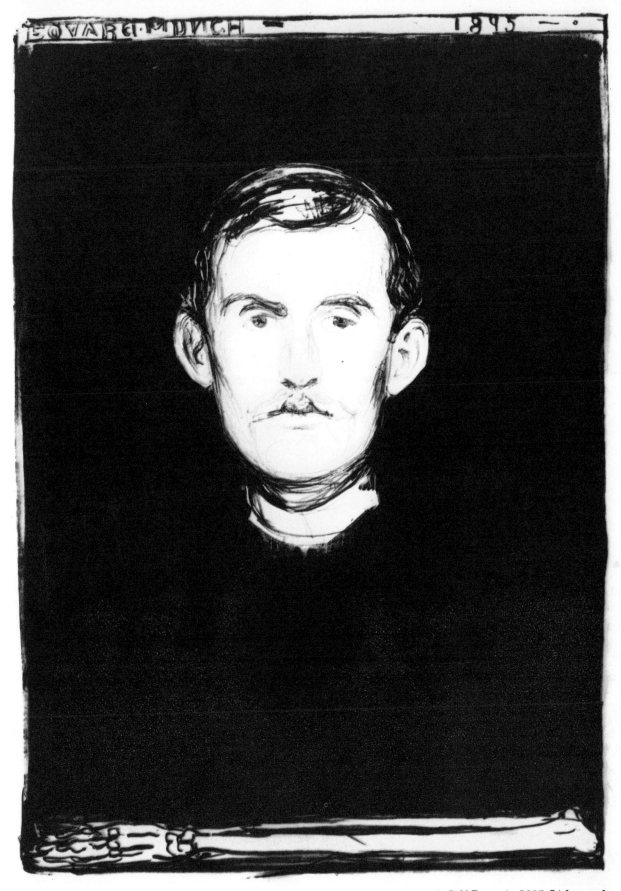

1 Self-Portrait. 1895. Lithograph

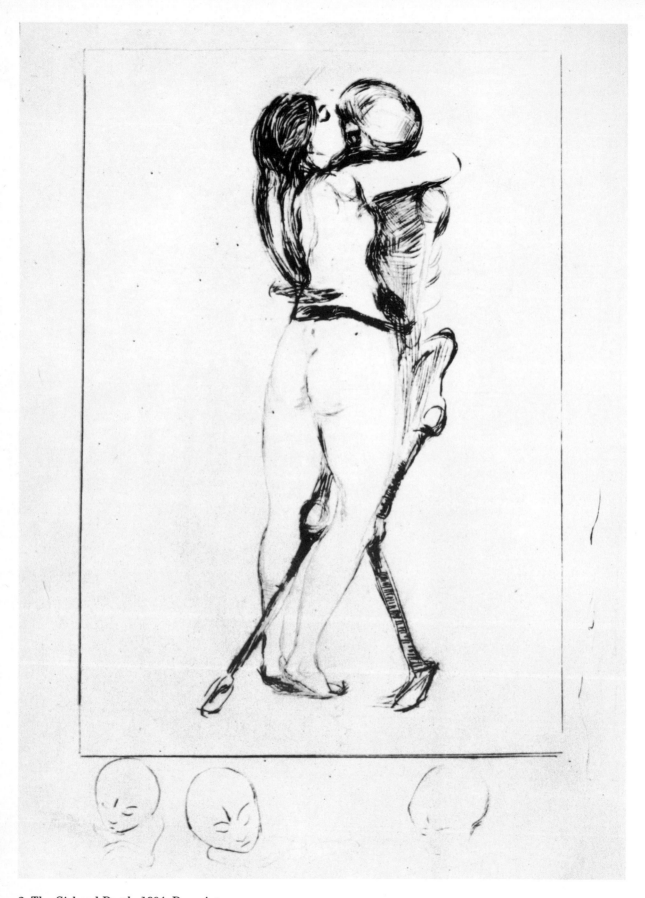

2 The Girl and Death. 1894. Drypoint

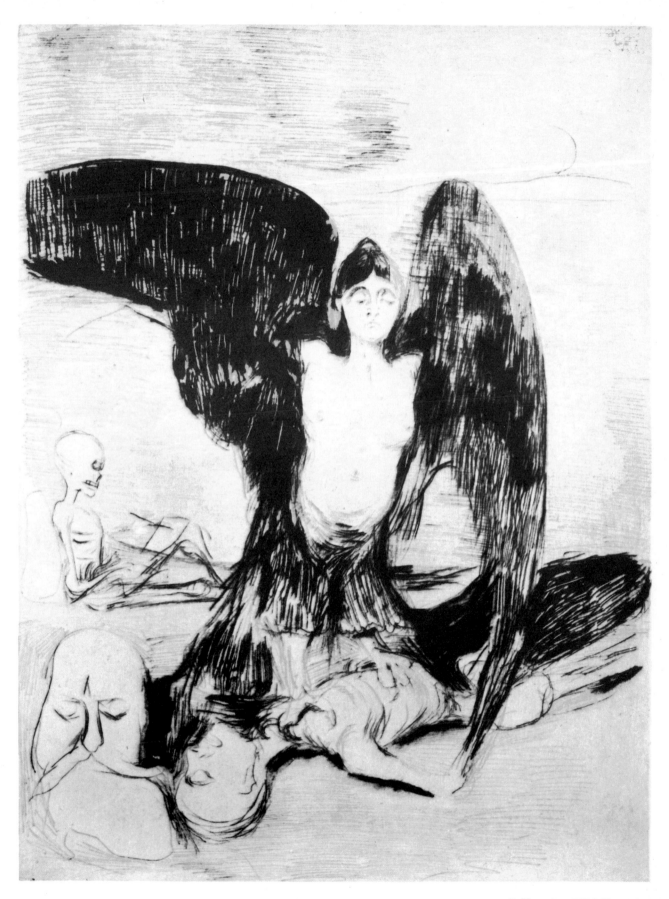

3 Vampire. 1894. Drypoint

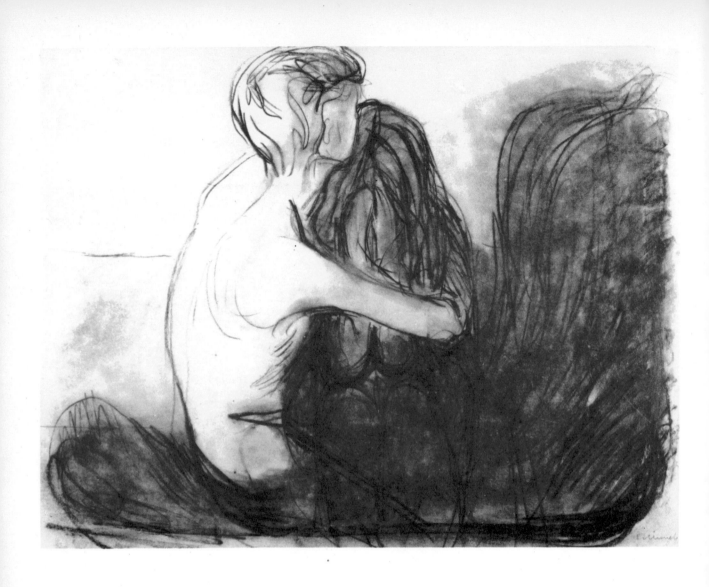

4 Consolation. 1894. Charcoal

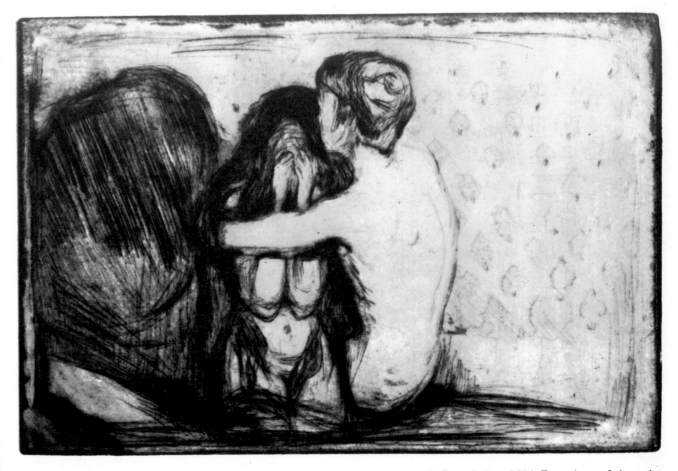

5 Consolation. 1894. Drypoint and Aquatint

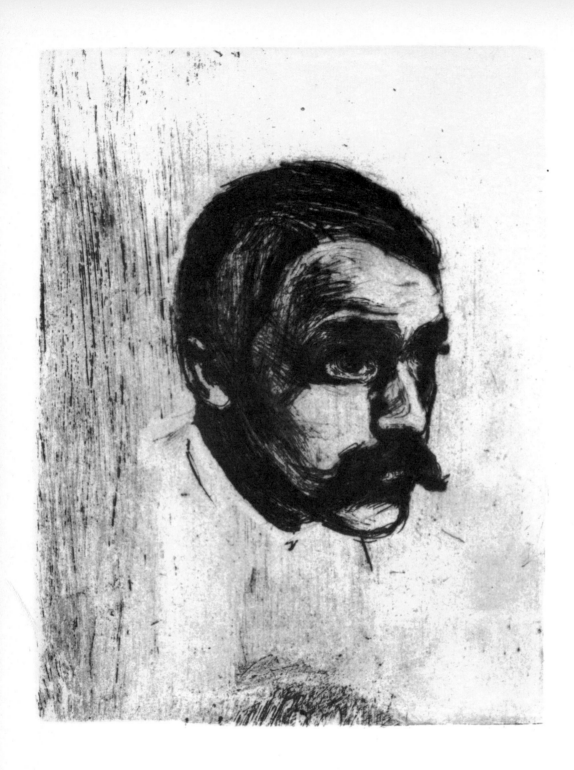

6 Portrait Sigbjørn Obstfelder. 1897. Etching

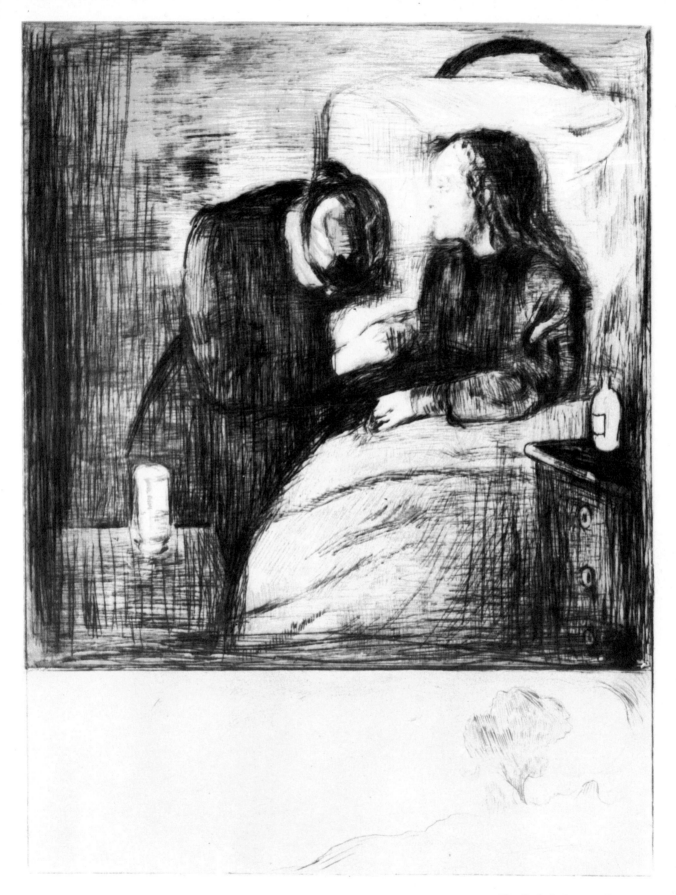

7 The Sick Girl. 1894. Drypoint

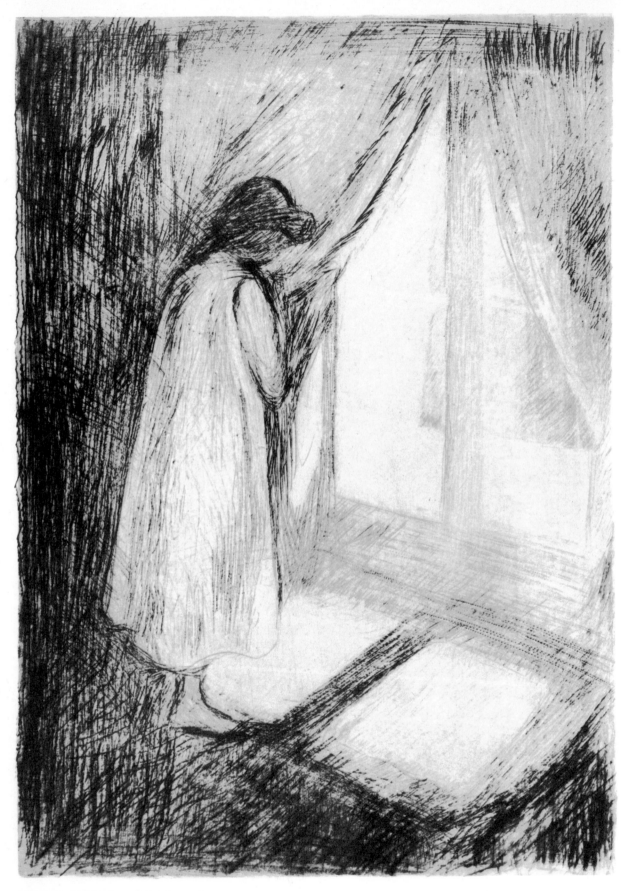

8 Girl at the Window. 1894. Drypoint

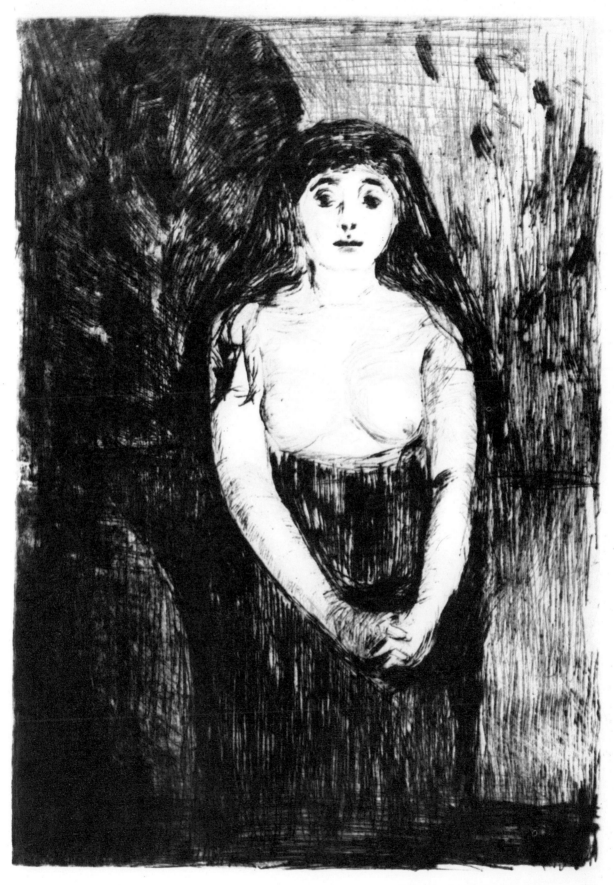

9 Study of a Model. 1894/95. Drypoint

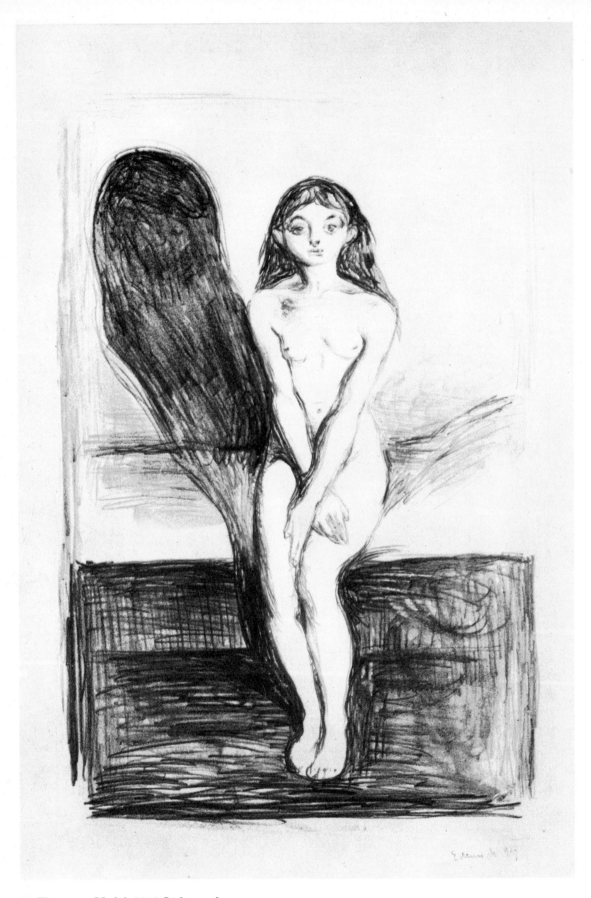

10 The young Model. 1894. Lithograph

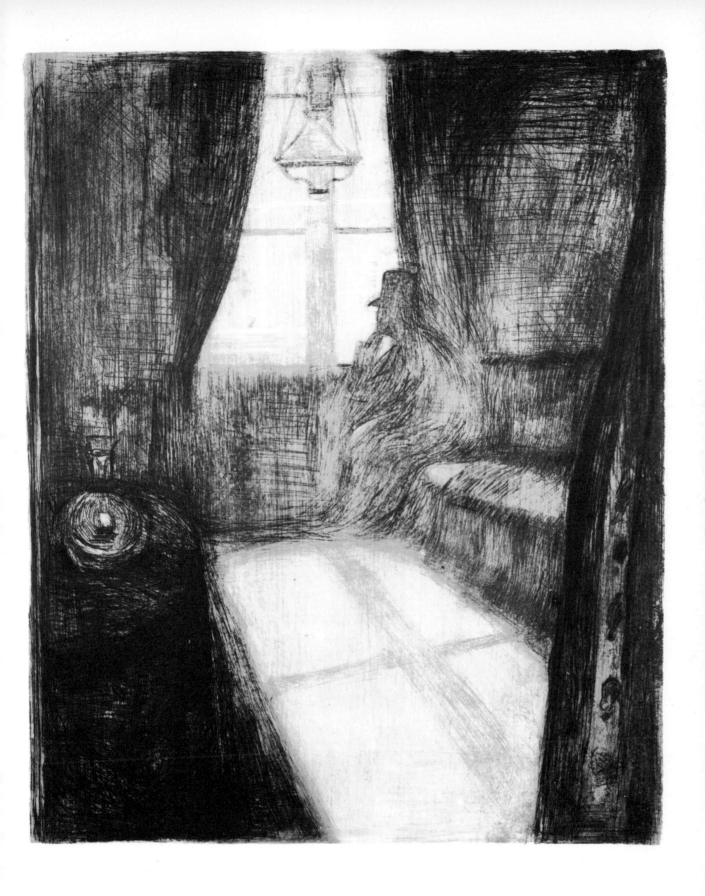

11 Moonlight. 1895. Drypoint and Aquatint

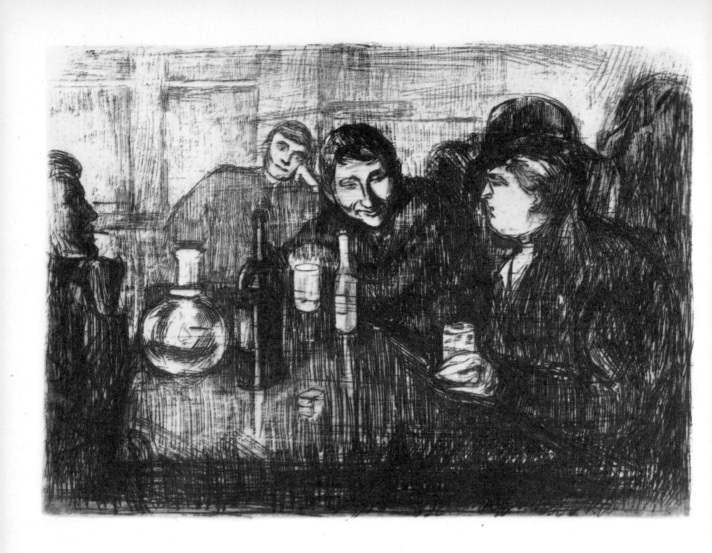

12 Christiania-Bohème I. 1895. Etching and Aquatint

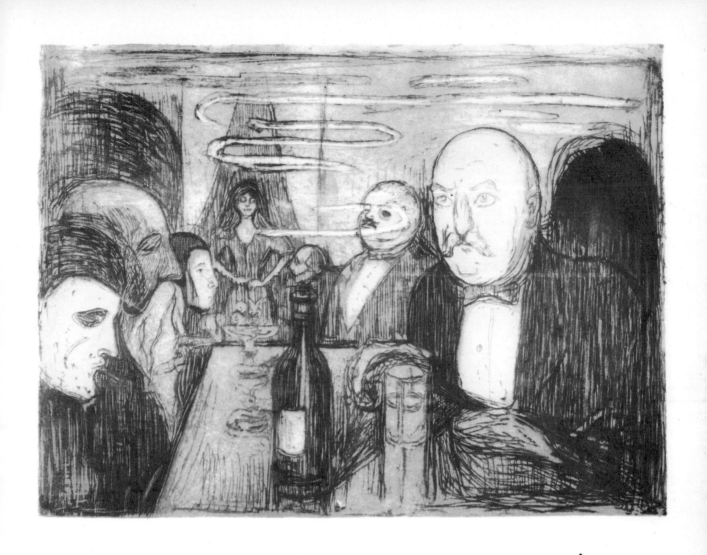

13 Christiania-Bohème II. 1895. Etching and Aquatint

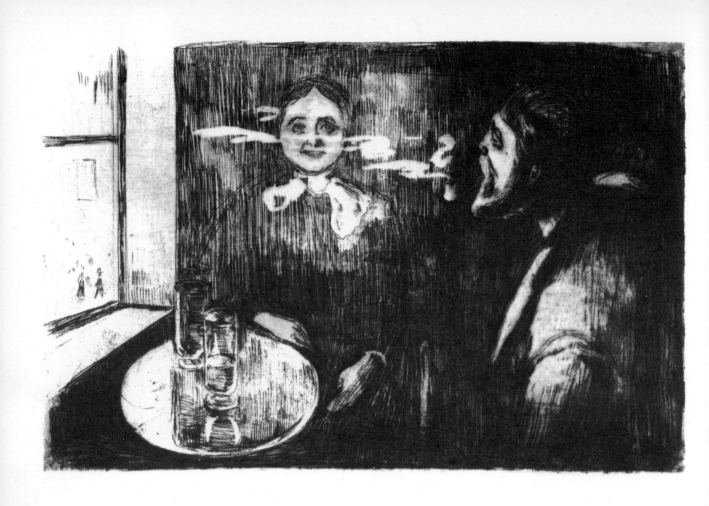

14 Tête-à-tête. 1895. Etching

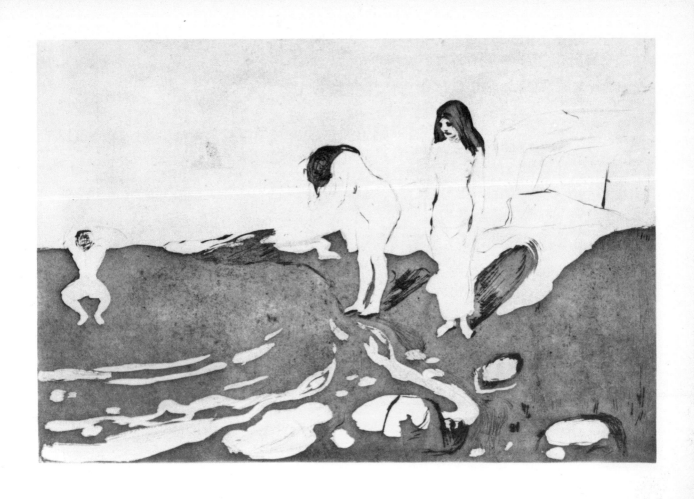

15 Bathing Girls. 1895. Drypoint and Aquatint

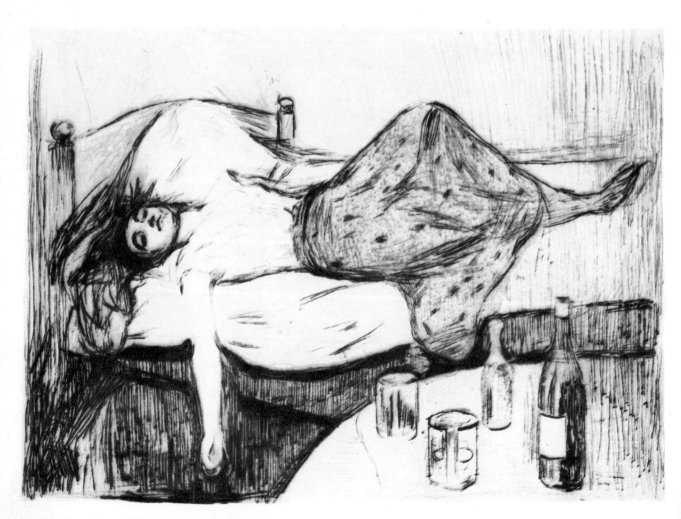

16 The Day After. 1895. Drypoint and Aquatint

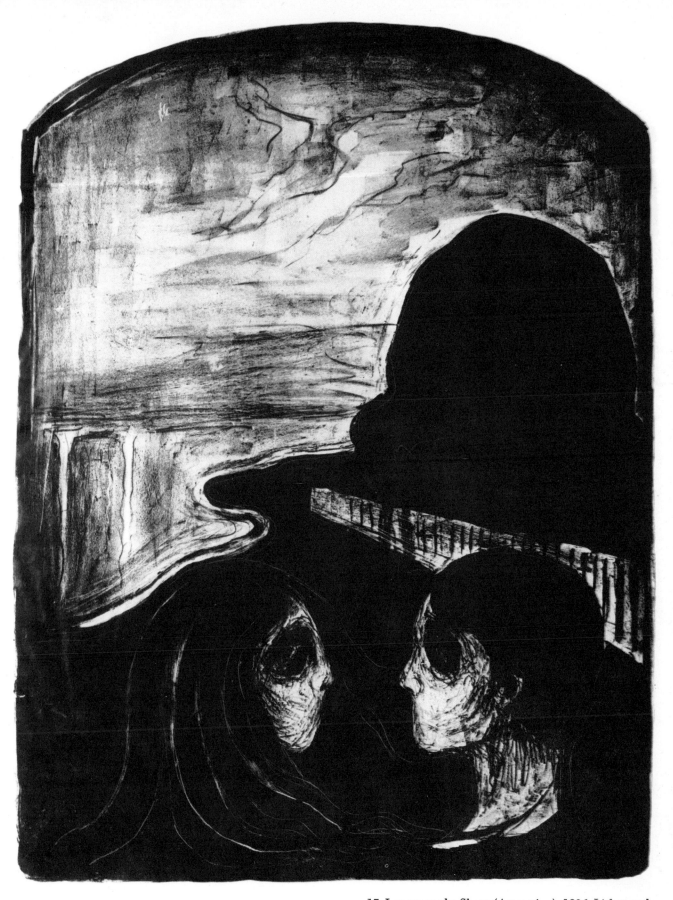

17 Lovers on the Shore (Attraction). 1896. Lithograph

18. Portrait Sigbjørn Obstfelder. 1896. Lithograph

19 Portrait Hans Jäger. 1896. Lithograph

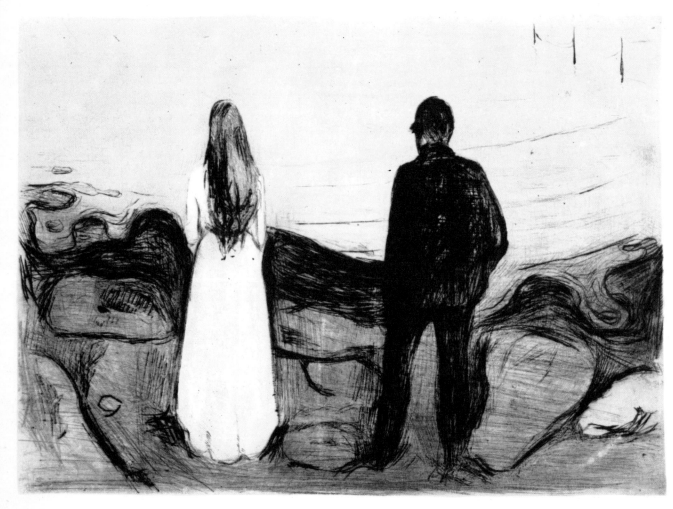

20 Two People (The Lonely Ones). 1895. Drypoint

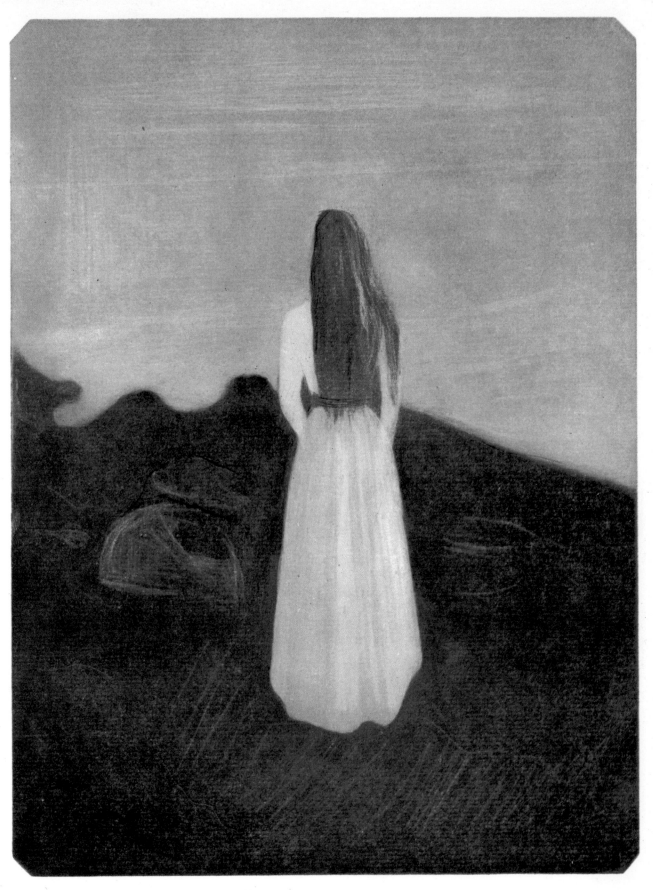

21 Young Girl on the Shore (The Lonely One). 1896. Coloured Mezzotint

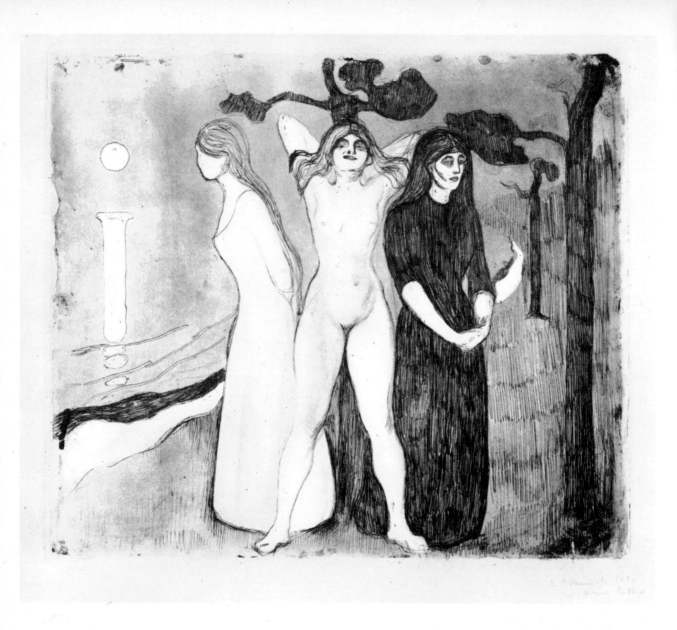

22 Woman. 1895. Drypoint and Aquatint

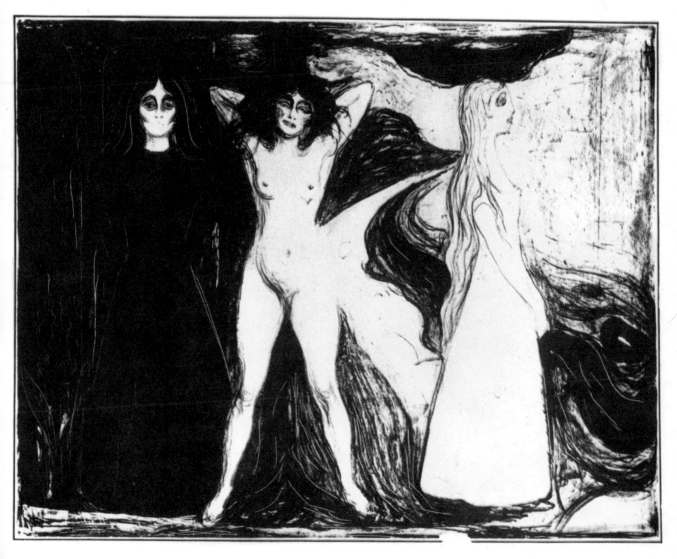

23 Woman (The Sphinx). 1899. Lithograph

24 Summer Night (The Voice). 1895. Drypoint and Aquatint

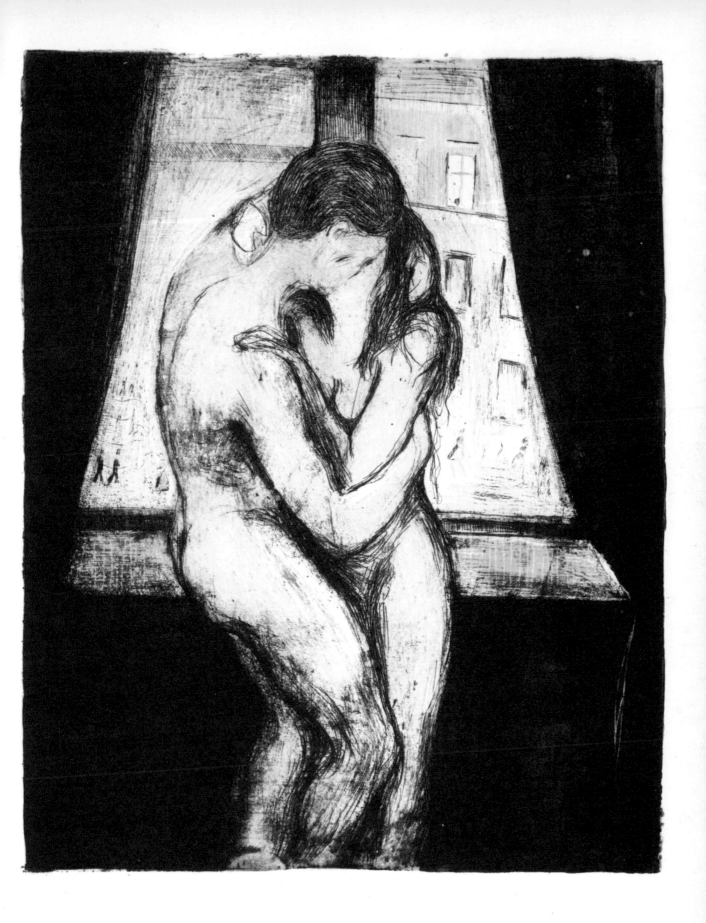

25 The Kiss. 1895. Drypoint and Aquatint

26 Portrait Graf Kessler. 1895. Lithograph

27 Portrait Dr. Max Asch. 1895. Drypoint

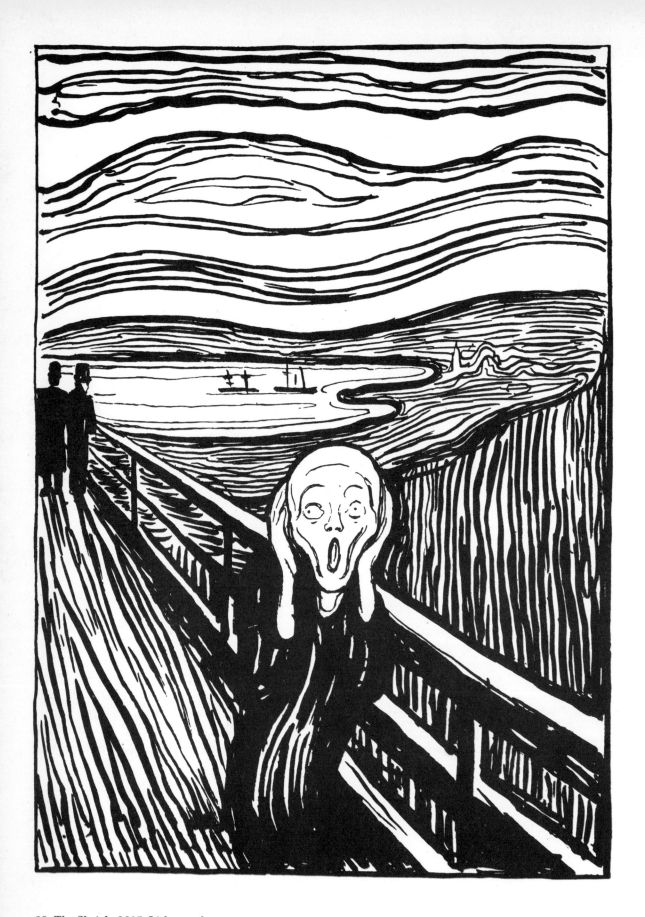

28 The Shriek. 1895. Lithograph

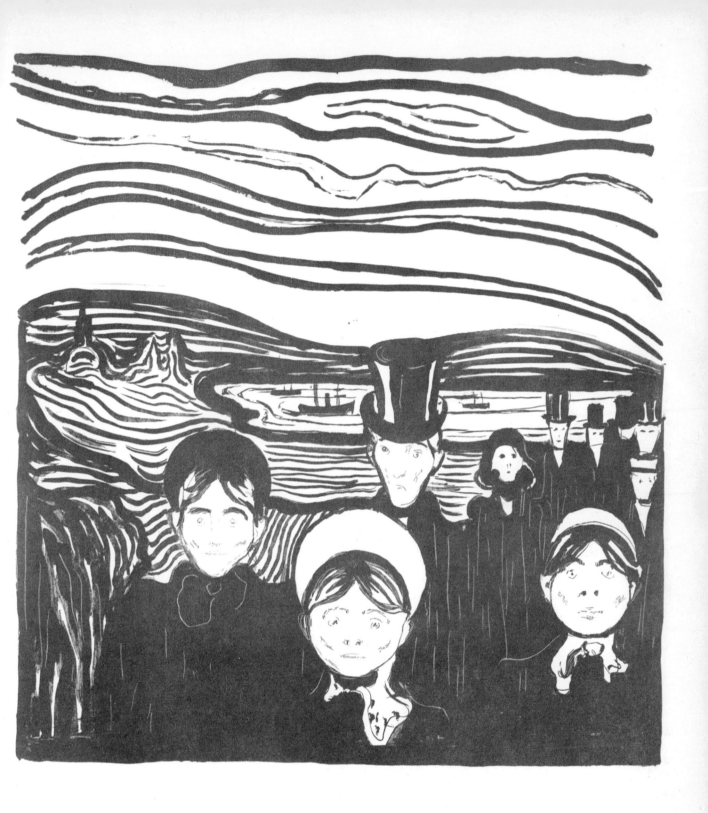

29 Anxiety. 1896. Two-coloured Lithograph

30 Evening. 1897. Lithograph

33 Lust. 1895. Lithograph

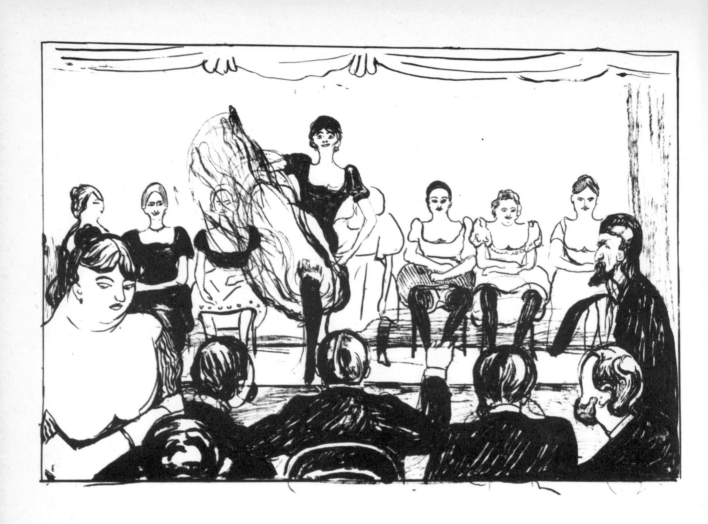

34 Music-Hall. 1895. Lithograph

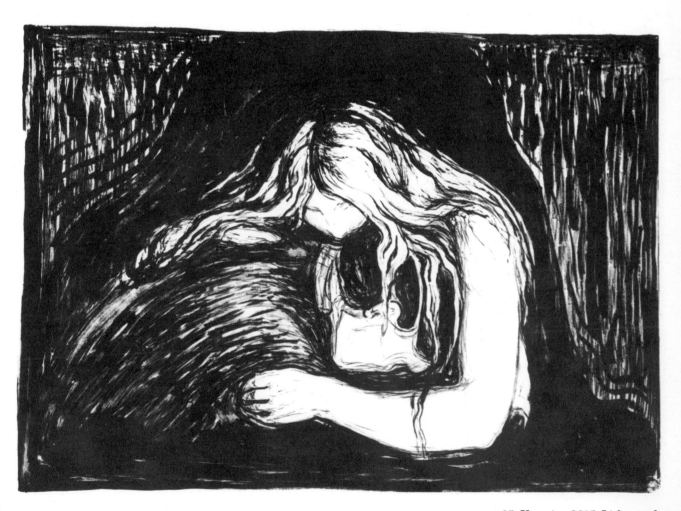

35 Vampire. 1895. Lithograph

36 Under the Yoke. 1896. Etching and Drypoint

37 Girl with Heart. 1896. Etching

38 Agony. 1895. Drawing

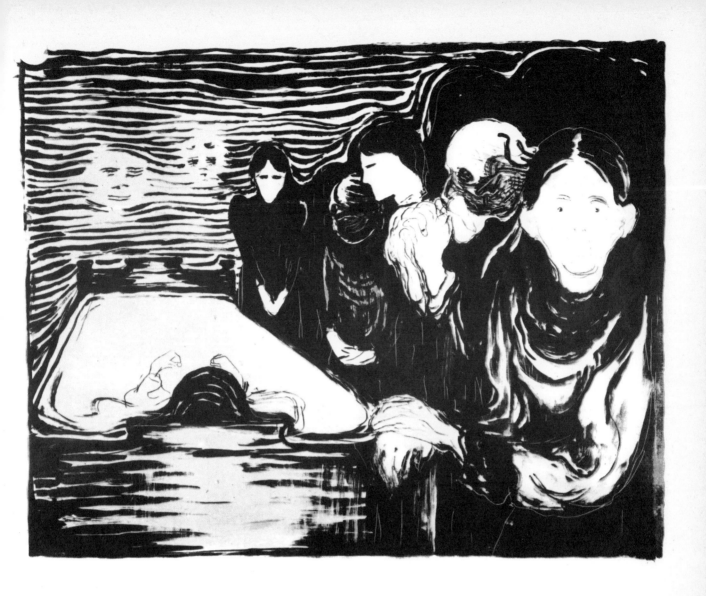

39 Agony. 1896. Lithograph

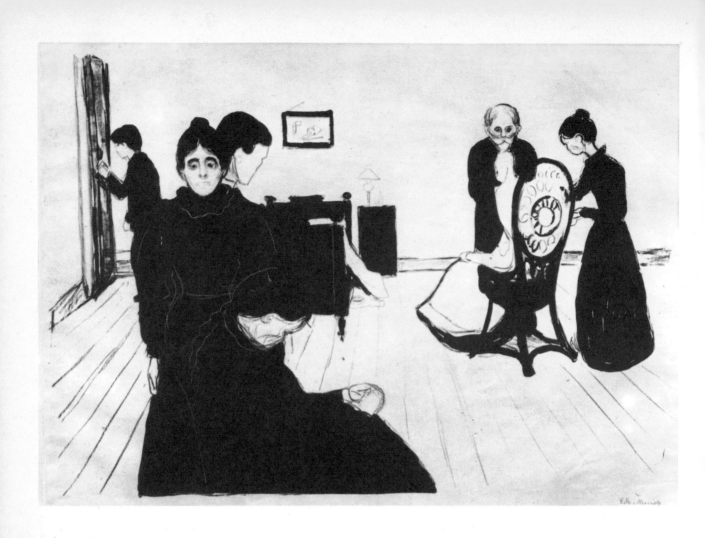

40 The Death Chamber. 1896. Lithograph

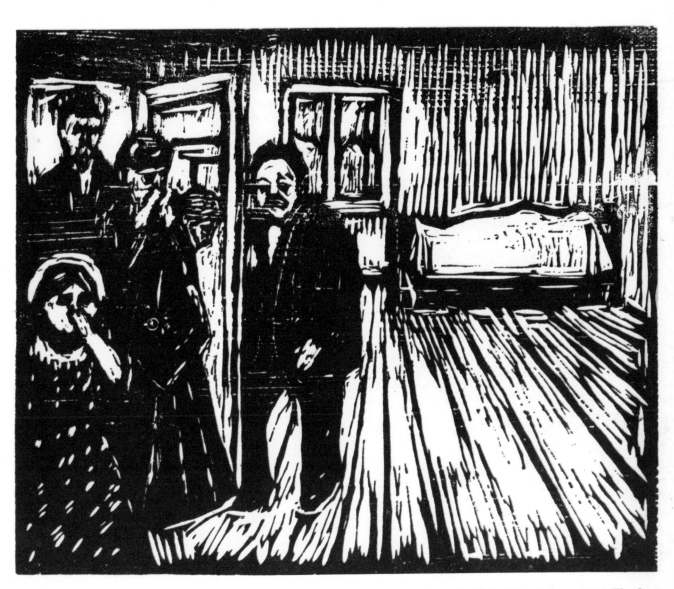

41 Visit of Condolence. 1904. Woodcut

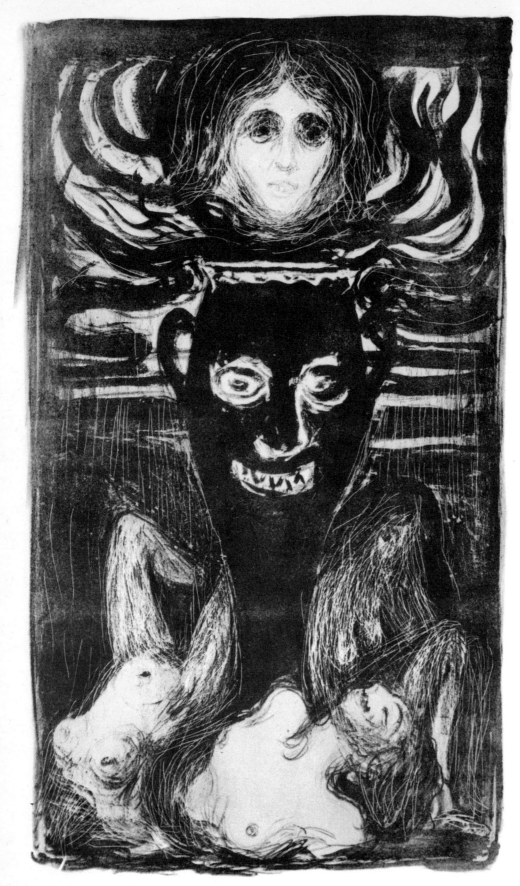

42 The Urn. 1896. Lithograph

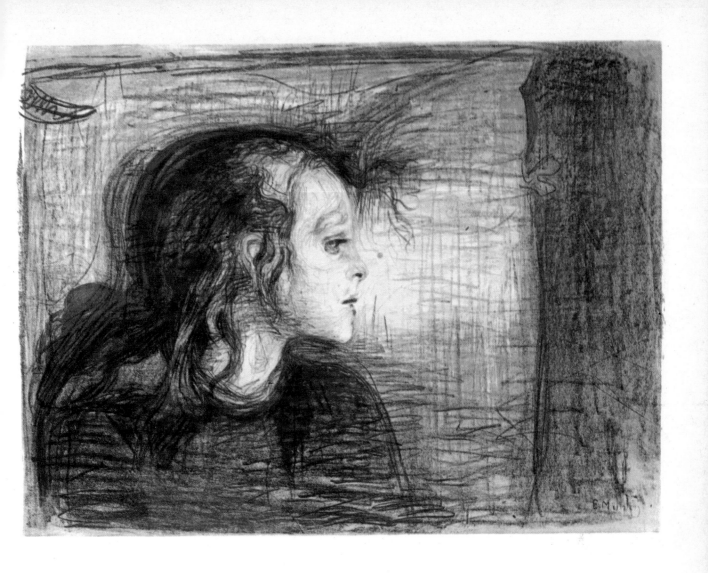

43 The Sick Girl. 1896. Coloured Lithograph

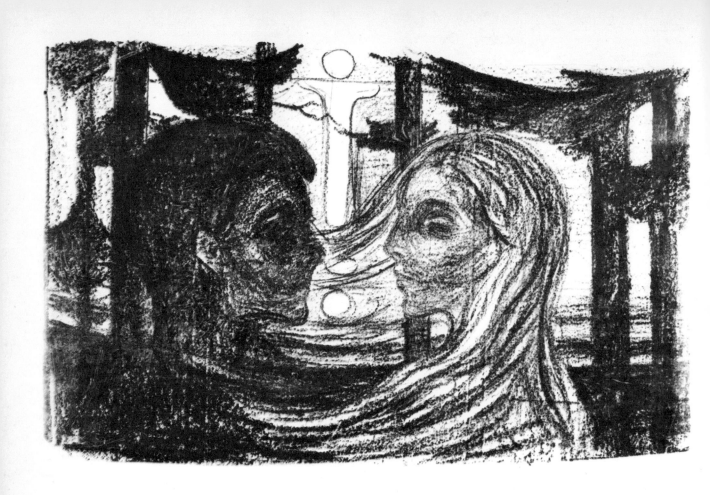

44 Attraction. 1896. Lithograph

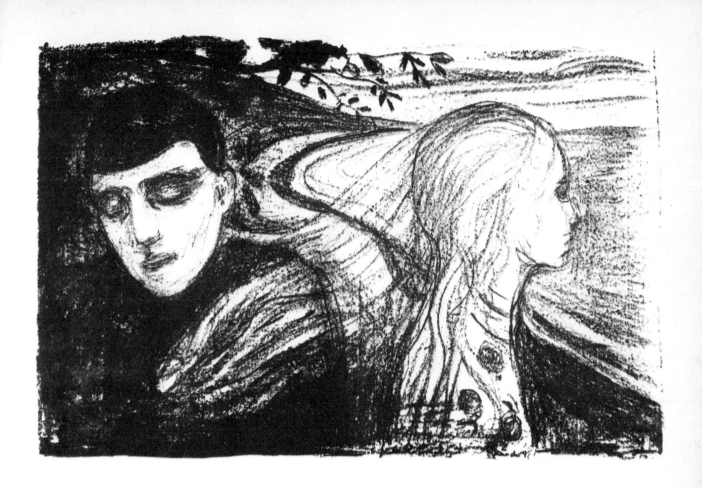

45 Separation. 1896. Coloured Lithograph

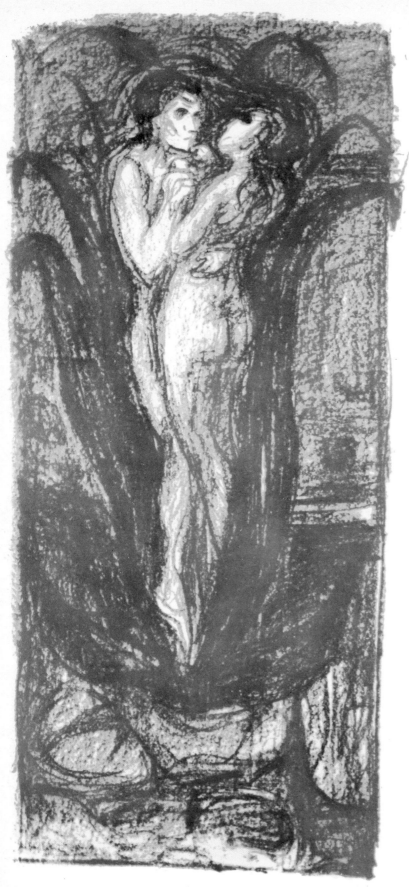

46 The Flower of Love. 1896. Lithograph

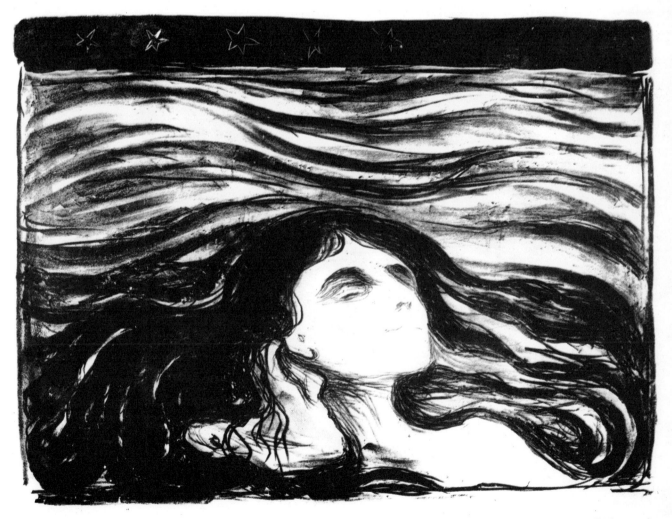

47 Lovers in the Waves. 1896. Lithograph

48 Portrait Stéphane Mallarmé. 1896. Lithograph

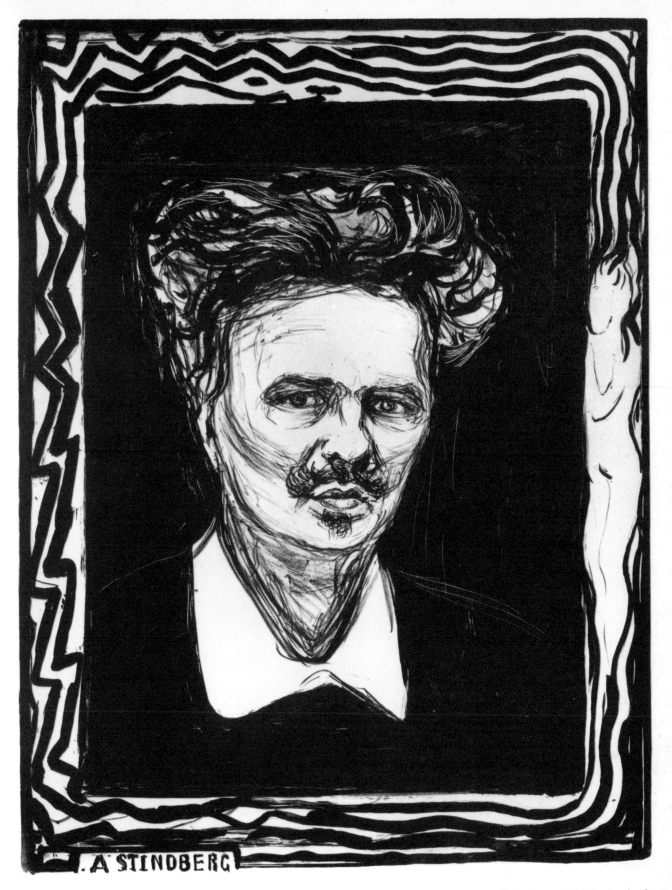

49 Portrait August Strindberg. 1896. Lithograph

50 Portrait Gunnar Heiberg. 1896. Coloured Lithograph

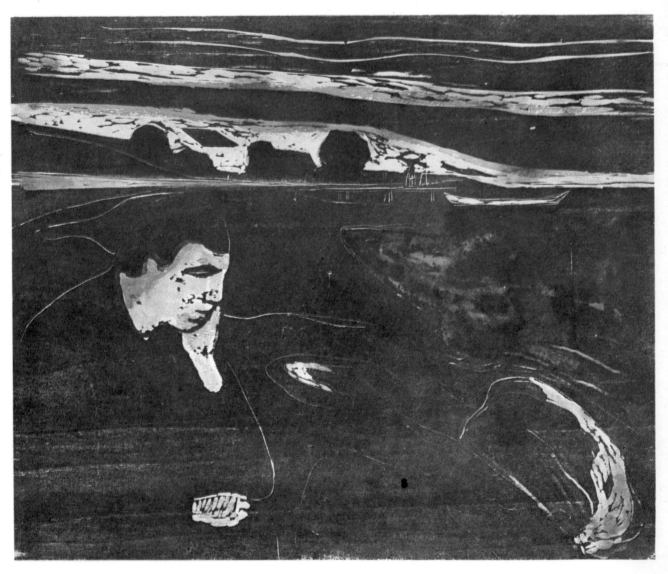

51 Evening (Melancholia). 1896. Coloured Woodcut

52 Self-Portrait. C. 1906–08. Woodcut

53 Moonlight. 1896. Coloured Woodcut

54 In Man's Brain. 1897. Woodcut

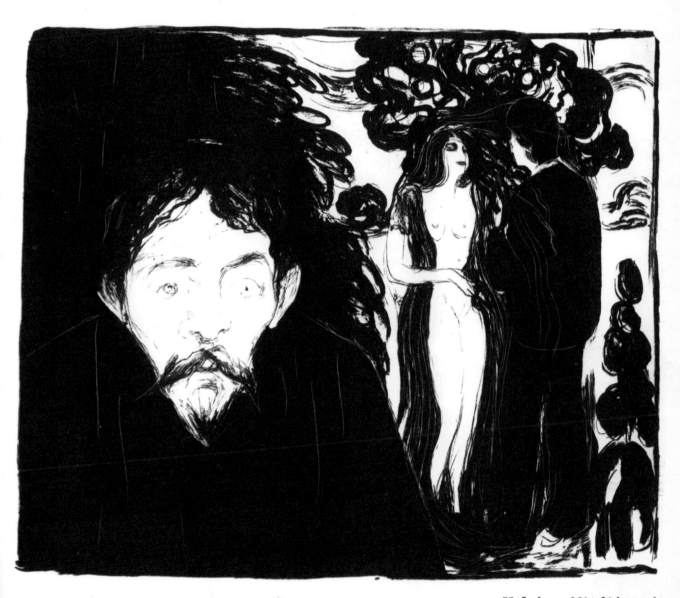

55 Jealousy. 1896. Lithograph

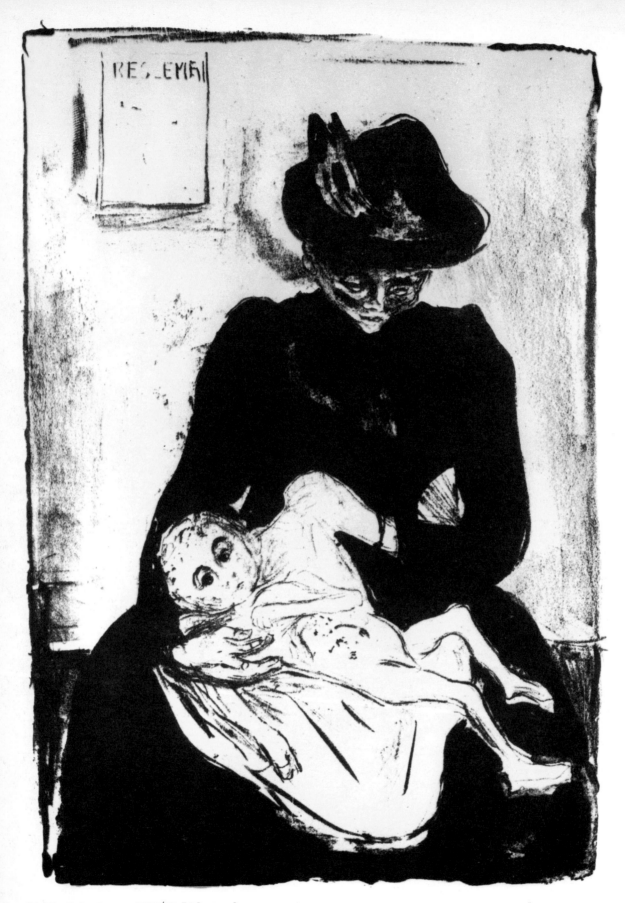

56 The Inheritance. 1897/99. Lithograph

57 Funeral March. 1897. Lithograph

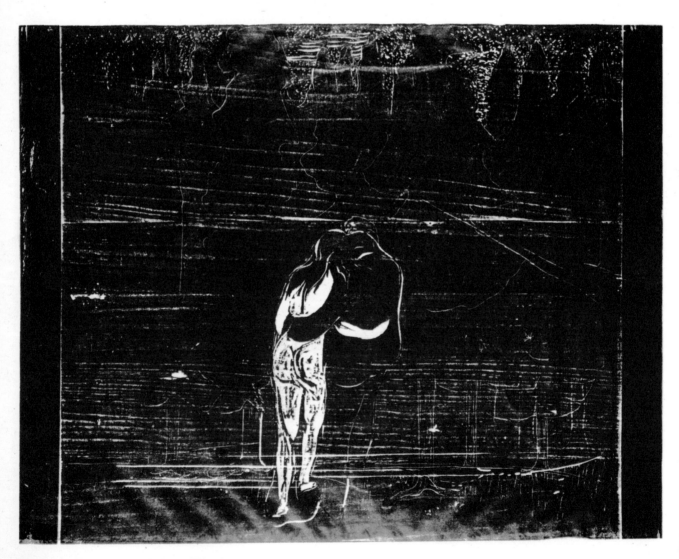

58 To the Forest. 1897. ColouredWoodcut

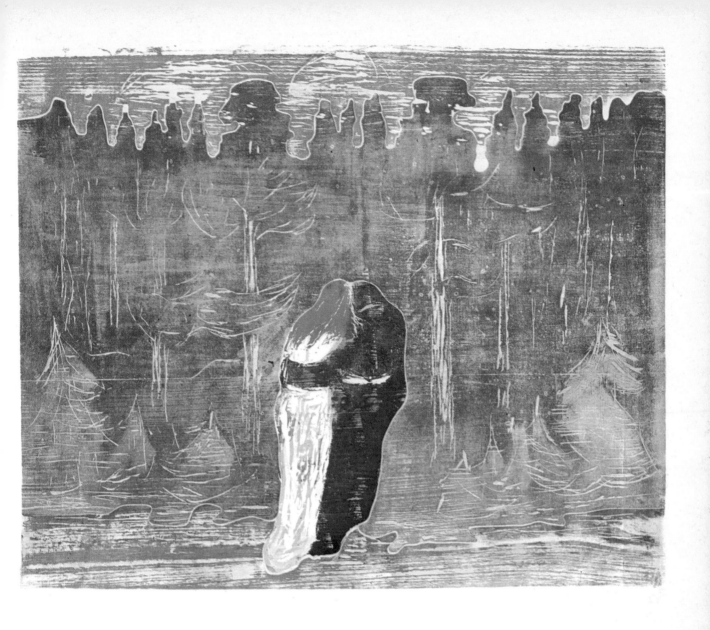

59 To the Forest. 1915. Coloured Woodcut

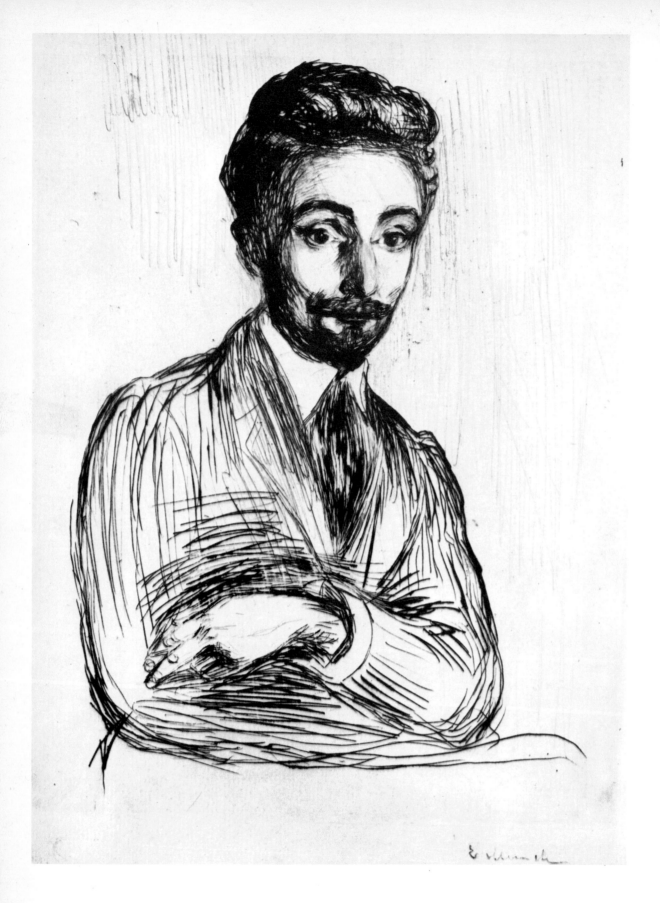

60 Portrait Helge Rode. 1898. Drypoint

61 Portrait Stanislaw Przybyszewski. 1898. Lithograph

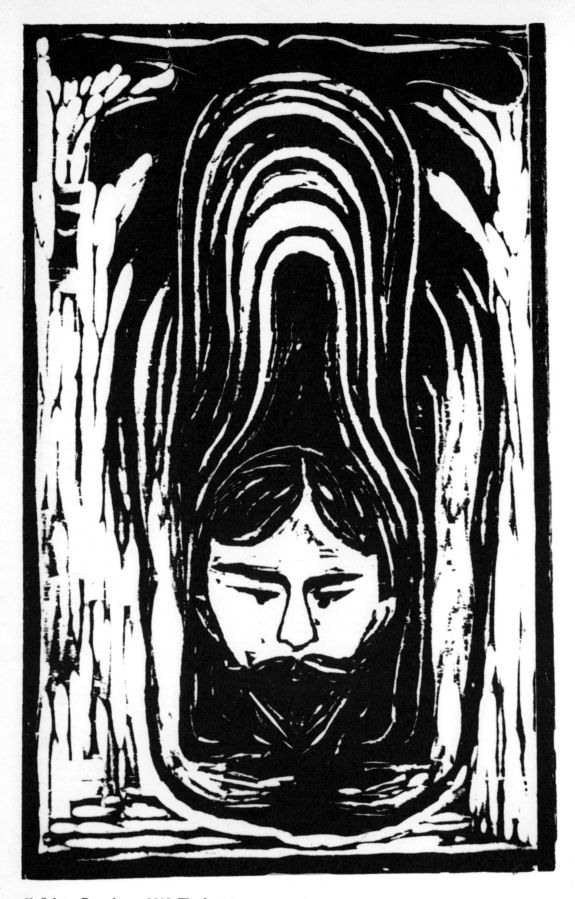

62 Salome Paraphrase. 1898. Woodcut

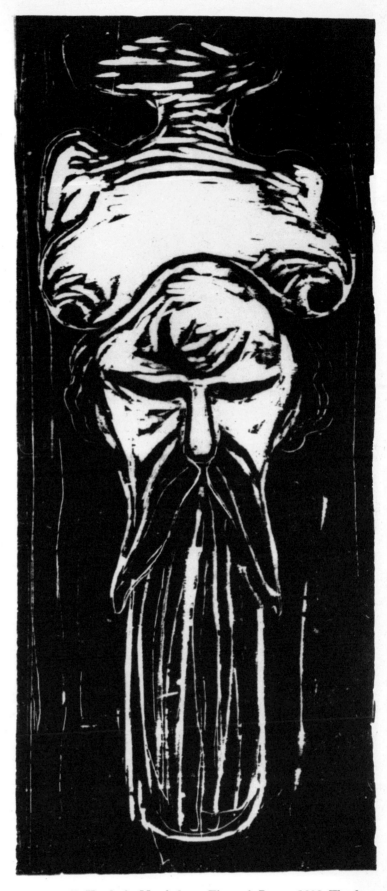

63 Head of a Man below a Woman's Breast. 1898. Woodcut

64 Fertility. 1898. Woodcut

65 Allegory. 1898. Woodcut

66 *Rouge et Noir*. 1898. Coloured Woodcut

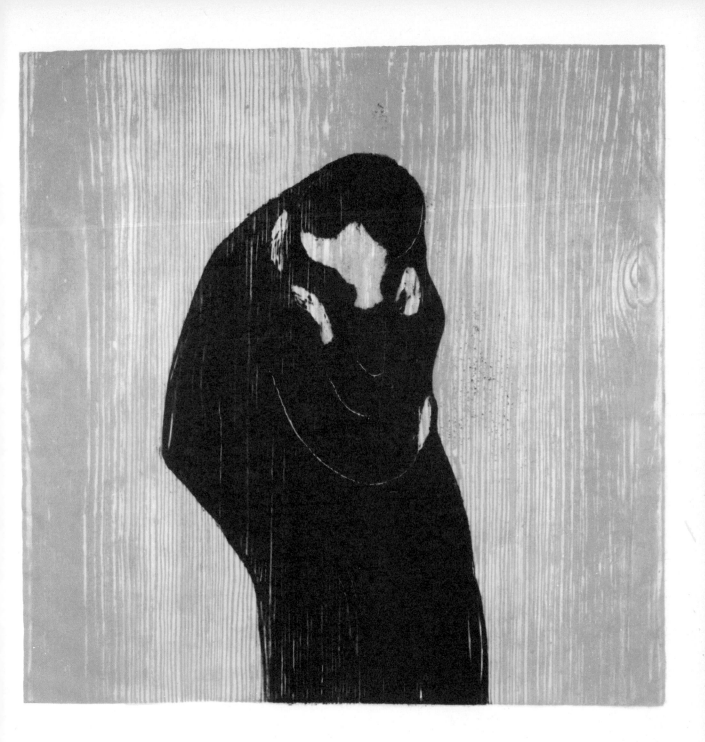

67 The Kiss. 1902. Woodcut

68 Large Snowscape. 1898. Woodcut

69 Seascape. 1899. Woodcut

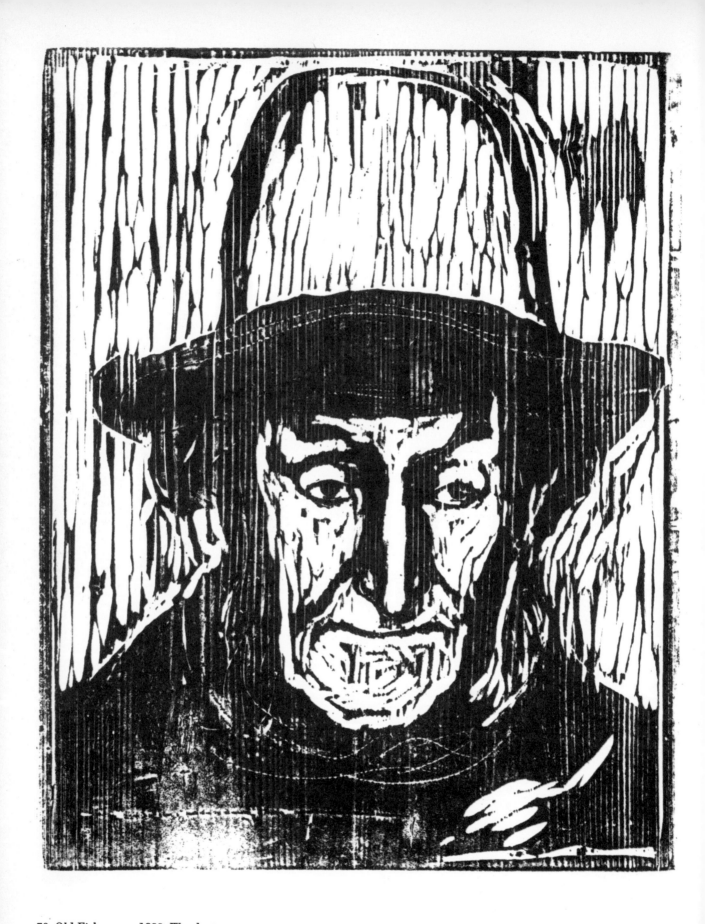

70 Old Fisherman. 1899. Woodcut

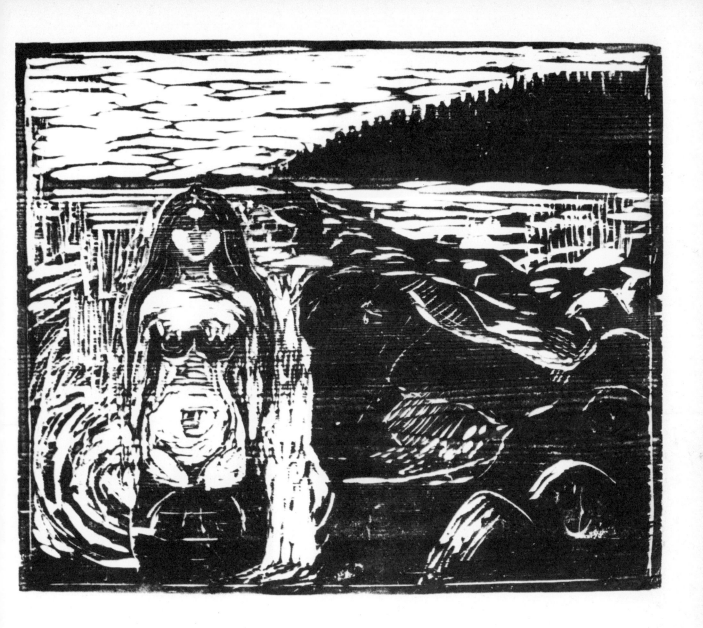

71 Bathing Girl. 1899. Woodcut

72 Youth and Age. 1909/10. Charcoal

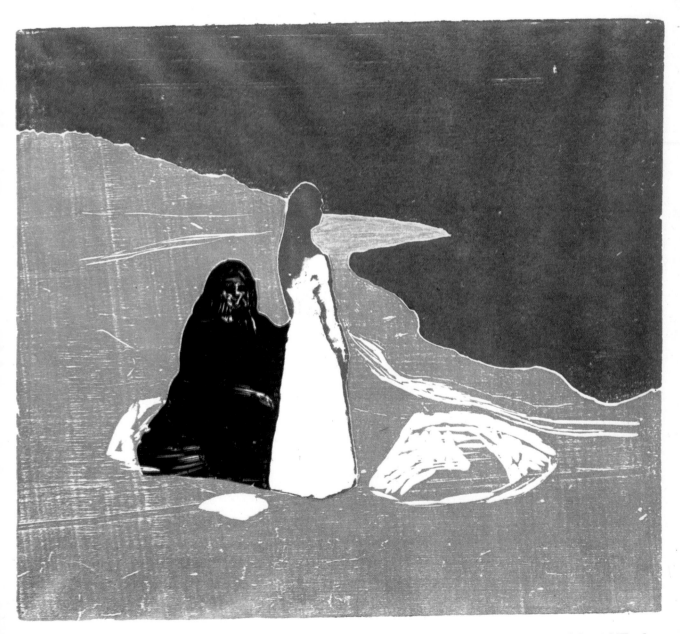

73 Women on the Shore. 1898. Coloured Woodcut

74 The Kiss of Death. 1899. Lithograph

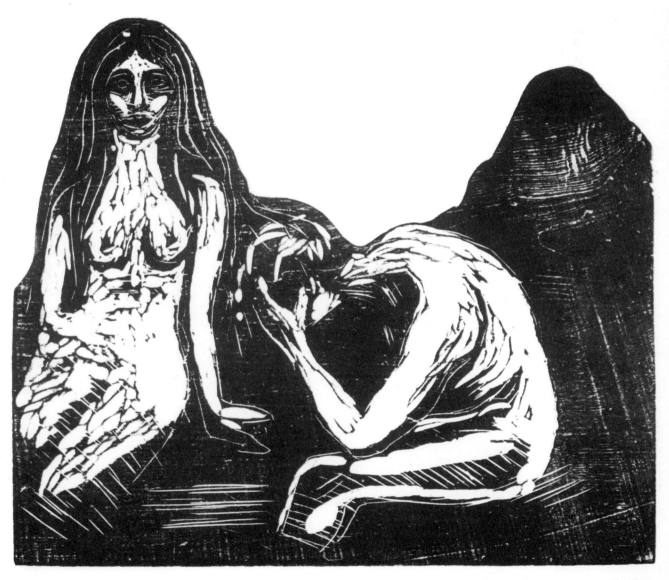

75 Man and Woman. 1899. Woodcut

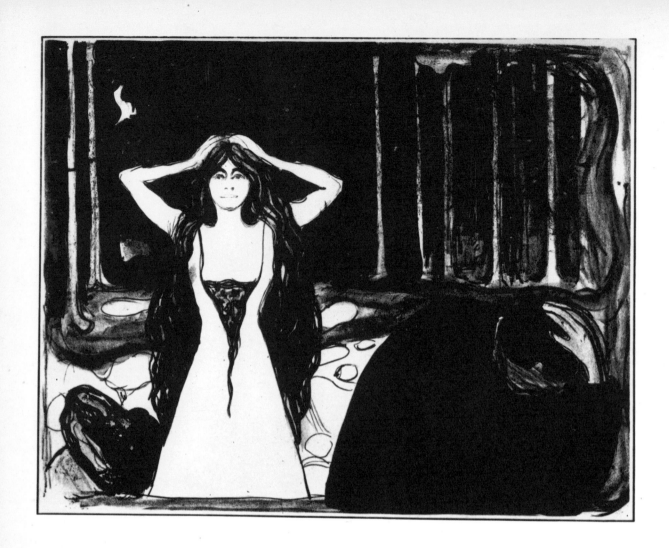

76 Ashes II. 1899. Lithograph

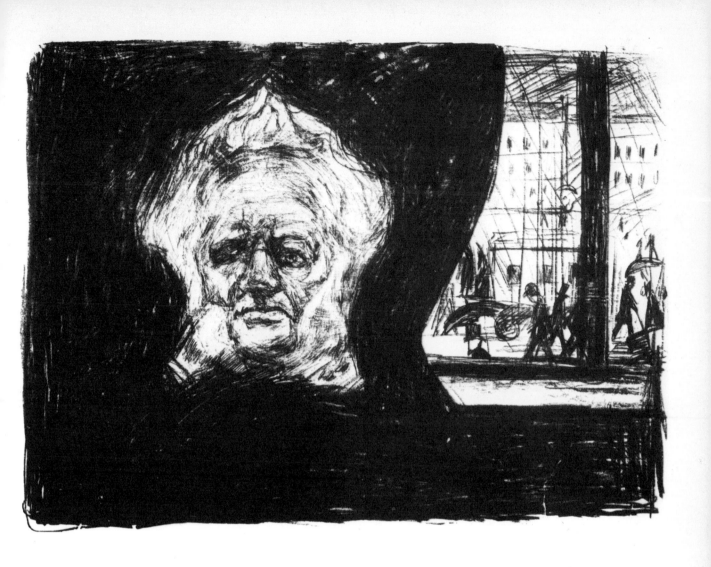

77 Ibsen in the Grand Hotel Cafe in Christiania. 1902. Lithograph

78 Meeting in Space. 1899. Coloured Woodcut

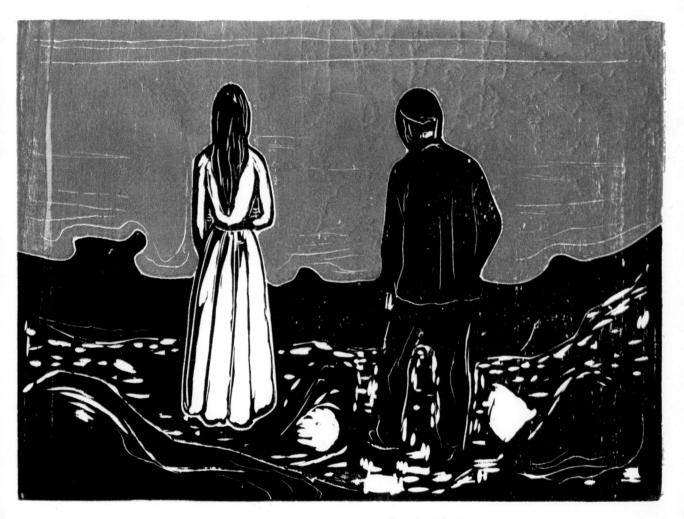

79 Two People (The Lonely Ones). 1899. Coloured Woodcut

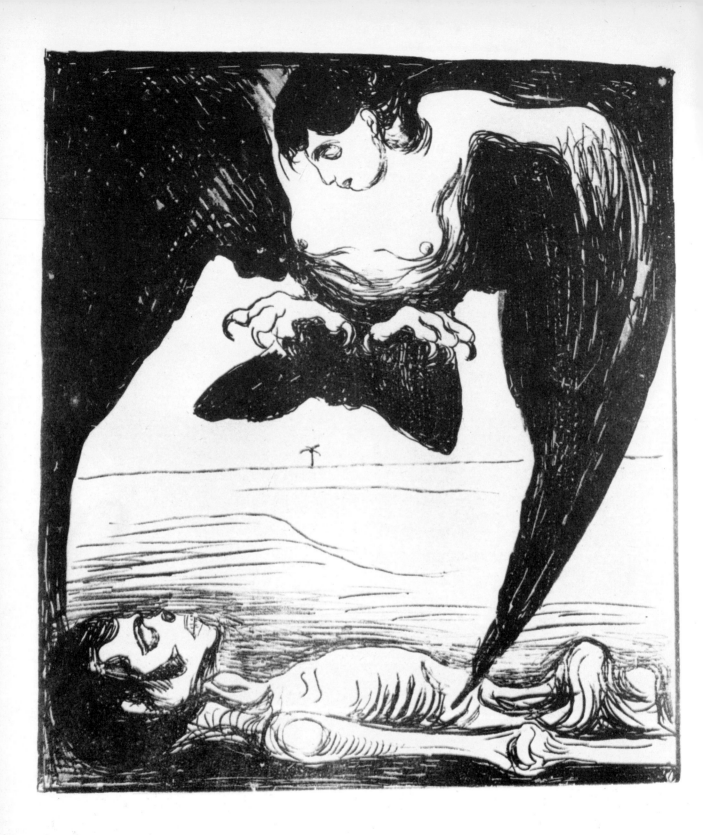

80 Harpy. 1900. Lithograph

81 Nude (Sin). 1901. Coloured Lithograph

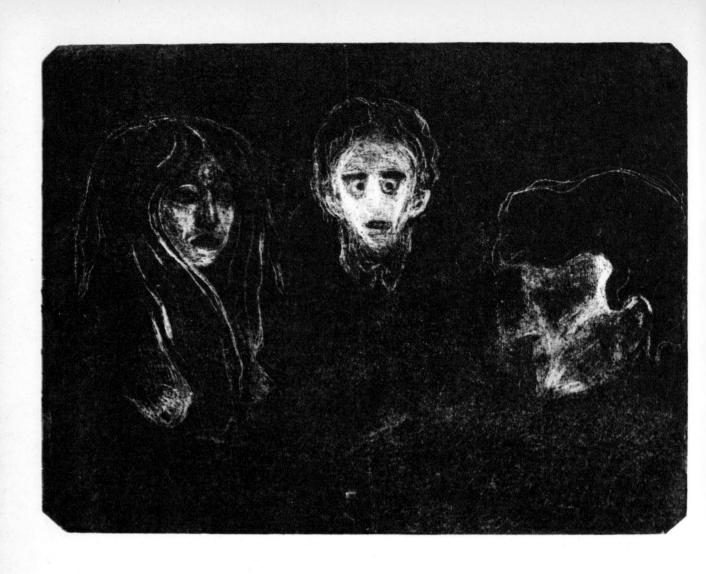

82 Three Faces. 1902. Mezzotint

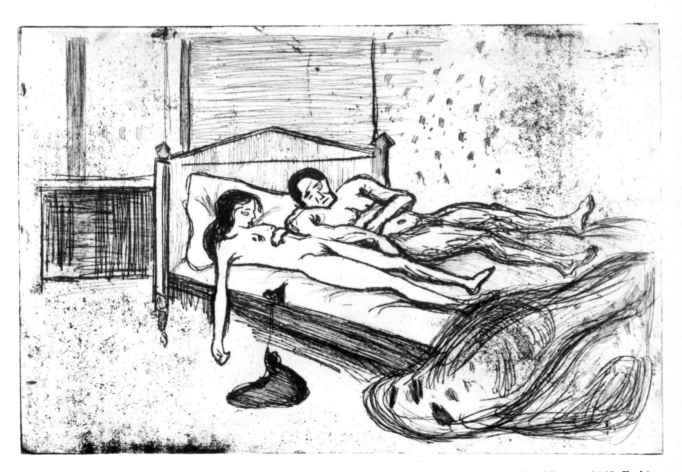

83 Dead Lovers. 1901. Etching

84 Workmen. 1902. Etching

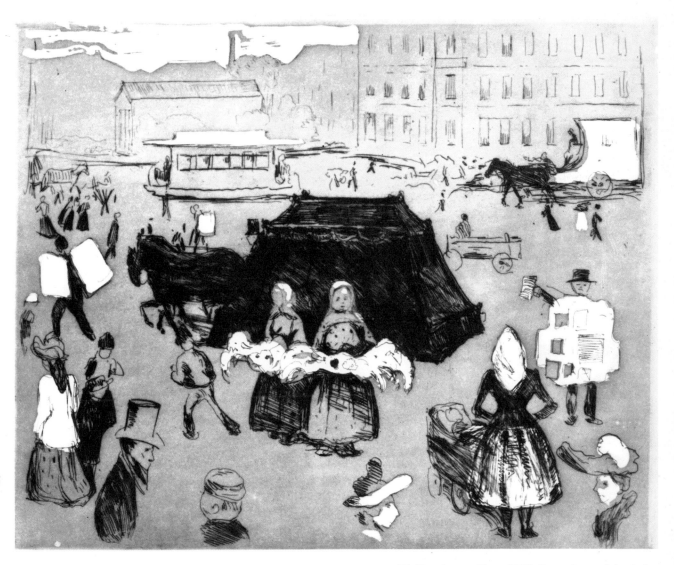

85 *Potsdamer Platz.* 1902. Drypoint and Aquatint

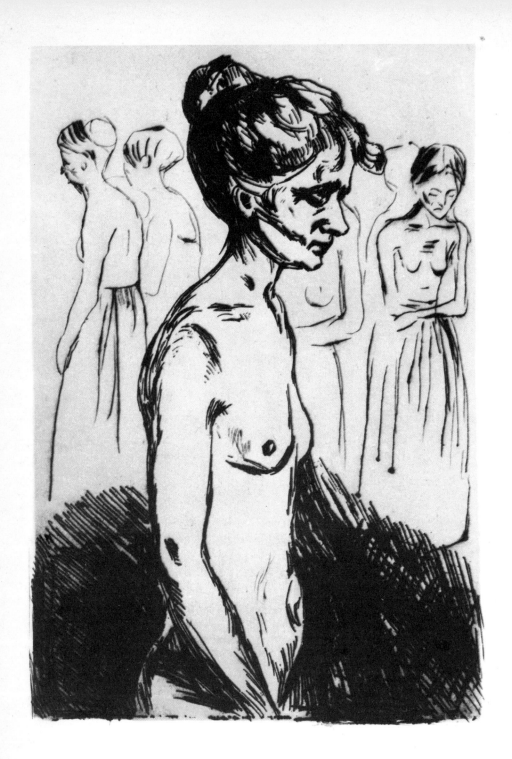

86 Old Women in Hospital. 1902. Etching

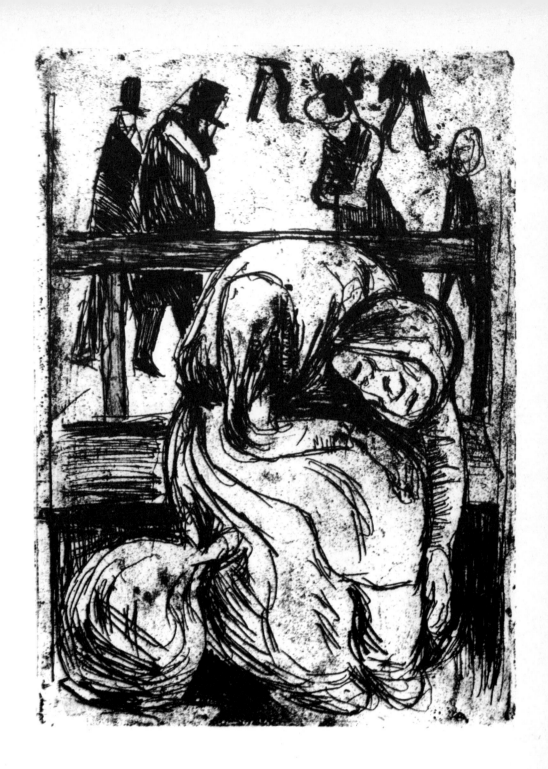

87 Old Woman on a Bench. 1902. Etching

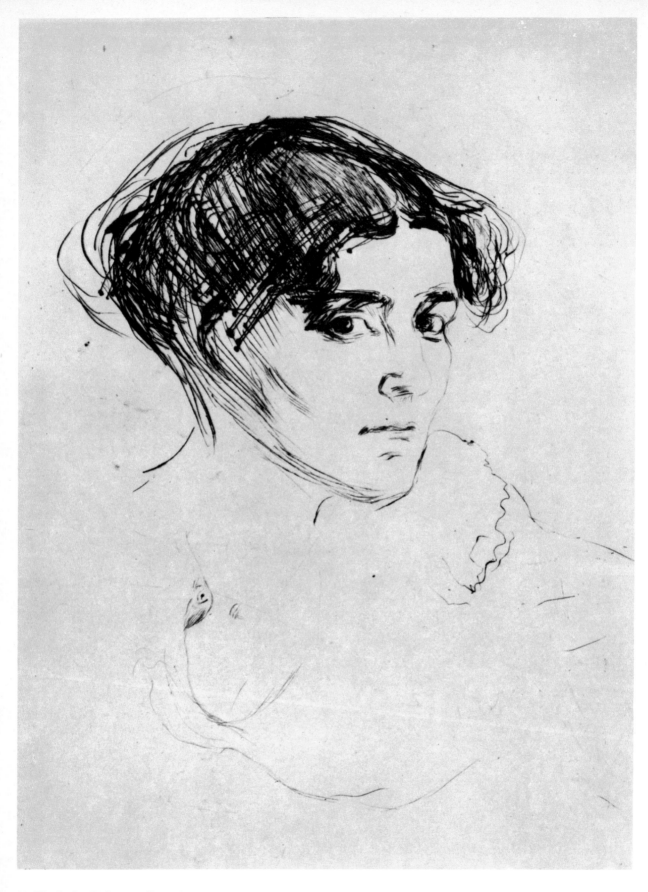

88 Head of a Girl. 1902. Drypoint

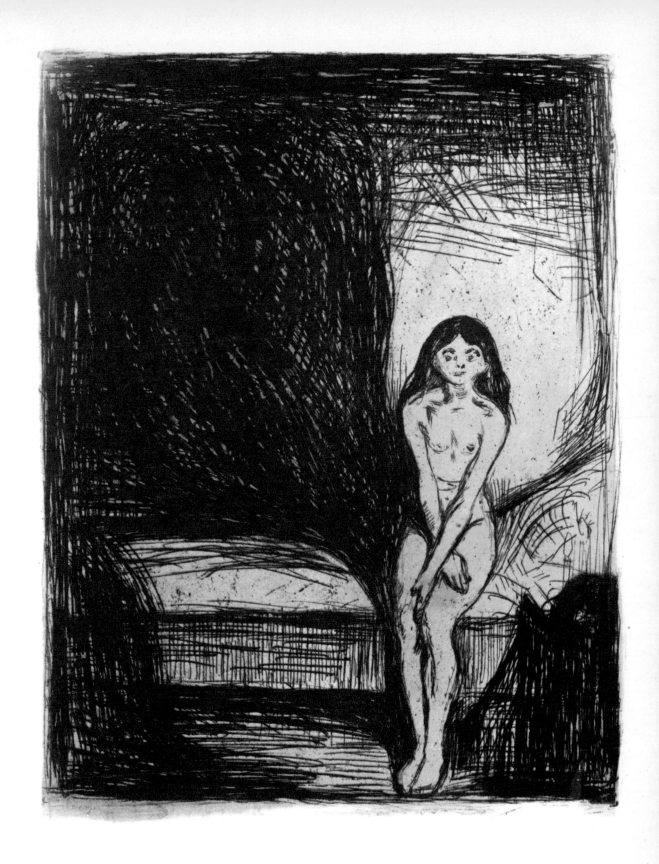

89 Puberty. 1902. Etching

90 Double Portrait Leistikow. 1902. Lithograph

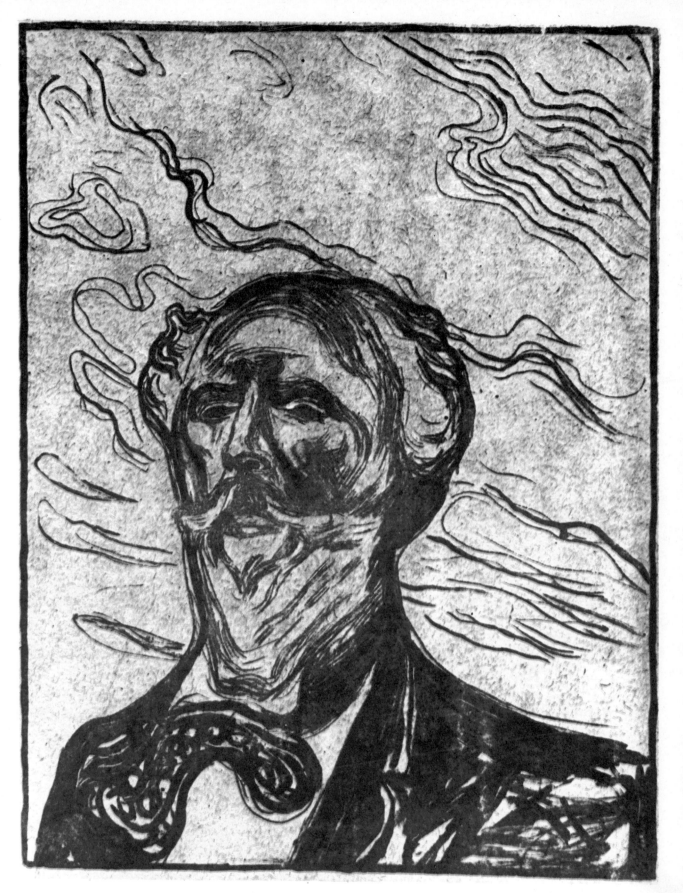

91 Portrait Holger Drachmann. 1901. Lithograph

92 Portrait Dr. Max Linde. 1902. Drypoint

93 Portrait Marie Linde. 1902. Lithograph

94 The Garden. 1902. Etching and Drypoint

95 The House. 1902. Etching and Drypoint

96 Lübeck. 1903. Etching

97 The Oak. 1903. Etching

98 Homage to Society. 1899. Lithograph

99 The Swamp. 1903. Lithograph

100 Phantoms. 1905. Drypoint

101 Cause and Effect. 1904. Lithograph

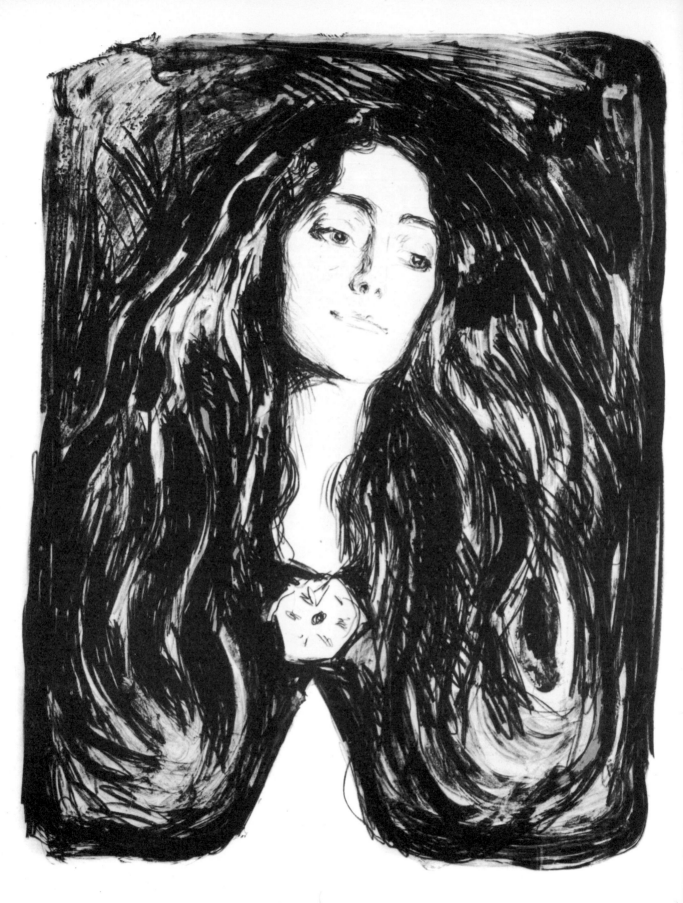

102 The Brooch (Eva Mudocci). 1903. Lithograph

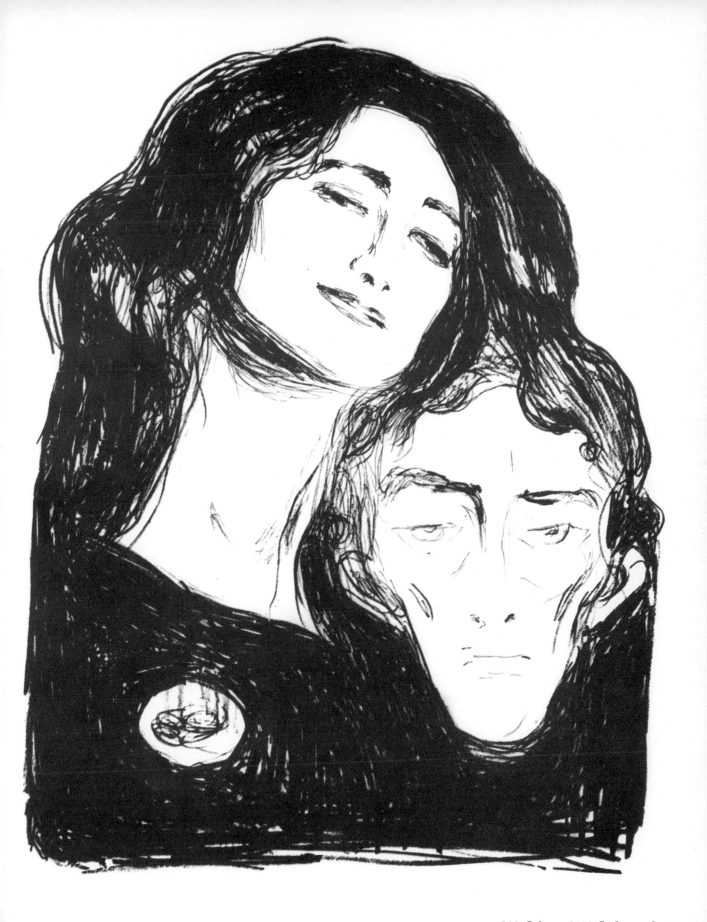

103 Salome. 1903. Lithograph

104 Violin Concert (Bella Edvards and Eva Mudocci). 1903. Lithograph

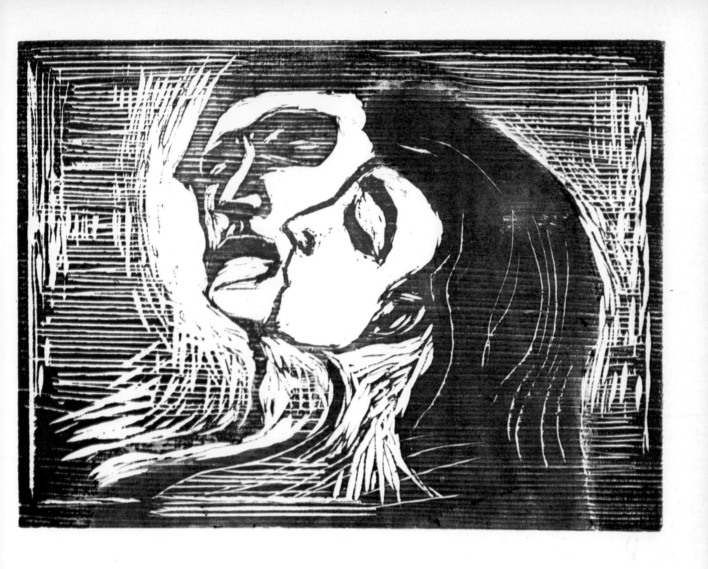

105 Man and Woman kissing. 1905. Coloured Woodcut

106 Little Norwegian Girl. 1908/09. Lithograph

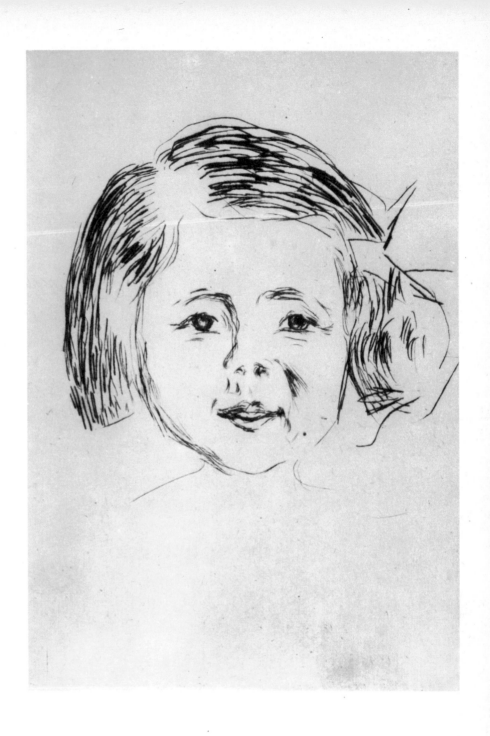

107 Head of a Child. 1905. Drypoint

108 Old Men and Boys. 1905. Woodcut

109 Old Man (Primitive Man). 1905. Woodcut

110 Washerwoman on the Shore. 1903. Woodcut

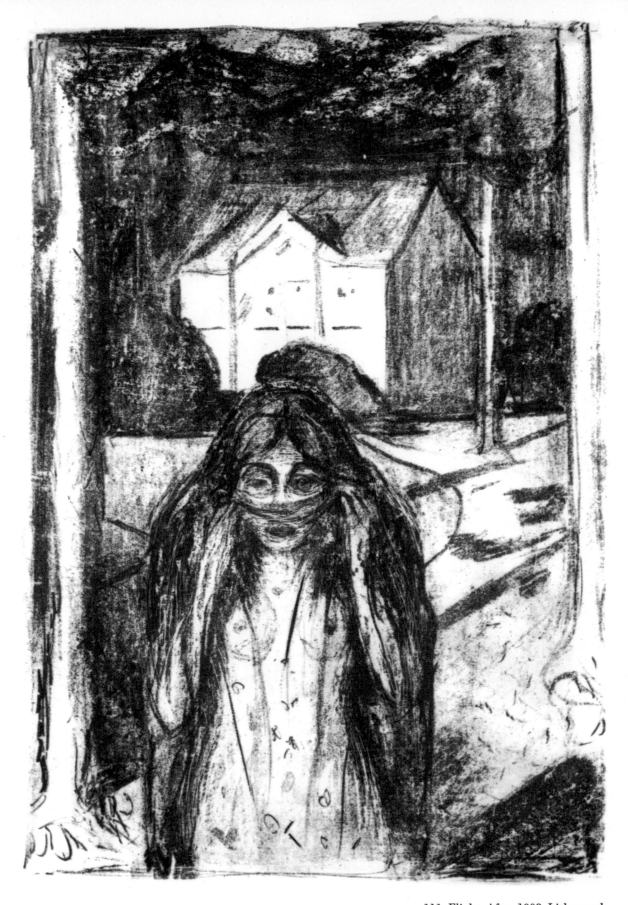

111 Flight. After 1908. Lithograph

112 Portrait Albert Kollmann. 1906. Lithograph

113 Portrait Henry van de Velde. 1906. Lithograph

114 Portrait Andreas Schwarz. 1906. Lithograph

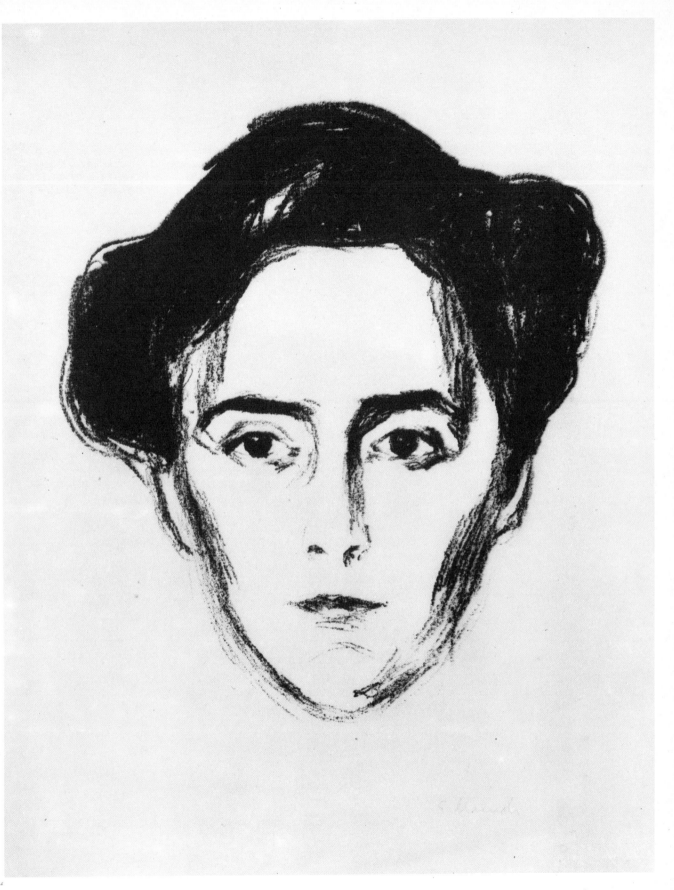

115 Portrait Frau Schwarz. 1906. Lithograph

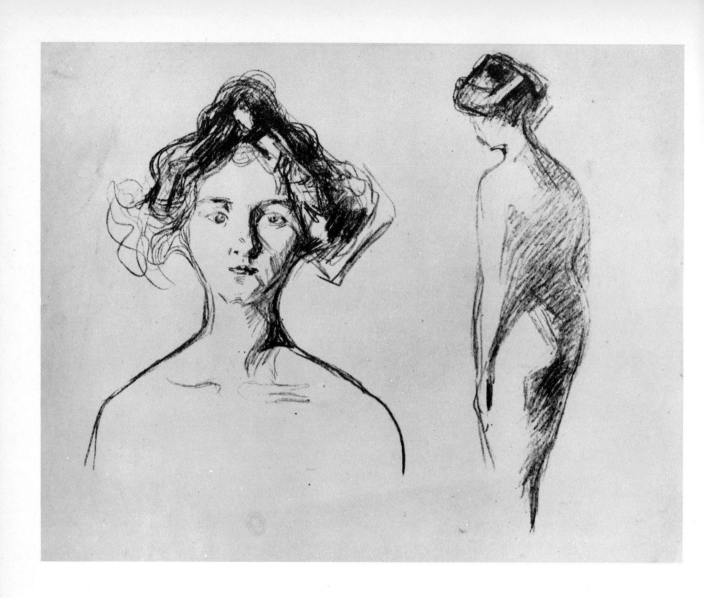

116 Portrait, and Nude seen from the rear. 1906. Crayon

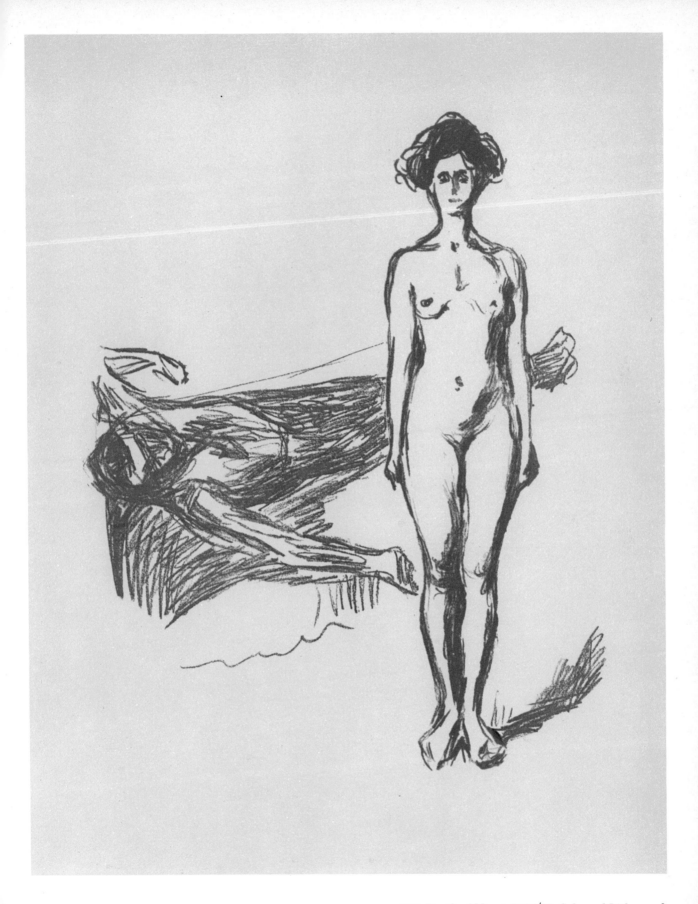

117 Death of Marat. 1906/07. Coloured Lithograph

118 Small Norwegian Landscape. 1907. Drypoint

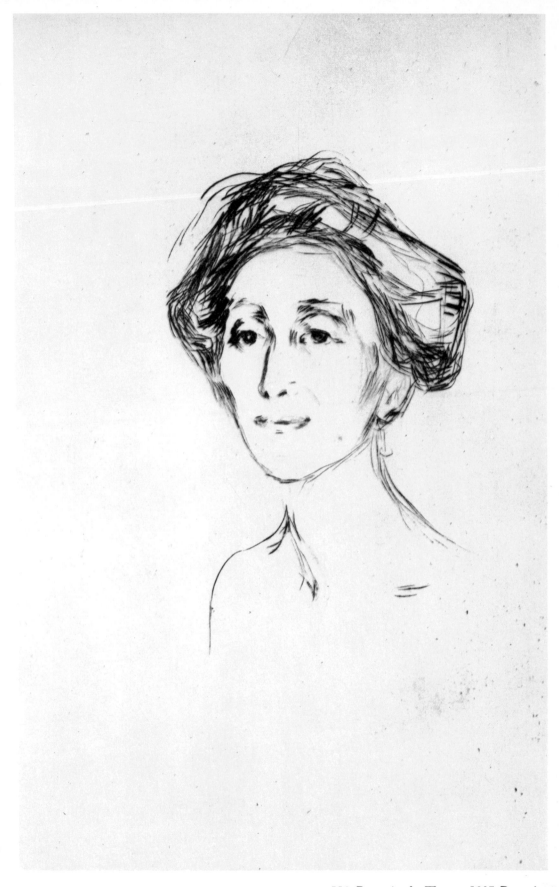

119 Portrait of a Woman. 1907. Drypoint

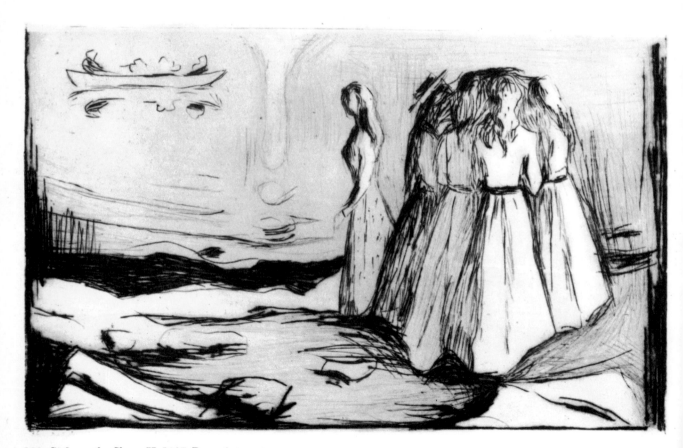

120 Girls on the Shore II. 1907. Drypoint

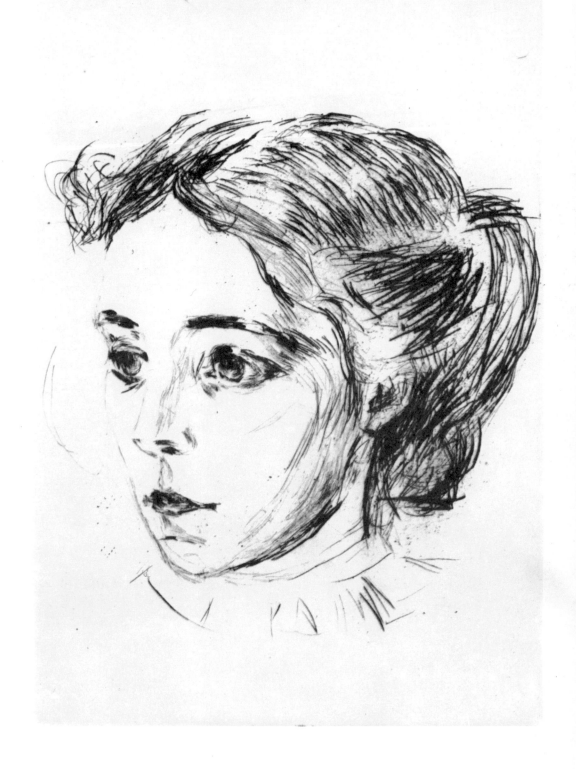

121 The Nurse. 1908/09. Drypoint

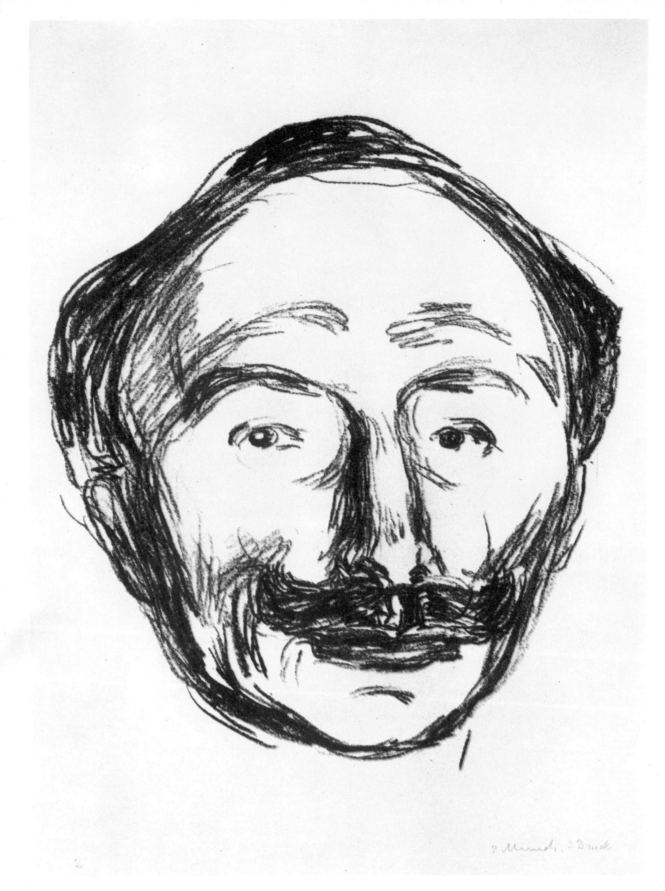

122 Portrait Emanuel Goldstein. 1908/09. Lithograph

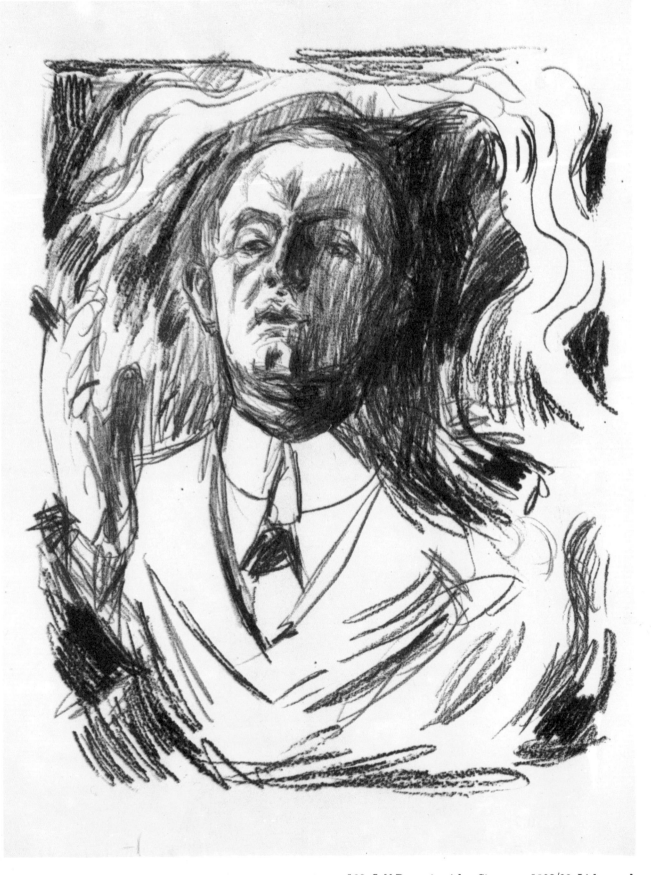

123 Self-Portrait with a Cigarette. 1908/09. Lithograph

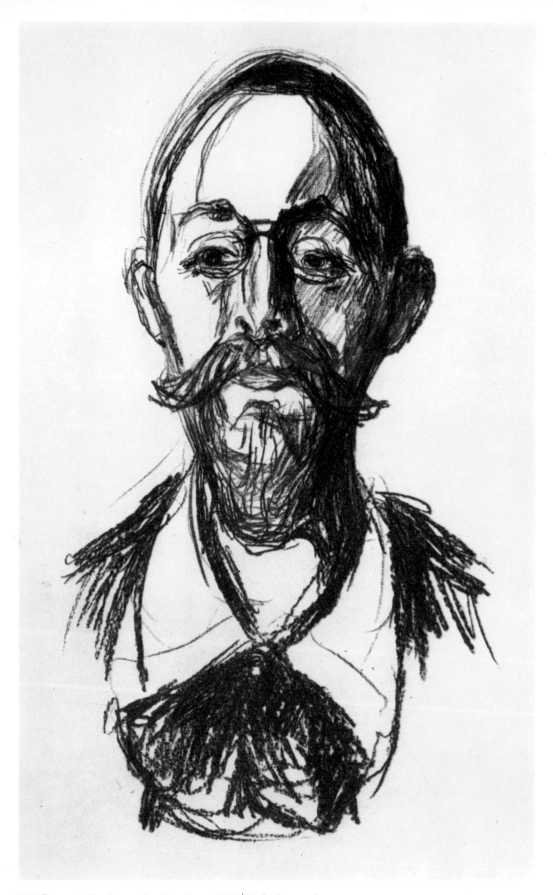

124 Portrait Professor Dr. Jacobson. 1908/09. Lithograph

125 a Melancholia (The insane Woman). 1908/09. Lithograph
125 b Nude mourning. 1908/09. Lithograph

126 Gorilla. 1909. Lithograph

127 Head of a Tiger. 1909. Lithograph

128 Women by the Shore on a Summer Night. 1909. Woodcut

129 Tempest. 1909. Woodcut

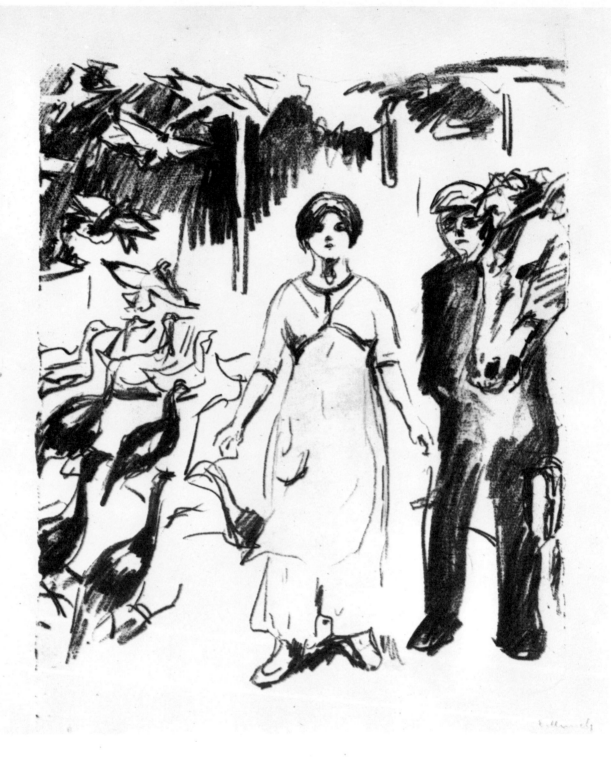

130 Girl and Youth in Poultry Yard. 1912. Lithograph

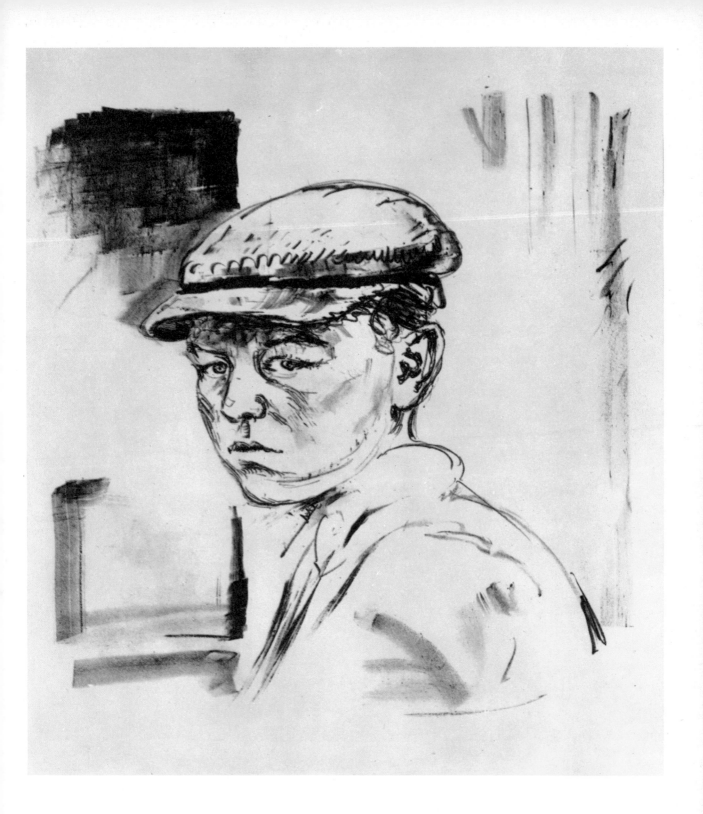

131 Young Farm Servant. 1912. Lithograph

132 Workman digging. 1920. Lithograph

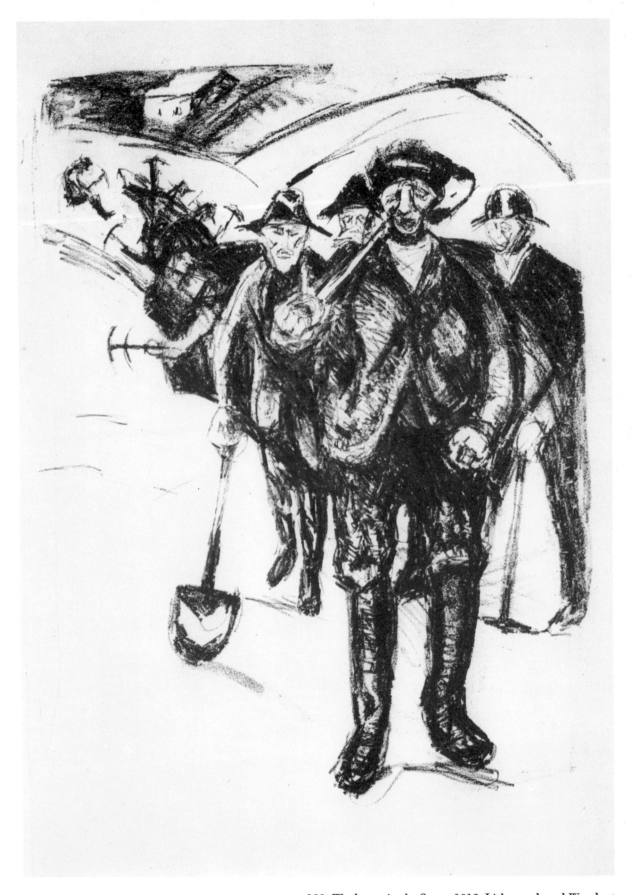

133 Workmen in the Snow. 1912. Lithograph and Woodcut

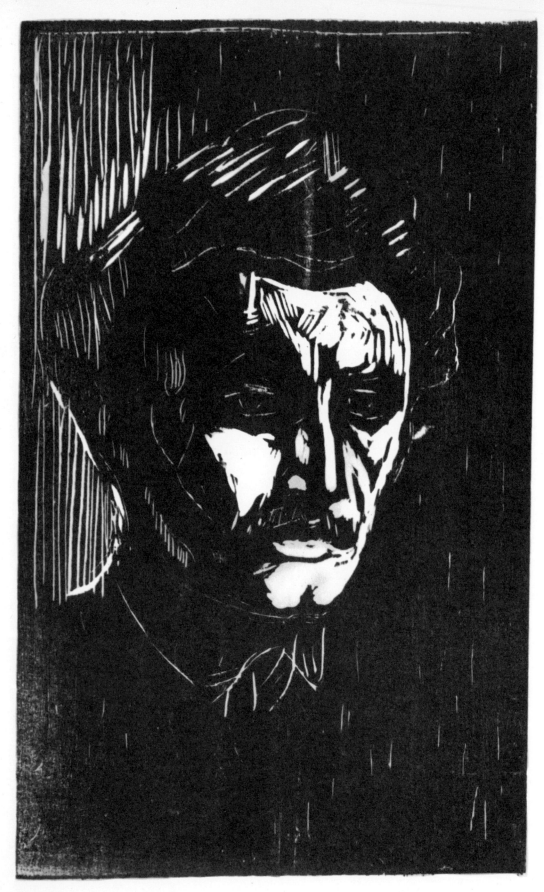

134 Self-Portrait. 1911. Woodcut

135 Two People. 1913. Drypoint

136 The Secret. 1913. Etching

137 The Bite. 1913. Etching

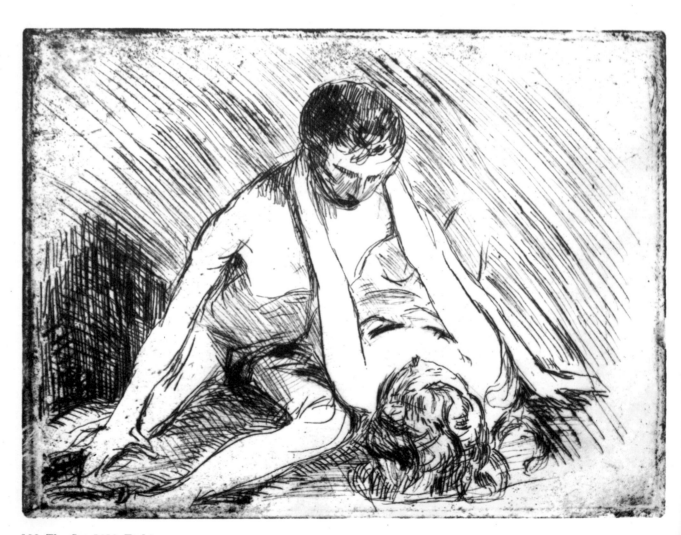

138 The Cat. 1913. Etching

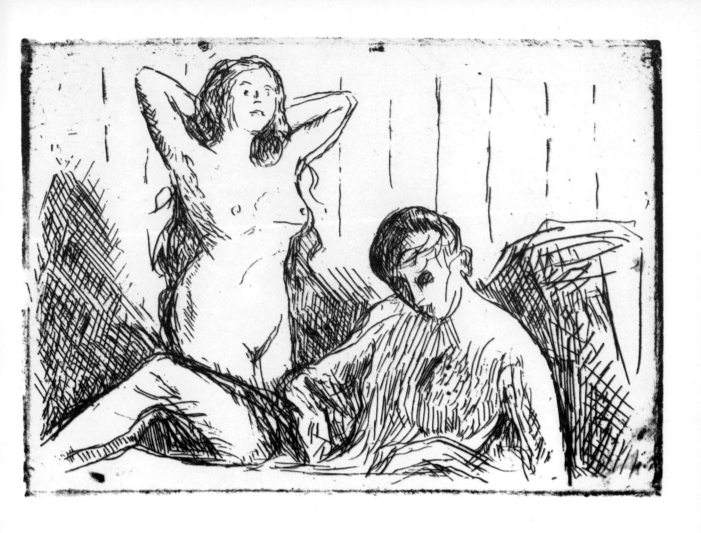

139 Ashes. 1913. Etching

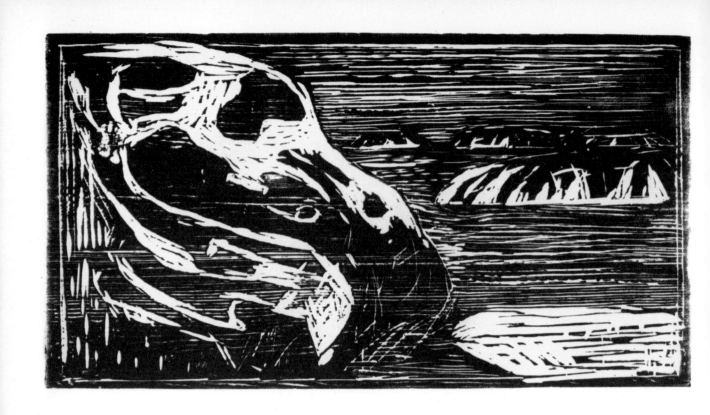

140 Cliffs by the Sea. 1912. Woodcut

141 The House on the Coast. 1915. Woodcut

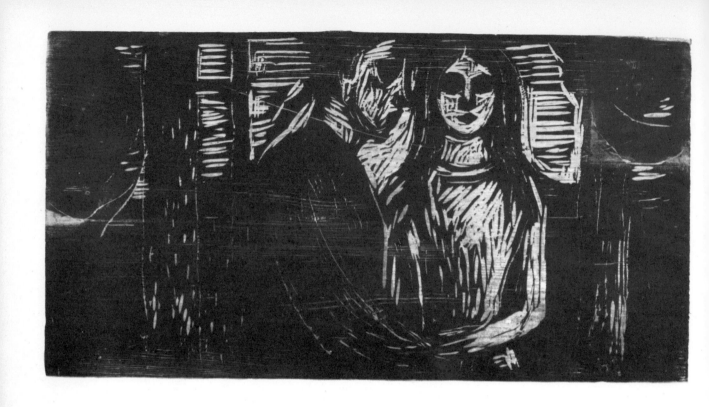

142 Lovers in a Pine Wood. 1915. Coloured Woodcut

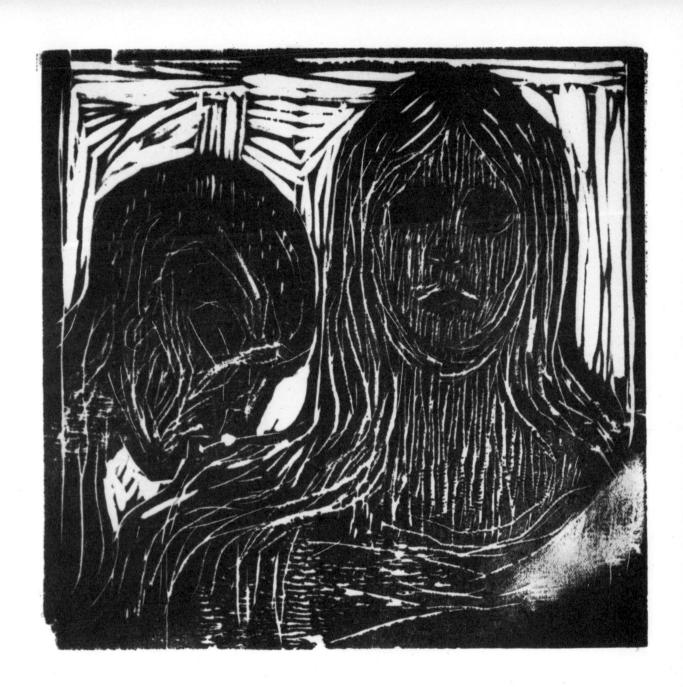

143 Kiss on the Hair. 1915. Woodcut

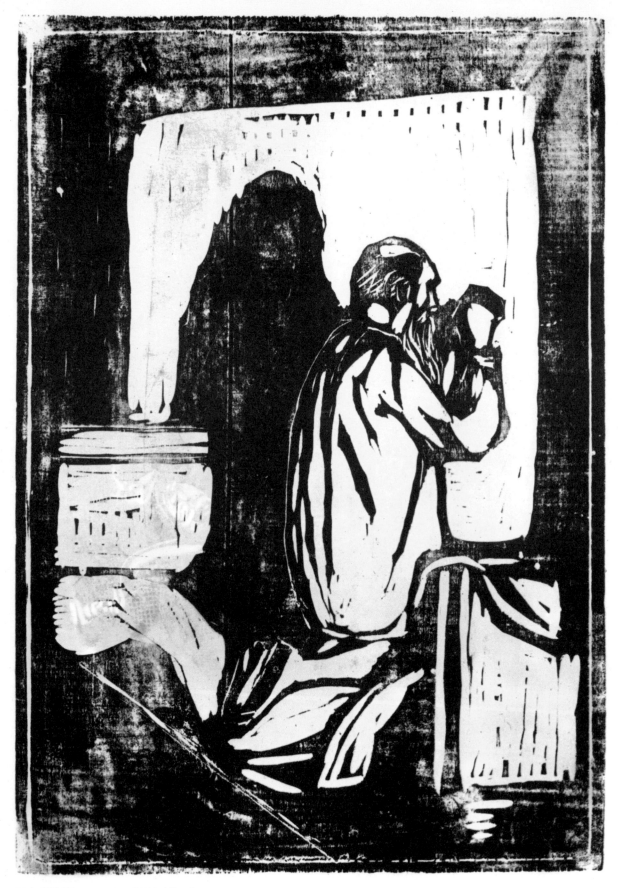

144 Old Man praying. 1902. Woodcut

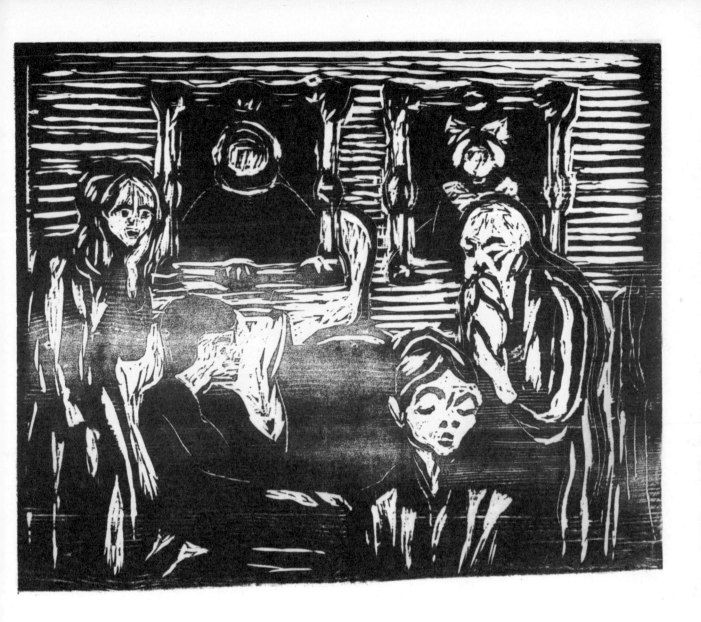

145 Sick Room. 1920. Woodcut

146 The Story. 1914. Lithograph

147 Alma Mater. 1914. Lithograph

148 Life and Death. 1897. Lithograph

149 Pregnant Woman leaning against a Tree. C. 1915. Lithograph

150 The Tree. 1915. Lithograph

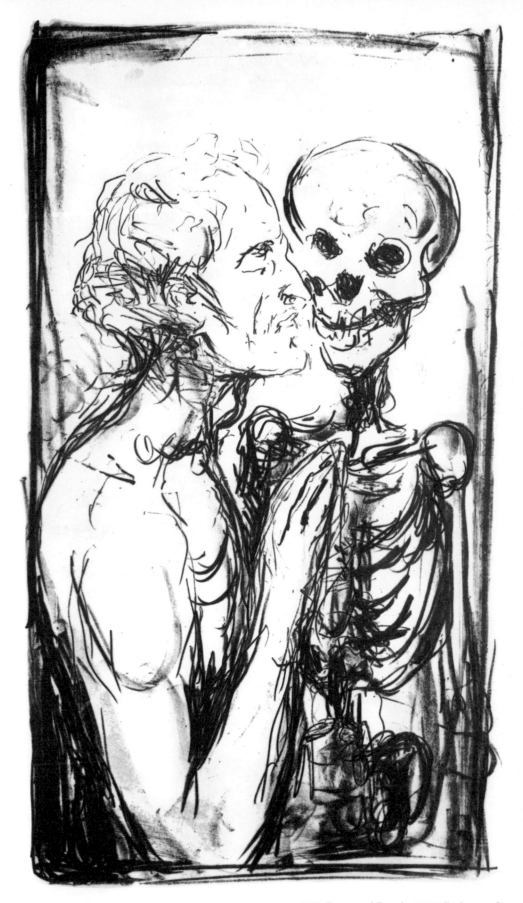

151 Dance of Death. 1915. Lithograph

152 Ship-building Yard. 1915/16. Etching

153 Galloping Horse. 1915. Etching

154 Head of a Lion. 1915. Lithograph

155 Picking Apples. 1916. Coloured Lithograph

156 Anxiety. 1915. Lithograph

157 Anxiety. C. 1915. Lithograph

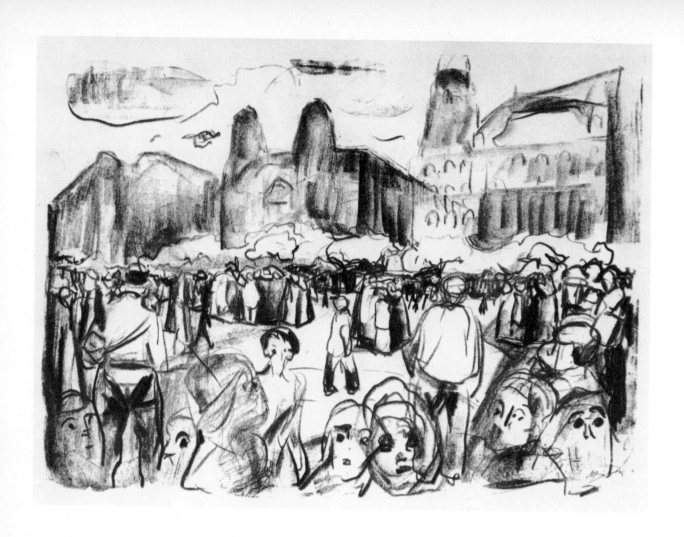

158 Demonstration at Frankfurt Railway Station. 1922. Lithograph

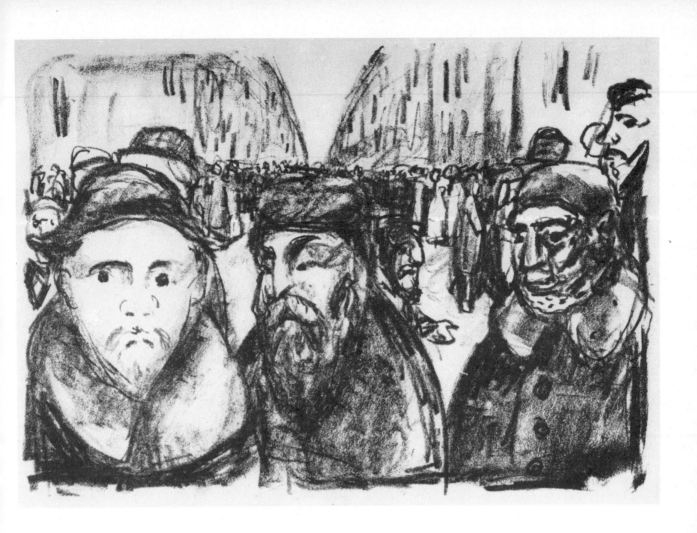

159 *Grenadierstrasse*, Berlin. 1920. Lithograph

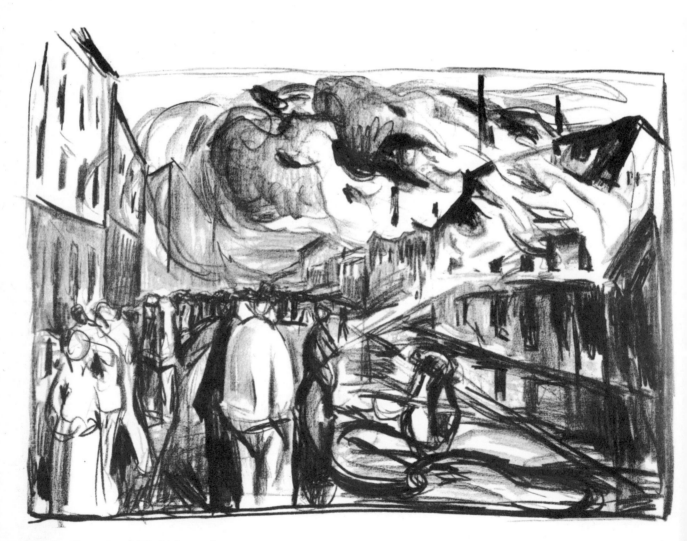

160 Conflagration. 1920. Lithograph

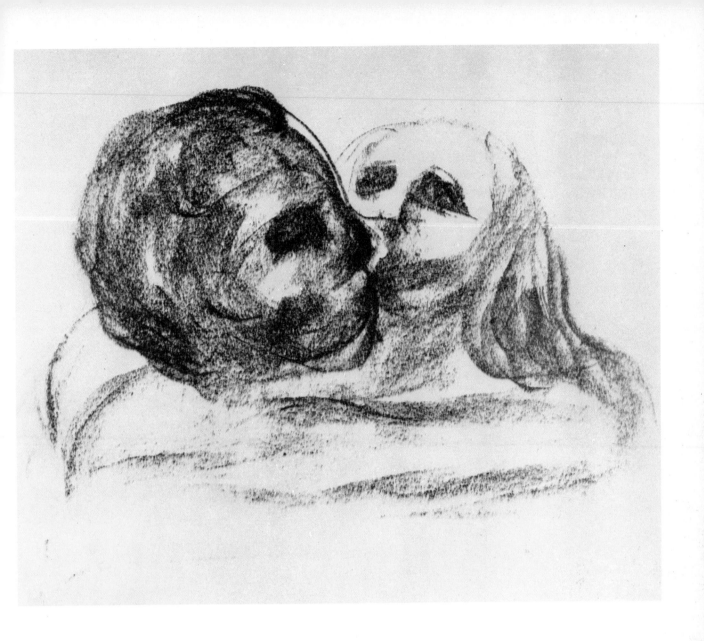

161 The Kiss. 1913. Lithograph

162 Girl from Skagen. 1920. Lithograph

163 Woman resting. 1919/20. Lithograph

164 Peasant Girl. 1922. Lithograph

165 Woman sitting (The Foot Bath). 1920. Lithograph

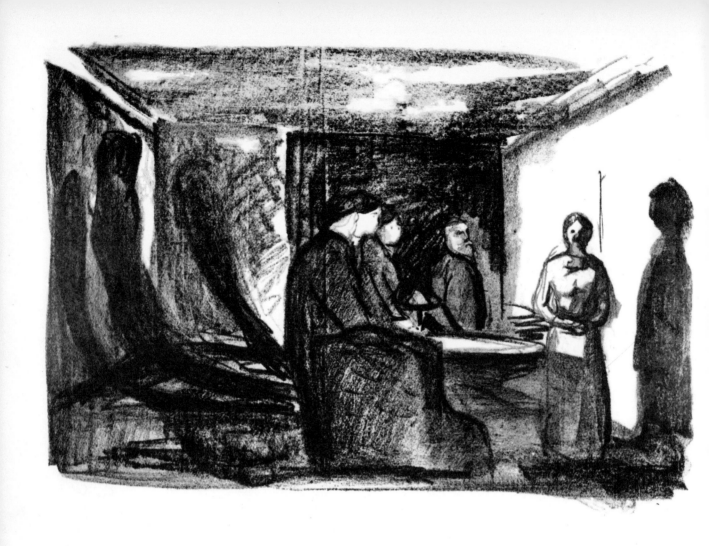

166 Family Scene (from Ibsen's 'Ghosts'). 1920. Lithograph

167 Oswald (from Ibsen's 'Ghosts'). 1920. Lithograph

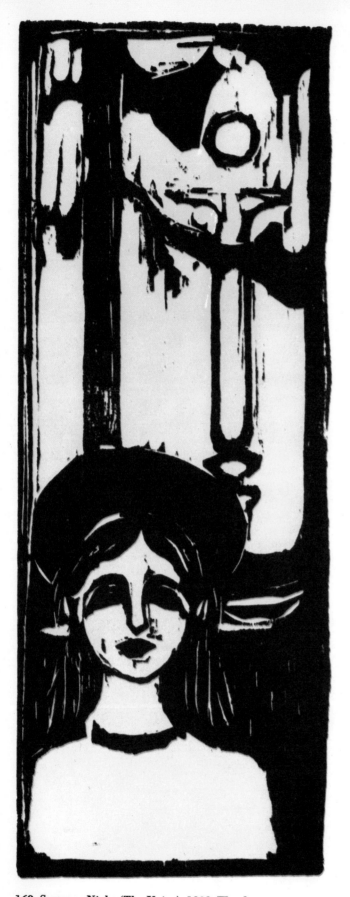

168 Summer Night (The Voice). 1898. Woodcut

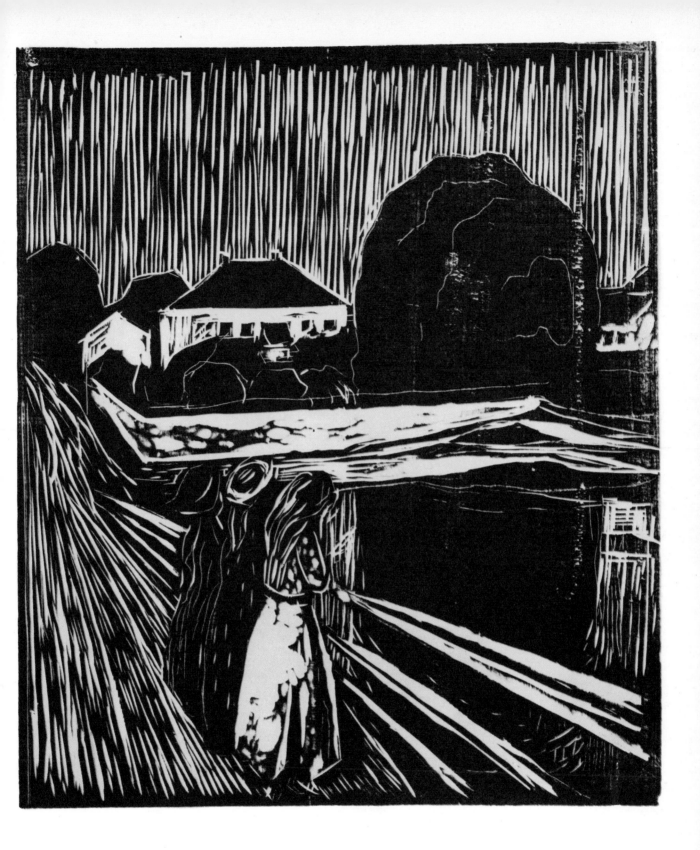

169 Girls on the Bridge. 1920. Woodcut

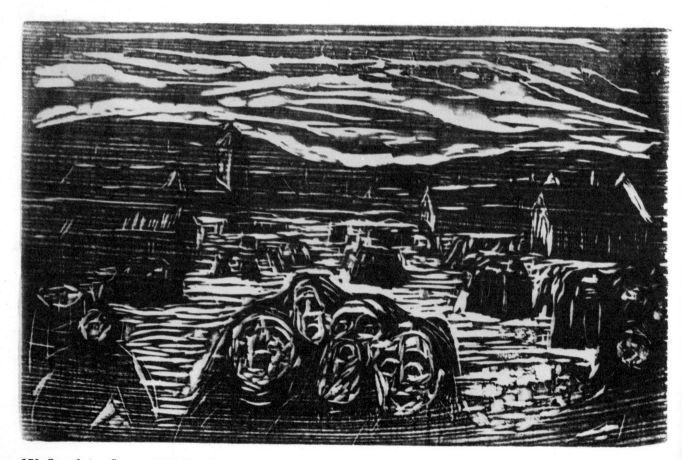

170 Crowds in a Square. 1920. Woodcut

171 Panic. 1920. Woodcut

172 The Last Hour (from Ibsen's 'The Pretenders'). 1920. Woodcut

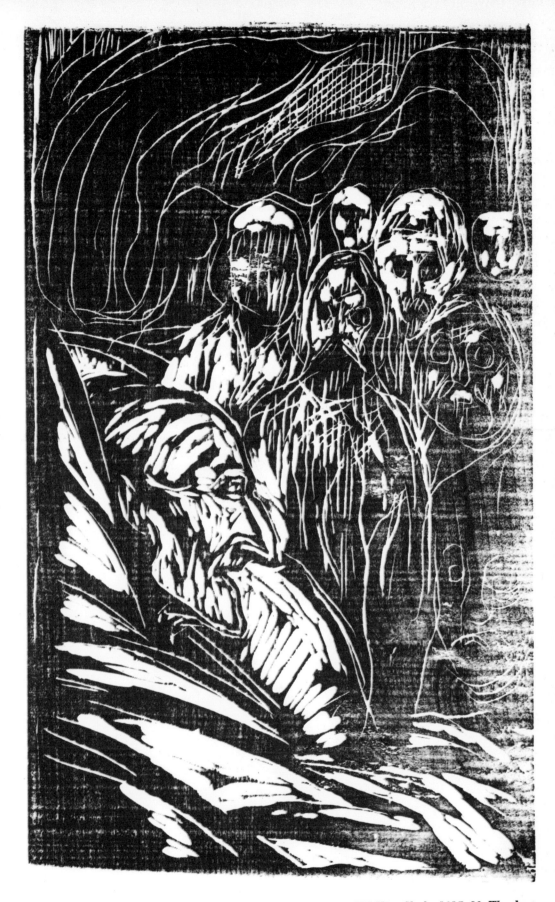

173 Old King Skule. 1917–20. Woodcut

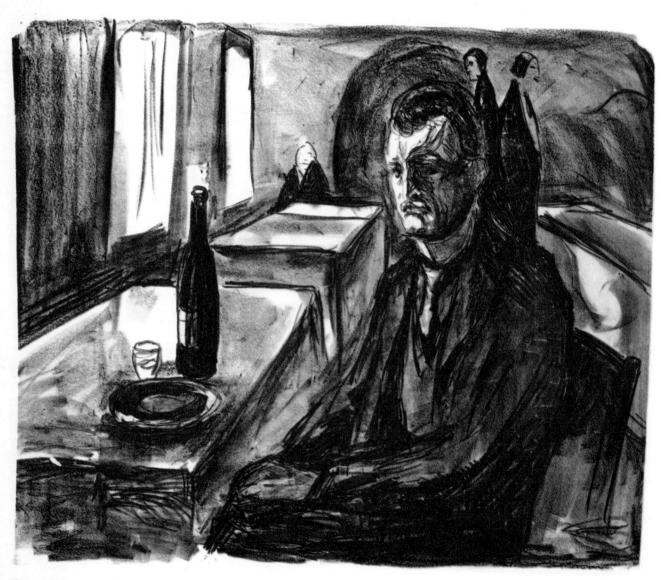

174 Self-Portrait with Wine Bottle. 1925/26. Lithograph

175 Self-Portrait after an Illness. 1922. Lithograph

176 Self-Portrait with Hat. 1932. Lithograph

177 Portrait Ludwig Justi. 1927. Lithograph

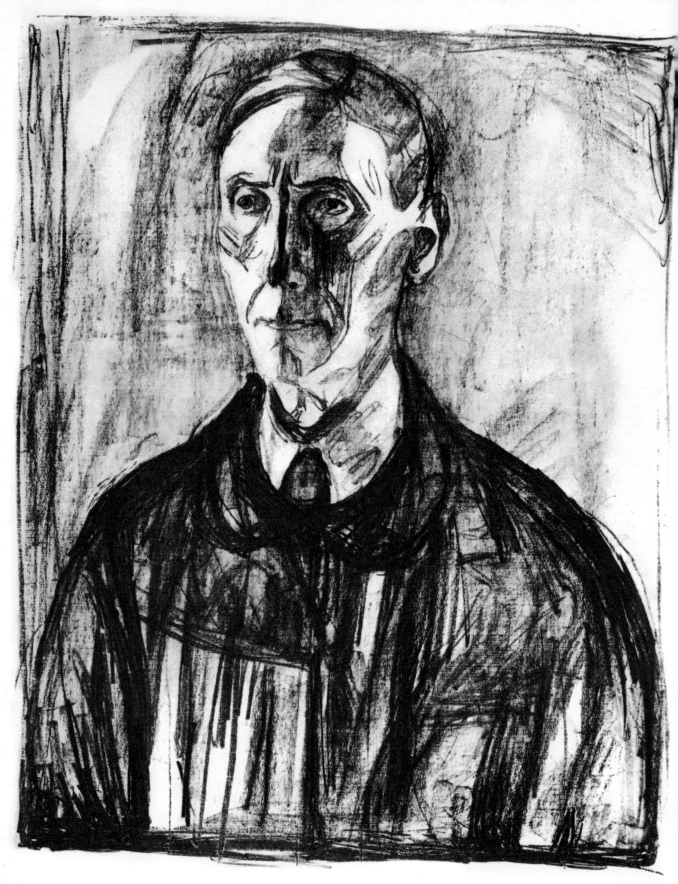

178 Portrait Professor Schreiner. C. 1930. Lithograph

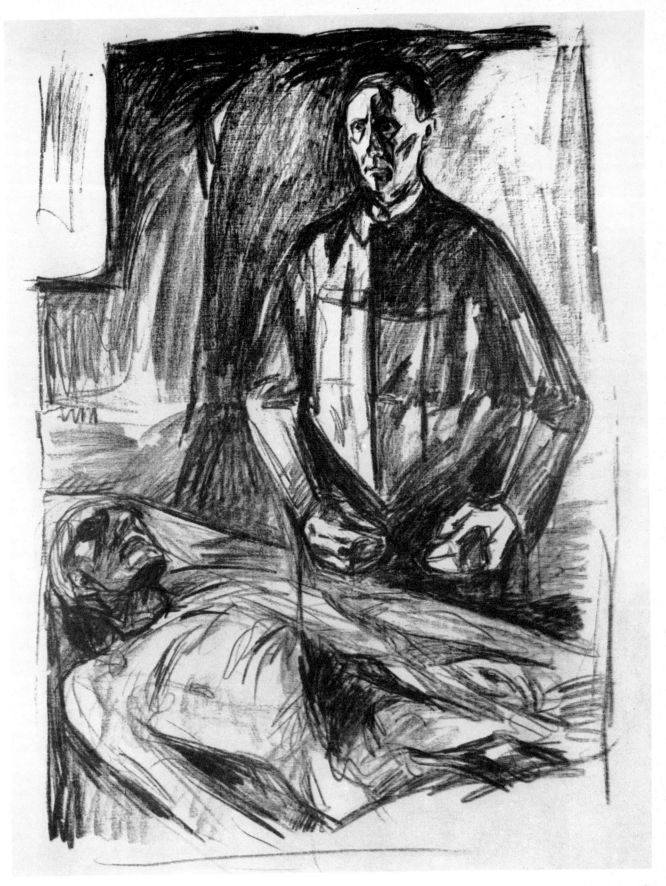

179 Professor Schreiner before Munch's Body. C. 1930. Lithograph

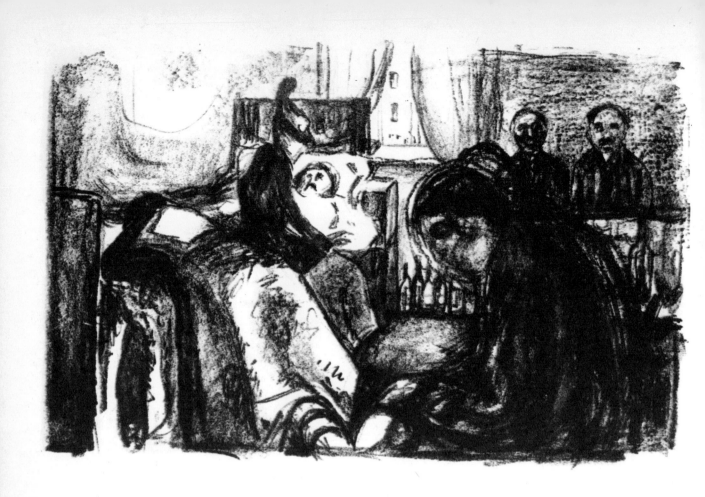

180 **Death of the Bohemian. 1927. Lithograph**

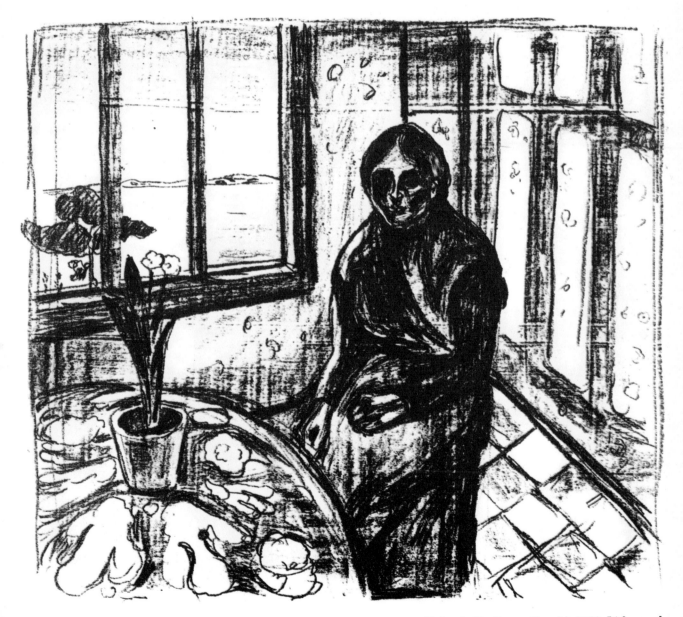

181 Melancholia (Laura Munch). 1930. Lithograph

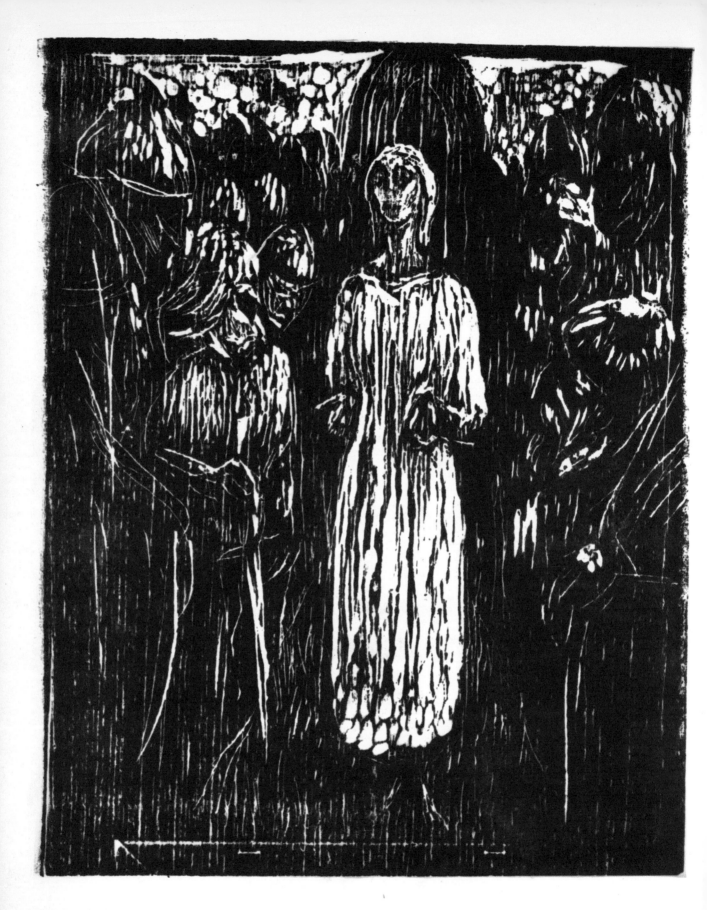

182 The Ordeal. 1927–31. Woodcut

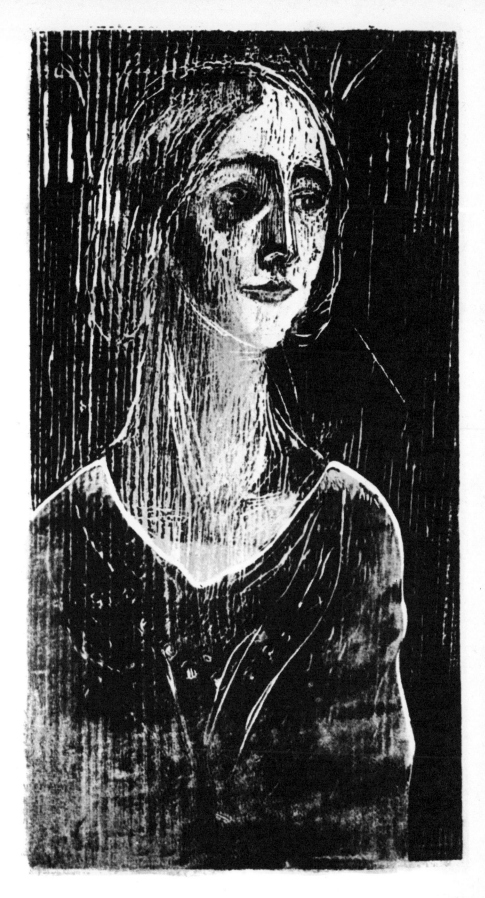

183 Birgitte III (The Gothic Girl). 1931. Woodcut

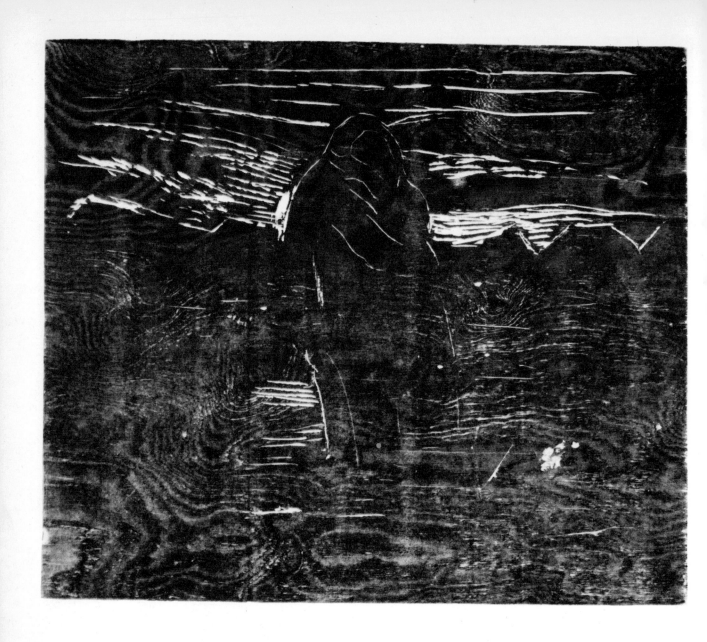

184 The Kiss in the Fields. C. 1943. Woodcut

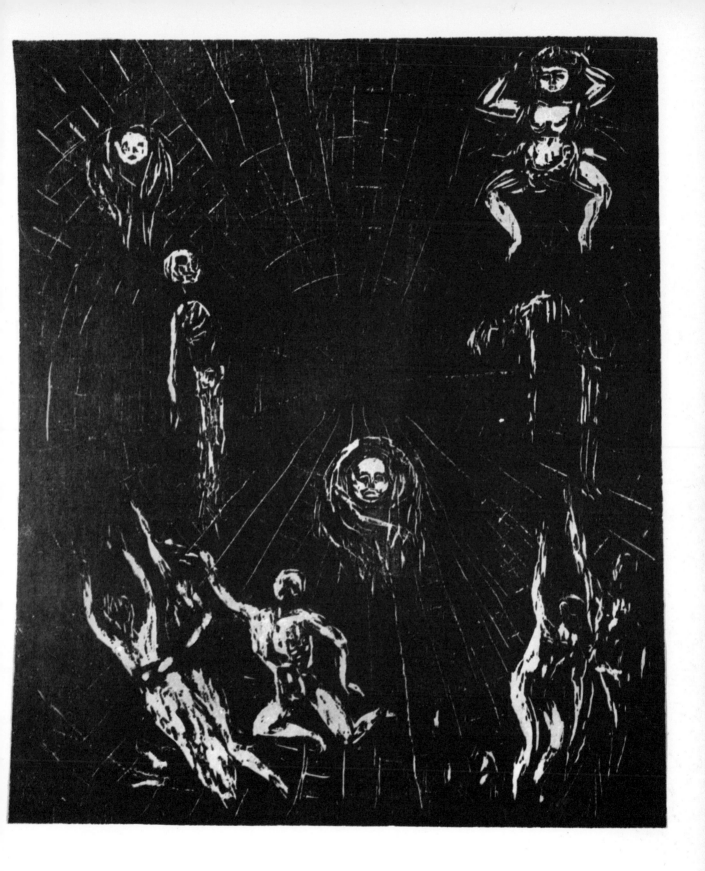

185 Spider's Web. 1943. Woodcut

33 *The Kiss.* 1892
Painting

34 *The Kiss.* 1895
Etching 34.3 : 27.3 cm. Sch 22; W 22

35 *The Kiss.* 1902
Woodcut 46.6 : 47.4 cm. Sch 102 D

36 Hans Baldung Grien, *Death and the Woman.* C. 1517
Painting. *Kunstmuseum*, Basle

37 *The two Girls and the Skeleton.* 1896
Drypoint 31.5 : 42.9 cm. Sch 44; W 36

38 *Three Heads. Paraphrases of The three Stages of Woman.* 1909
Lithograph from Alpha and Omega. C. 30 : 18.5 cm. Sch 309

39 *Salome.* 1905
Drypoint 14 : 10 cm. Sch 223

40 *Three Flamingoes.* 1909
Lithograph 20.7 : 34 cm. Sch 298 b

41 *Two Lion Marmosets.* 1915
Lithograph 20.3 : 23 cm. Sch 436

42 *Alpha and Omega.* 1909
Lithograph 25 : 44 cm. Sch 310

43 *The Rising Moon.* 1909
Lithograph 21 : 43.5 cm. Sch 311

44 *The Forest.* 1909
Lithograph 33.5 : 42 cm. Sch 322

45 *Shadows.* 1909
Lithograph 25 : 49.3 cm. Sch 313

46 *The Snake is strangled.* 1909
Lithograph 21.5 : 32.5 cm. Sch 314

47 *The Bear.* 1909
Lithograph 23 : 19 cm. Sch 315

48 *The Tiger.* 1909
Lithograph 31 : 37.5 cm. Sch 316

49 *Tiger and Bear.* 1909
Lithograph 24.5 : 46 cm. Sch 317

50 *Omega and the Flowers.* 1909
Lithograph 26 : 18.5 cm. Sch 318

51 *Omega's Eyes.* 1909
Lithograph 23 : 18 cm. Sch 319

52 *Omega and the Donkey.* 1909
Lithograph 23.5 : 35 cm. Sch 320

53 *Omega and the Pig.* 1909
Lithograph 32 : 46.5 cm. Sch 321

54 *Omega weeps.* 1909
Lithograph 27.5 : 18.5 cm. Sch 322

55 *Omega's Flight.* 1909
Lithograph 24.5 : 49 cm. Sch 323

56 *Alpha's Progeny.* 1909
Lithograph 25.5 : 50 cm. Sch 324

57 *Despair.* 1909
Lithograph 42 : 33 cm. Sch 325

58 *Omega's Death.* 1909
Lithograph 30 : 53 cm. Sch 326

59 *Alpha's Death.* 1909
Lithograph 28.5 : 48.5 cm. Sch 327

60 *Portrait Hans Jäger III.* 1943
Lithograph. MS 548

61 *Self-Caricature.* C. 1927
Line block from a drawing Schiefler III, S 29

62 Seventeen Vignettes for G. Schiefler, Edvard Munch. *Das graphische Werk.* 1906–1926. Berlin 1928
These vignettes are mostly variations of earlier work, for example: Garden (Sch 176, 1902), Sister Inger on the Shore (painting, 1889), The House (Sch 187, 1902), The Poodle (Bødtker caricature, Sch 206, 1903), Woman in three Stages (compare: Sch 21, 1895), The Fat Man (Heiberg caricature, compare: Sch 208, 1903) etc. In auction catalogues (*Stuttgarter Kunstkabinett*, 35. *Auktion* 1960, No 1260, and *Galerie Bassenge*, Berlin, *Auktion* 8, November 1960, No 1398) the vignettes, printed on one sheet were called lithographs, though Schiefler's catalogue lists them in the impressum expressly as line blocks

from drawings. Presumably these were printed separately for collectors.

63 *Munch at the Easel in the Snow.* C. 1927
Line block from a drawing Schiefler III, S 10

64 Letter to Julius Meier-Graefe, with drawing (Self-Portrait, Christmas 1924)

65 *The Heart.* 1899
Coloured Woodcut 25.2 : 18.4 cm. Sch 134

Plates

1 *Self-Portrait.* 1895
Lithograph 45.7 : 32 cm. Sch 31

2 *The Girl and Death.* 1894
Drypoint 30.6 : 22 cm. Sch 3 II; W 3 II

3 *Vampire.* 1894
Drypoint 29.9 : 22.9 cm. Sch 4 I; W 4 I

4 *Consolation.* 1894
Charcoal 47.8 : 63.2 cm. Preliminary sketch for Sch 6. *Munch-Museum,* Oslo

5 *Consolation.* 1894
Drypoint and Aquatint 20.8 : 30.9 cm. Sch 6; W 6

6 *Portrait Sigbjørn Obstfelder.* 1897
Etching 17.9 : 13.7 cm. Sch 88; W 53

7 *The Sick Girl.* 1894
Drypoint 38.7 : 29.2 cm. Sch 7 V c; W 7 V

8 *Girl at the Window.* 1894
Drypoint 22 : 15.7 cm. Sch 5 V c; W 5 V

9 *Study of a Model.* 1894/95
Drypoint 26.1 : 18.2 cm. Sch 9; W 8

10 *The young Model.* 1894
Lithograph 40 : 27.5 cm. Sch 8

11 *Moonlight.* 1895
Drypoint and Aquatint 31 : 25.3 cm. Sch 13; W 12

12 *Christiania-Bohème I.* 1895
Etching and Aquatint 21.9 : 29.8 cm. Sch 10 II c; W 9 III

13 *Christiania-Bohème II.* 1895
Drypoint and Aquatint 28 : 37.6 cm. Sch 11; W 10

14 *Tête-à-Tête.* 1895
Etching 21.8 : 32.8 cm. Sch 12 III c; W 11 II

15 *Bathing Girls.* 1895
Etching and Aquatint 28 : 37.6 cm. Sch 14 III; W 13 III

16 *The Day After.* 1895
Drypoint and Aquatint 20.4 : 29.6 cm. Sch 15 IV c; W 14 V

17 *Lovers on the Shore (Attraction).* 1896
Lithograph 48 : 36 cm. Sch 65

18 *Portrait Sigbjørn Obstfelder.* 1896
Lithograph 36 : 27.5 cm. Sch 78

19 *Portrait Hans Jäger.* 1896
Lithograph 46 : 33 cm. Sch 76

20 *Two People (The Lonely Ones).* 1895
Drypoint 22.8 : 26.7 cm. Sch 20 V b; W 19 V

21 *Young Girl on the Shore (The Lonely One).* 1896
Coloured Mezzotint 28.7 : 21.8 cm. Sch 42

22 *Woman.* 1895
Drypoint and Aquatint 29.5 : 34.5 cm. Sch 21 B III a; W 21 IV

23 *Woman (The Sphinx).* 1899
Lithograph 46 : 59.4 cm. Sch 122

24 *Summer Night (The Voice).* 1895
Drypoint and Aquatint 24.4 : 32.4 cm. Sch 19 I; W 18 I

25 *The Kiss.* 1895
Drypoint and Aquatint 34.3 : 27.3 cm. Sch 22 a; W 22

26 *Portrait Graf Kessler.* 1895
Lithograph 23 : 17.5 cm. Sch 30 I

27 *Portrait Dr. Max Asch.* 1895
Drypoint 26.5 : 18.8 cm. Sch 27 I a;
W 27 II

28 *The Shriek.* 1895
Lithograph 35 : 25.2 cm. Sch 32

29 *Anxiety.* 1896
Two-coloured Lithograph 41.2 : 38.5 cm.
Sch 61 b II

30 *Evening.* 1897
Lithograph 35.4 : 14.8 cm. Sch 97

31 *Madonna (Conception).* 1895.
The coloured stones were added in
1902.
Coloured Lithograph 60.7 : 44.3 cm.
Sch 33 A II b

32 *The Alley (Carmen).* 1895
Lithograph 42.8 : 26.8 cm. Sch 36 b

33 *Lust.* 1895
Lithograph 48 : 29 cm. Sch 35

34 *Music-Hall (Academy of Music,
Berlin, Friedrichstrasse).* 1895
Lithograph 44.6 : 63 cm. Sch 37

35 *Vampire.* 1895
Lithograph 38.8 : 55.7 cm. Sch 34 a II

36 *Under the Yoke.* 1896
Etching and Drypoint 23.6 : 33 cm.
Sch 49

37 *Girl with Heart.* 1896
Etching 23.6 : 23.7 cm. Sch 48

38 *Agony.* 1895
Drawing 22.3 : 31.8 cm. Preliminary
Sketch for Sch 72. *Munch-Museum*, Oslo

39 *Agony.* 1896
Lithograph 40 : 50.9 cm. Sch 72

40 *The Death Chamber.* 1896
Lithograph 38.5 : 55 cm. Sch 73

41 *Visit of Condolence.* 1904
Woodcut 49.5 : 50.9 cm. Sch 218 a

42 *The Urn.* 1896
Lithograph 46 : 26.5 cm. Sch 63

43 *The Sick Girl.* 1896
Coloured Lithograph 42 : 56.4 cm.
Sch 59 d

44 *Attraction.* 1896
Lithograph 39.5 : 62.5 cm. Sch 66

45 *Separation.* 1896
Coloured Lithograph 41.7 : 64.5 cm.
Sch 68 a

46 *The Flower of Love.* 1896
Lithograph 62 : 29 cm. Sch 70

47 *Lovers in the Waves.* 1896
Lithograph 31 : 41.9 cm. Sch 71

48 *Portrait Stéphane Mallarmé.* 1896
Lithograph 40.1 : 29.3 cm. Sch 79 a

49 *Portrait August Strindberg.* 1896
Lithograph 61 : 46 cm. Sch 77 II

50 *Portrait Gunnar Heiberg.* 1896
Coloured Lithograph 48.9 : 42.2 cm.
Sch 75 II

51 *Evening (Melancholia).* 1896
Coloured Woodcut 37.6 : 45.5 cm. Sch 82 b

52 *Self-Portrait.* C. 1906–08
Woodcut 43.5 : 42 cm. MS 697

53 *Moonlight.* 1896
Coloured Woodcut 41.2 : 46.5 cm.
Sch 81 Ac 2

54 *In Man's Brain.* 1897
Woodcut 37.2 : 56.7 cm. Sch 98

55 *Jealousy.* 1896
Lithograph 47.5 : 57.2 cm. Sch 58

56 *The Inheritance (Mother with syph-
ilitic Child).* C. 1897–99
Lithograph 43 : 30.7 cm. MS 545

57 *Funeral March.* 1897
Lithograph 55.5 : 37 cm. Sch 94

58 *To the Forest.* 1897
Coloured Woodcut 52.7 : 64.7 cm.
Sch 100 b

59 *To the Forest.* 1915
Coloured Woodcut 51 : 64.6 cm. Sch 444

60 *Portrait Helge Rode*. 1898
Drypoint 27.5 : 20.6 cm. Sch 103 IV;
W 55 IV

61 *Portrait Stanislaw Przybyszewski*.
1898
Lithograph 54.2 : 43.7 cm. Sch 105

62 *Salome Paraphrase*. 1898
Woodcut 40 : 25 cm. Sch 109

63 *Head of a Man below a Woman's
Breast*. 1898
Woodcut 44.6 : 19.4 cm. Sch 338

64 *Fertility*. 1898
Woodcut 42 : 51.9 cm. Sch 110

65 *Allegory*. 1898
Woodcut 46.5 : 33 cm. Sch 114

66 *Rouge et Noir*. 1898
Coloured Woodcut 25.2 : 19 cm. Sch 115

67 *The Kiss*. 1902
(First State 1897)
Woodcut 46.6 : 47.4 cm. Sch 102 D

68 *Large Snowscape*. 1898
Woodcut 32.3 : 45.3 cm. Sch 118 a

69 *Seascape*. 1899
Woodcut 37.2 : 57.2 cm. Sch 125

70 *The old Fisherman*. 1899
Woodcut 44.2 : 35.3 cm. Sch 124

71 *Bathing Girl (The Water-Sprite)*.
1899
Woodcut 42.5 : 51.8 cm. Sch 128

72 *Youth and Age*. C. 1909
Charcoal 38.5 : 30.6 cm. *Munch-Museum*,
Oslo

73 *Women on the Shore*. 1898
Coloured Woodcut 45.4 : 51.1 cm.
Sch 117 b

74 *The Kiss of Death*. 1899
Lithograph 29.5 : 46 cm. Sch 119

75 *Man and Woman*. 1899
Woodcut 42 : 51 cm. Sch 132

76 *Ashes II*. 1899
Lithograph 35.4 : 45.5 cm. Sch 120

77 *Ibsen in the Grand Hotel Cafe in
Christiania*. 1902
Lithograph 43.5 : 59.3 cm. Sch 171

78 *Meeting in Space*. 1899
Coloured Woodcut 18.1 : 25.1 cm. Sch 135

79 *Two People (The Lonely Ones)*.
1899
Coloured Woodcut 39.5 : 53 cm. Sch 133

80 *Harpy*. 1900
Lithograph 36.5 : 31.9 cm. Sch 137

81 *Nude (Sin)*. 1901
Coloured Woodcut 49.5 : 39.8 cm.
Sch 142 c

82 *Three Faces*. 1902
Mezzotint 29.6 : 39.4 cm. Sch 145; W 60

83 *Dead Lovers*. 1901
Etching 32 : 49.2 cm. Sch 139 II; W 58 II

84 *Workman*. 1902
Etching 44.6 : 12.5 cm. Sch 146; W 61

85 *Potsdamer Platz*. 1902
Drypoint and Aquatint 23.8 : 29.6 çm.
Sch 156 II; W 71 III

86 *Old Women in Hospital*. 1902
Etching 18.8 : 13.1 cm. Sch 154; W 69

87 *Old Woman on a Bench*. 1902
Etching 20 : 14.9 cm. Sch 152

88 *Head of a Girl*. 1902
Drypoint 33.7 : 26 cm. Sch 162; W 77

89 *Puberty*. 1902
Etching 19.8 : 15.8 cm. Sch 164; W 79

90 *Double Portrait Leistikow*. 1902
Lithograph 53 : 86.8 cm. Sch 170

91 *Portrait Holger Drachmann*. 1901
Lithograph 58.7 : 51 cm. Sch 141

92 *Portrait Dr. Max Linde*. 1902
Drypoint 35 : 25 cm. Sch 178; W 85

93 *Portrait Marie Linde*. 1902
Lithograph 27.5 : 21 cm. Sch 190

94 *The Garden*. 1902
Etching and Drypoint 49.6 : 64.4 cm.
Sch 188; W 95

95 *The House.* 1902
Etching and Drypoint 49.3 : 64.6 cm.
Sch 187; W 94

96 *Lübeck.* 1903
Etching 49.6 : 64.4 cm. Sch 195; W 99

97 *The Oak.* 1903
Etching 64.2 : 49.6 cm. Sch 196; W 100

98 *Homage to Society.* 1899
Lithograph 41.8 : 52.8 cm. Sch 121

99 *The Swamp.* 1903
Lithograph 26 : 49.5 cm. Sch 205

100 *Phantoms.* 1905
Drypoint 14.1 : 19 cm. Sch 224

101 *Cause and Effect.* 1904
Lithograph 33 : 42 cm. MS 516

102 *The Brooch (Eva Mudocci).* 1903
Lithograph 55.5 : 46 cm. Sch 212

103 *Salome.* 1903
Lithograph 40.5 : 30.5 cm. Sch 213

104 *Violin Concert (Bella Edvards
and Eva Mudocci).* 1903
Lithograph 47.3 : 54.3 cm. Sch 211 II

105 *Man and Woman kissing.* 1905
Coloured Woodcut 39.5 : 54 cm. Sch 230 a

106 *Little Norwegian Girl.* 1908/09
Lithograph 41.4 : 20.1 cm. Sch 284 b

107 *Head of a Child.* 1905
Drypoint 17.3 : 12.4 cm. Sch 220; W 113

108 *Old Men and Boys.* 1905
Woodcut 35.1 : 44.2 cm. Sch 235

109 *Old Man (Primitive Man).* 1905
Woodcut 68.7 : 45.6 cm. Sch 237

110 *Washerwoman on the Shore.* 1903
Woodcut 30 : 46 cm. Sch 210

111 *Flight.* 2nd state, after 1908
(1st state 1898)
Lithograph approx. 62.5 : 44.5 cm.
MS 446

112 *Portrait Albert Kollmann.* 1906
Lithograph 43 : 33.5 cm. Sch 244

113 *Portrait Henry van de Velde.*
1906
Lithograph 26 : 17.5 cm. Sch 246

114 *Portrait Andreas Schwarz.* 1906
Lithograph 29 : 22 cm. Sch 251

115 *Portrait Frau Schwarz.* 1906
Lithograph 26.7 : 24.6 cm. Sch 252

116 *Portrait and Nude seen from
rear.* 1906
Crayon 53.8 : 67.8 cm. Study for Sch 253.
Munch-Museum, Oslo

117 *Death of Marat.* 1906/07
Coloured Lithograph 44 : 34.5 cm.
Sch 258 b 2

118 *Small Norwegian Landscape.* 1907
Drypoint 8.8 : 12.5 cm. Sch 260; W 133

119 *Portrait of a Woman.* 1907
Drypoint 23.5 : 15.5 cm. Sch 261; W 134

120 *Girls on the Shore II.* 1907
Drypoint 12 : 18 cm. Sch 263; W 136

121 *The Nurse.* 1908/09
Drypoint 20.5 : 15.2 cm. Sch 269; W 140

122 *Portrait Emanuel Goldstein.*
1908/09
Lithograph 27.6 : 24.6 cm. Sch 276 c

123 *Self-Portrait with Cigarette.*
1908/09
Lithograph 56.4 : 45.7 cm. Sch 282

124 *Portrait Professor Dr. Jacobson.*
1908/09
Lithograph 51.5 : 29.5 cm. Sch 273 b 2

125 a *Melancholia (The Insane Woman).*
1908/09
Lithograph 24.9 : 11.7 cm. Sch 286 b

125 b *Nude, mourning.* 1908/09
Lithograph 27.9 : 11.9 cm. Sch 285 b

126 *Gorilla.* 1909
Lithograph 26 : 14.7 cm. Sch 291

127 *Head of a Tiger.* 1909
Lithograph 35 : 25.5 cm. Sch 288 b

128 *Women by the Shore on a Summer Night.* 1909
Woodcut 21.7 : 33 cm. Sch 339

129 *Tempest.* 1909
Woodcut 21.6 : 33.5 cm. Sch 341

130 *Girl and Youth in Poultry Yard.* 1912
Lithograph 44.6 : 37.6 cm. Sch 372

131 *Young Farm Worker.* 1912
Lithograph 35 : 30.5 cm. Sch 373 b

132 *Workmen digging.* 1920
Lithograph 43.5 : 59.2 cm. Sch 484 b

133 *Workmen in the Snow.* 1912
Lithograph and Woodcut 64.8.: 51 cm. Sch 385

134 *Self-Portrait.* 1911
Woodcut 53.5 : 35 cm. Sch 352 b

135 *Two People.* 1913
Drypoint 17.8 : 23.9 cm. Sch 398

136 *The Secret.* 1913
Etching 16 : 23.8 cm. Sch 403

137 *The Bite.* 1913
Etching 19.7 : 27.6 cm. Sch 396

138 *The Cat.* 1913
Etching 24 : 31.5 cm. Sch 397

139 *Ashes.* 1913
Etching 20 : 27.8 cm. Sch 400

140 *Cliffs by the Sea.* 1912
Woodcut 31.6 : 60 cm. Sch 389

141 *The House on the Coast.* 1915
Woodcut 34.6 : 54.1 cm. Sch 441 a

142 *Lovers in a Pine Wood.* 1915
Coloured Woodcut 32 : 60 cm. Sch 442

143 *Kiss on the Hair.* 1915
Woodcut 15.8 : 16.8 cm. Sch 443

144 *Old Man Praying.* 1902
Woodcut 46.1 : 32.5 cm. Sch 173

145 *Sick Room.* 1920
Woodcut 49.3 : 60 cm. Sch 492

146 *The Story.* 1914
Lithograph 41.7 : 78.6 cm. Sch 426 I b

147 *Alma Mater.* 1914
Lithograph 37 : 84 cm. Sch 427

148 *Life and Death.* 1897
Lithograph 36.5 : 25 cm. Sch 95

149 *Pregnant Woman leaning against a Tree.* c. 1915
Lithograph 68 : 46 cm. MS 476

150 *The Tree.* 1915
Lithograph 21.2 : 35.5 cm. Sch 433

151 *Dance of Death.* 1915
Lithograph 49 : 29 cm. Sch 432

152 *Ship-building Yard.* 1915/16
Etching 33.6 : 39.8 cm. W 183

153 *Galloping Horse.* 1915
Etching 38 : 32.9 cm. Sch 431; W 175

154 *Head of a Lion.* 1915
Lithograph 49.8 : 45.8 cm. Sch 456 c

155 *Picking Apples.* 1916
Coloured Lithograph 54.1 : 49.7 cm. Sch 459

156 *Anxiety.* 1915
Lithograph 26 : 39 cm. Sch 437

157 *Anxiety.* c. 1915
Lithograph 22 : 29 cm. MS 559

158 *Demonstration at Frankfurt Railway Station.* 1922
Lithograph 30 : 40.5 cm. Sch 510

159 *Grenadierstrasse, Berlin.* 1920
Lithograph 28 : 39.5 cm. Sch 496

160 *Conflagration.* 1920
Lithograph 54 : 74 cm. Sch 483

161 *The Kiss.* 1913
Lithograph 23 : 34 cm. Sch 413

162 *Girl from Skagen.* 1920
Lithograph 43.7 : 30 cm. Sch 475

163 *Woman resting.* 1919/20
Lithograph 58.1 : 46.3 cm. Sch 469

164 *Peasant Girl.* 1922
Lithograph 57.4 : 43.2 cm. Sch 508

165 *Woman sitting. (The Foot-Bath).*
1920
Lithograph 59.8 : 44.2 cm. Sch 482

166 *Family Scene (from: Ibsen's 'Ghosts').* 1920
Lithograph 40 : 63 cm. Sch 486

167 *Oswald (from: Ibsen's 'Ghosts').*
1920
Lithograph 39 : 50 cm. Sch 487

168 *Summer Night (The Voice).* 1898
Woodcut 25.1 : 9.3 cm. Sch 113

169 *Girls on the Bridge.* 1920
Woodcut 49.8 : 42.8 cm. Sch 488 a

170 *Crowds in a Square.* 1920
Woodcut 30.8 : 49.3 cm. Sch 490

171 *Panic.* 1920
Woodcut 38.9 : 53.5 cm. Sch 489

172 *The last Hour (from: Ibsen's 'The Pretenders').* 1920
Woodcut 42.5 : 58 cm. Sch 491

173 *Old King Skule (The death of bishop Niclas?).* 1917–20
Woodcut 56 : 36 cm. MS 669

174 *Self-Portrait with Wine Bottle.*
1925/26
Lithograph 42.5 : 50.5 cm. MS 492

175 *Self-Portrait after an Illness.* 1920
Lithograph 41.5 : 60 cm. Sch 503

176 *Self-Portrait with Hat.* 1932
Lithograph 21 : 19 cm. MS 456

177 *Portrait Ludwig Justi.* 1927
Lithograph 31.5 : 19.9 cm. MS 453

178 *Portrait Professor Schreiner.*
c. 1930
Lithograph 67.7 : 43.7 cm. MS 554

179 *Professor Schreiner before Munch's Body.* c. 1930
Lithograph 74 : 55 cm. MS 551

180 *Death of the Bohemian.* 1927
Lithograph approx. 25 : 40 cm. MS 538

181 *Melancholia (Laura Munch).* 1930
Lithograph from a painting of C. 1900,
37.5 : 54.1 cm.

182 *The Ordeal.* 1927–31
Woodcut 46 : 37.5 cm. MS 657

183 *Birgitte III (The Gothic Girl-Portrait Birgitte Prestö).* 1931
Woodcut 60 : 32 cm. MS 703

184 *The Kiss in the Fields.* c. 1943
Woodcut 40.3 : 49 cm. MS 707

185 *Spider's Web.* 1943
Woodcut 52 : 42 cm. MS 706